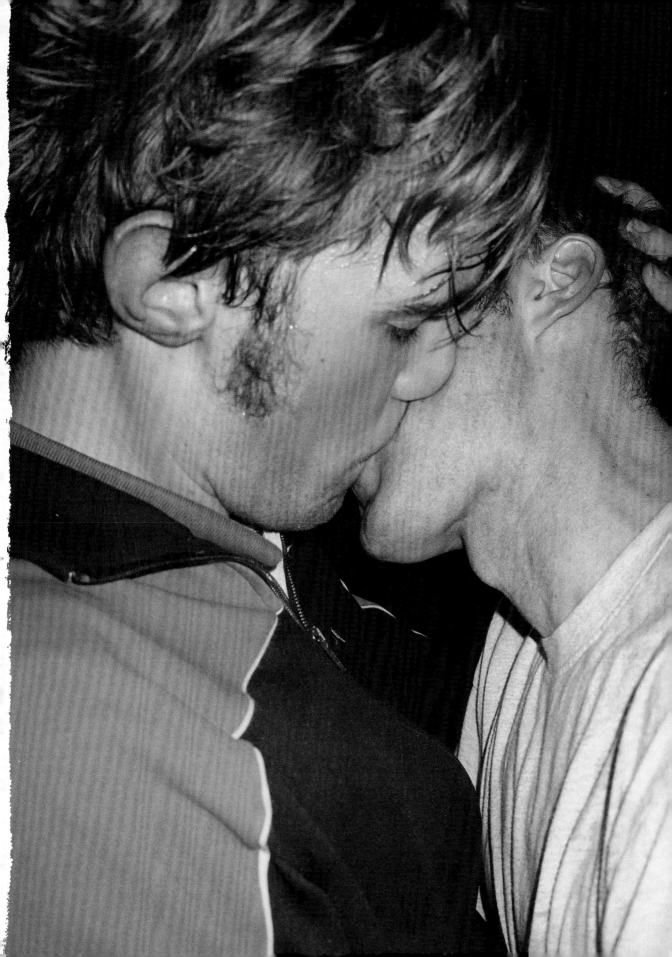

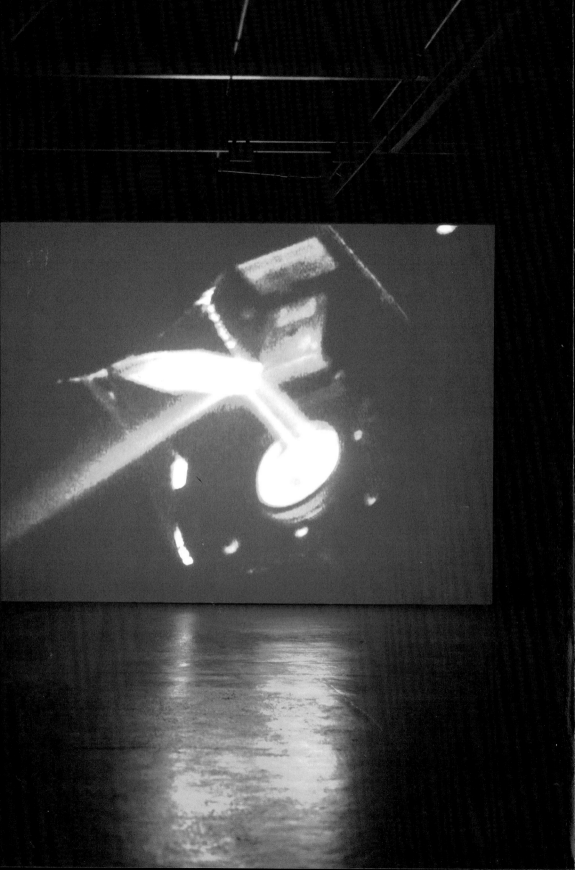

Julie Ault
Daniel Birnbaum
Russell Ferguson
Dominic Molon
Lane Relyea
Mark Wigley

Hammer Museum
Los Angeles

Museum of
Contemporary Art
Chicago

In association
with Yale
University Press
New Haven
and London

Wolfgang Tillmans

This catalogue is published in conjunction with the exhibition *Wolfgang Tillmans,* which was co-organized by the Hammer Museum, Los Angeles, and the Museum of Contemporary Art, Chicago.

Exhibition curated by Russell Ferguson, Deputy Director for Exhibitions and Programs, and Chief Curator, at the Hammer Museum, and Dominic Molon, Pamela Alper Associate Curator at the Museum of Contemporary Art.

The exhibition was presented at

Museum of Contemporary Art, Chicago
May 20 to August 13, 2006

Hammer Museum, Los Angeles
September 17, 2006 to January 7, 2007

Hirshhorn Museum and Sculpture Garden, Washington, DC
February 15 to May 13, 2007

Support for the Hammer Museum presentation is made possible, in part, by Stanley and Gail Hollander, and by Michael Rubel.

Support for the Museum of Contemporary Art presentation is generously provided by Margot and George Greig and Sara Albrecht. Air transportation is provided by American Airlines, the official airline of the Museum of Contemporary Art.

Published in 2006 by the Hammer Museum, Los Angeles, and the Museum of Contemporary Art, Chicago, in association with Yale University Press, New Haven and London.

Hammer Museum
10899 Wilshire Blvd
Los Angeles CA 90024-4343
www.hammer.ucla.edu

Museum of Contemporary Art
220 East Chicago Ave
Chicago IL 60611-2643
www.mcachicago.org

Yale University Press
PO Box 209040
New Haven CT 06520-9040
www.yalebooks.com

ISBN: 0-300-12022-2

Library of Congress Control Number: 2006922372

Produced by the Publications Department of the Museum of Contemporary Art, Chicago, Hal Kugeler, Director

Edited by Amy Teschner and Kamilah Foreman
Designed by Jeffrey Mumford

Printed in Altona, Manitoba, Canada by Friesens

The Armand Hammer Museum of Art and Cultural Center is operated by the University of California, Los Angeles. Occidental Petroleum Corporation has partially endowed the Museum and constructed the Occidental Petroleum Cultural Center Building, which houses the Museum.

The Museum of Contemporary Art, Chicago (MCA) is a private, nonprofit, tax-exempt organization accredited by the American Association of Museums. The MCA is generously supported by its Board of Trustees, individual and corporate members, private and corporate foundations, and government agencies, including the Illinois Arts Council, a state agency. The Chicago Park District generously supports MCA programs. Air transportation is provided by American Airlines, the official airline of the Museum of Contemporary Art.

All works by Wolfgang Tillmans included in this catalogue are chromogenic development prints (C-prints), unless otherwise described. When a work exists in varying dimensions, no size is included in the caption. These works normally exist in three sizes: 12 × 16 in. (30 × 40 cm), 20 × 24 in. (51 × 61 cm) as a C-print, and approximately 53 × 80 in. (135 × 205 cm) in both inkjet and framed C-print. When a work exists in only one size or one medium, that information is included in the caption.

All works by Wolfgang Tillmans that appear in this publication are courtesy Andrea Rosen Gallery, New York, and Regen Projects, Los Angeles.

Cover: *Trinitatis*, 2002
Back cover: *himmelblau*, 2005
Page 1: *The Cock (kiss)*, 2002
Page 2: Installation view, Maureen Paley, London, 2002, *Lights (Body)*, 2000/2002, video installation, 5 minutes, looped

Foreword

Over the past two decades, Wolfgang Tillmans has redefined photography. First recognized in the early 1990s for his intensely affecting and unconventional images of friends and other young people in his social circle, he has developed a highly distinctive style of image making that encompasses a broad range of subjects—from still lifes that transform the folds of casually tossed clothes into a profound experience of the everyday, to abstractions featuring textures, lines, and contours that possess an almost bodily presence. Tillmans also takes a powerfully unique approach to presenting his work, varying the size of his photographs based on the specific spatial situation of the particular venue and producing them as large ink-jet prints and framed C-prints that emphasize both their pictorial and material qualities.

Building on several successful collaborations between our two institutions, we could not be more proud to co-organize this retrospective exhibition of Tillmans's work. Despite international acclaim and recognition—including major solo exhibitions in Europe, Japan, and the United Kingdom—*Wolfgang Tillmans* represents the first substantial survey of his work in American museums. We recognize Dominic Molon, Pamela Alper Associate Curator at the Museum of Contemporary Art, Chicago, and Russell Ferguson, Deputy Director of Exhibitions and Chief Curator at the Hammer Museum, Los Angeles, for their foresight in initiating this project and for their devoted efforts in bringing it to completion.

It is gratifying that this exhibition will be seen in Chicago, Los Angeles, and Washington DC, providing audiences across the country an opportunity to appreciate Tillmans's astonishing vision. We are grateful to our colleague Olga Viso, Director of the Hirshhorn Museum and Sculpture Garden, Washington DC, for her support and enthusiasm.

Generous individuals in both Chicago and Los Angeles helped make this exhibition possible. In Chicago support was provided by Margot and George Greig and Sara Albrecht. Air transportation was provided by American Airlines. In Los Angeles support was provided by Stanley and Gail Hollander and Michael Rubel. We wish to thank them for sharing our passion and making it possible to present this important body of work.

Finally, we wish to offer Wolfgang Tillmans our gratitude for his truly provocative and inspiring art.

Robert Fitzpatrick
Pritzker Director
Museum of Contemporary Art
Chicago

Ann Philbin
Director
Hammer Museum
Los Angeles

window, New Inn Yard, 1997

Introduction

Few artists have changed the manner in which photographic images are made, read, and received in the past two decades as much as Wolfgang Tillmans. Since the mid-1980s, he has reinterpreted representational genres from portraiture to still life to landscape, and invented a radical presentational approach that engages the particular dynamics of specific spaces. First recognized in the early 1990s for photographs of friends and others in his immediate milieu, Tillmans has since expanded his practice to incorporate conceptually inspired meditations on natural phenomena as well as often startlingly beautiful abstractions that result from experiments with the photographic process, among other subjects. His ability to calculatedly create intimate and immediate images combined with his innovative exhibition strategies has made him one of the most influential photographic artists of the past twenty years.

Wolfgang Tillmans is the artist's first retrospective exhibition in the United States, providing an unprecedented opportunity for American audiences to appreciate the expansive range of his vision and experience his distinctive installations in person. Despite being the subject of numerous substantive solo exhibitions in Europe and the United Kingdom, his work has been primarily understood in the United States through various books that have received wide distribution and earned him a significant reputation. A concentrated presentation of his work, however, is long overdue in this country. Thus it is with great and sincere excitement that the Museum of Contemporary Art, Chicago, the Hammer Museum, Los Angeles, and the Hirshhorn Museum and Sculpture Garden in Washington, DC will provide an overdue opportunity for viewers to appreciate Tillmans's calculated use of scale, juxtaposition, and placement to determine the physical, psychological, and emotional effect of his images.

Tillmans's democratic approach to the valuation of subjects and situations as they appear to his eye and are retranslated through the medium of photography, video, and publications was perhaps most succinctly yet poignantly articulated in the title of his 2003 exhibition (and accompanying catalogue) at the Tate Britain, *If One Thing Matters, Everything Matters*. The production of an "impossible color" through the loosening of control in the photographic development thus carries the same weight as a portrait of Tony Blair or a view of a beautifully incidental fold of clothing over a stairway post or a view of a rainbow arching over the house in a Shaker community. Daniel Birnbaum's essay in this catalogue takes an inspired look at Tillmans's singular sense of the visual, while fellow artist Julie Ault provides an intimate appreciation of the effect and logic of his various installations. Lane

Relyea examines Tillmans's redefinition of the terms of abstraction as we currently understand it, and Mark Wigley provides a careful assessment of the work's complicated spatial dynamics and dimensions. We are honored and grateful to have such inspired texts from esteemed colleagues join our own contributions on Tillmans's relationship to photoconceptualism and to portraiture, respectively.

A project of this size and scope could not have been realized without the invaluable contributions of numerous individuals who worked tirelessly on it with passion and enthusiasm. We wish to thank Robert Fitzpatrick, Pritzker Director at the MCA, Chicago, who championed the exhibition from its inception and contributed guidance and inspiration to ensure its success. Ann Philbin, Director of the Hammer Museum, encouraged the resumption of a partnership between the two institutions that accomplished wonders with the 2004 Lee Bontecou exhibition, and was a dedicated supporter of the show. Elizabeth Smith, James W. Alsdorf Chief Curator at the MCA, was instrumental in giving the project its initial backing and her valuable insights and feedback on the progress of the exhibition receive our warm appreciation.

At the MCA, we extend our deepest appreciation to Hal Kugeler, Director of Publications, and Jeffrey Mumford, Senior Designer, for respectively overseeing the production of a book that exceeds our wildest expectations and for a thoughtful design that respects the intimate clarity of Tillmans's vision while effectively constructing an unprecedented visual understanding of his work. Scott Short, Senior Preparator, Exhibitions, and his crew were remarkable in handling the challenges of such an unconventional installation. We thank Greg Cameron, Deputy Director and Chief Development Officer; Julie Havel, Director of Corporate, Foundation, and Government Relations; and Rob Sherer, Manager of Individual Giving, for adeptly pulling together the necessary financial support for the tour and the Chicago presentation of the show. Jennifer Draffen, Director of Collections and Exhibitions, was characteristically attentive and thorough in her work on the contract and tour of the show. We also wish to thank Amy Louvier, Assistant Registrar; Kate Kraczon, Curatorial Administrative Assistant; Kamilah Foreman, Assistant Editor; Diana Fabian, Editor; Michael Green, Coordinator of Rights and Reproductions; Wendy Woon, Beatrice C. Mayer Director of Education; Sarah Jesse, Manager of Public Programs; Angelique Williams, Director of Marketing; and Karla Loring, Director of Media Relations. Editorial Interns Anna Castelaz and Rebecca Sullivan and Curatorial Intern Alexis Klein also provided generous assistance with details of the publication.

At the Hammer Museum, we give particular thanks to Senior Registrar Portland McCormick and her colleague Julie Dickover for their tireless efforts in organizing

the consolidation and shipping of the entire exhibition. Exhibition Coordinator and Assistant Curator Aimee Chang skillfully oversaw contracts and details of the exhibition tour, in close collaboration with Chief Financial Officer Deborah Snyder and Associate Director of Administration Jenni Kim. Jennifer Wells Green and Megan Kissinger, along with the rest of the development staff, were instrumental in securing funding for the exhibition. The installation was overseen by Chief Preparator Mitch Browning, and by Steven Putz. The Hammer's Communications Director, Steffen Böddeker, handled press releases and events, and, along with Melissa Goldberg, was unstinting in his work to promote and publicize the show. James Bewley, the Hammer's Head of Public Programming, organized a series of programs that provided a thought-provoking complement to the exhibition. The other curators at the Museum, Cynthia Burlingham, Gary Garrels, James Elaine, and Carolyn Peter, were supportive of this project throughout.

Thanks are also due to the rest of the Hammer Museum staff, including George Barker, Lynne Blaikie, Paul Butler and his staff, Jennifer Cox, Sean Deyoe, Claudine Dixon, John Alan Farmer, Andrea Gomez, Emily Gonzalez, Bette Jo Howlett, Alison Locke, Mo McGee, Grace Murakami, Michael Nauyok, Catherine O'Brien, David Paley, Paulette Parker, Rebecca Perez, Claire Rifelj, Sophia Rochmes, David Rodes, Trinidad Ruiz, Roberto Salazar, Maggie Sarkissian, Mary Ann Sears, and Sarah Stifler.

Many other individuals contributed to the success of the exhibition and publication. Amy Teschner masterfully edited the texts for this book and deserves our utmost appreciation. Andrea Rosen provided passionate support for the exhibition and her staff—including Susanna Greeves, Brannie Jones, Jeremy Lawson, and Tamsen Greene—provided substantial assistance as well. We also wish to thank Daniel Buchholz of Galerie Daniel Buchholz, Cologne; Maureen Paley of Maureen Paley, London; and Shaun Caley Regen and Lisa Overduin of Regen Projects, Los Angeles. We wish to recognize Kerry Brougher, Director of Art and Programs and Chief Curator at the Hirshhorn Museum and Sculpture Garden, Washington DC, who was instrumental in bringing the exhibition to that institution, and Kristen Hileman, Assistant Curator, for her work on the show. We are grateful to the following for their help in providing assistance in various ways with the catalogue: Catherine Belloy, Marian Goodman Gallery, New York; Michelle Reyes, The Felix Gonzalez-Torres Foundation, New York; Brad Kaye, Gagosian Gallery, New York; and James Rondeau, Frances and Thomas Dittmer Curator of Contemporary Art, and Nora Riccio, Collection Manager, Contemporary Art, at the Art Institute of

Chicago. At Wolfgang Tillmans's studio we wish to thank Marte Eknaes, Stephen Dupont, Federico Martelli, Conor Dolon, and Kylee Newton.

Finally, we wish to express our deepest and most profound thanks to Wolfgang Tillmans, whose generosity of time and spirit and boundless enthusiasm helped to make the presentation of his work an absolute pleasure. The rare combination of sensitivity, organization, dedication, and insight that he brings to the collaborative process is reflected in the visionary work that he creates and which it has been our privilege finally to present in depth to an American audience.

Dominic Molon
Pamela Alper Associate Curator
Museum of Contemporary Art, Chicago

Russell Ferguson
Deputy Director for Exhibitions
and Programs, and Chief Curator
Hammer Museum, Los Angeles

Gold (e), 2002

Wolfgang Tillmans

A New Visual Register for Our Perceptual Apparatus

Daniel Birnbaum

There are photographs by Wolfgang Tillmans that seem inexhaustible. Not because they are complicated in their composition or so jam-packed with visual information that new details keep emerging. That can sometimes be the case, but the richness I'm after is of a different kind. I can return to some of his pictures over and over again and every time experience the same sense of something fundamentally inscrutable. For instance, I can't stop looking at the 1997 photograph *untitled (La Gomera),* which casts a spell on me not just because it's strange — obviously, I don't quite understand what's going on here — but also because of its undeniable visual appeal. Two people are crawling on all fours on the beach, creating a huge drawing in the sand. A line meanders, two curves and then a full loop, but its beginning has eluded the picture. The duo on the beach keep crawling, and the line is still not completed. They stay together and their future is still open. Mysteriously a white dog is following in their heels, it's just about to enter the loop as if part of a secret scheme. Clearly this is just some kind of playful activity on the beach, and yet the twofold crawl and the pattern it produces in the sand seem to carry a deeper meaning. I can't explain why it seems significant to me, even slightly ominous. (I read the artist's remark that this picture was made in the darkest period of his life as a kind of confirmation. But a confirmation of what?) Finally, the upper left corner seems to open up a window to a new chapter or an entirely different story: in the distance a human being with a dog — already barely visible — is about to break out of the frame and leave.

You are free to use your eyes and attribute value to things the way you want. The eyes are a great subversive tool because they technically don't underlie any control, they are free when used freely.
— Wolfgang Tillmans[1]

Taken from a location above the beach, the photograph displays well-defined zones marked by different textures and hues: gray rocks, the smooth sand with the meandering dark graph, rocks again (wet and therefore almost black), then the white foam created by breaking waves, and finally the bright surface of the slightly wrinkled sea. These fields create a well-balanced composition with obvious painterly qualities. (Squint for a second, and the image turns abstract without losing its allure.) "I don't think in media-specific categories. I think first of all, 'A field of color is a field of color,'" says Tillmans in response to the question of how his pictures relate to the history of painting.[2] And yet, while denying that he is painting with the camera, he is ready to acknowledge that his art transcends the photography con-

1 Wolfgang Tillmans, in conversation with the author, December 2005.

2 Wolfgang Tillmans and Isa Genzken, "In Conversation: Who Do You Love?" *Artforum*, 44, no. 3, 228.

Daniel Birnbaum 16

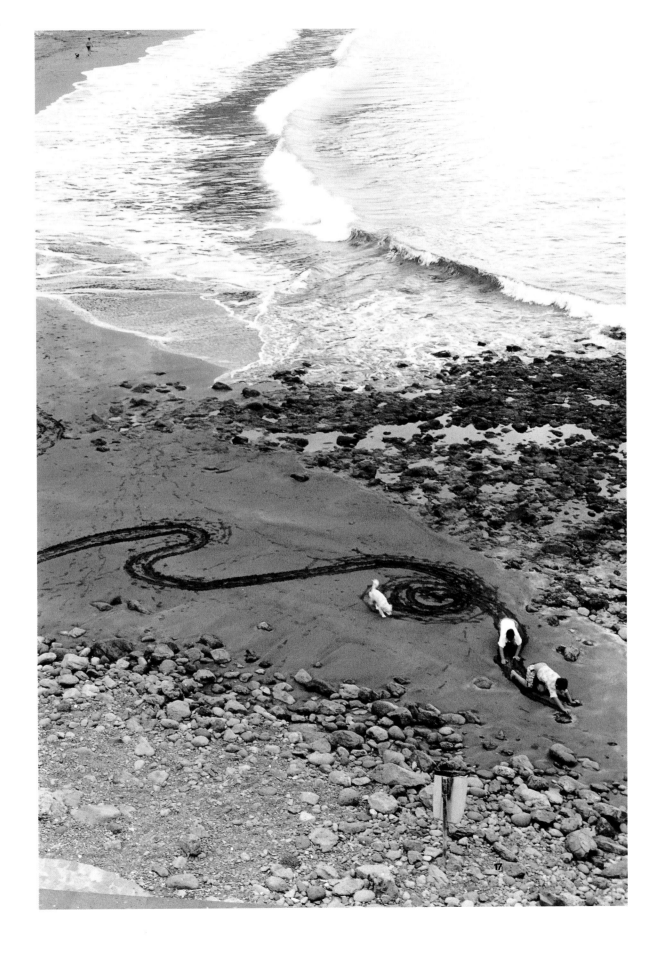

text: "And in that respect my frame of reference obviously includes more than just the 150 years of photographic picture-making."[3]

To me there is no doubt that the visual pleasure—yes, beauty—conveyed by *untitled (La Gomera)* and numerous other classic Tillmans pictures relates to a richer pictorial history than that of the camera. "I don't seek out what looks painterly, and I don't try to make my pictures look like paintings," says Tillmans.[4] Of course an emphasis on pure esthetics and on issues of composition, color, and texture—in short, the painterly—could easily lead us astray as to the ultimate significance of this politically motivated art. But if one doesn't acknowledge this dimension and instead only stresses the transitory and haphazard nature of his pictures something vital is missing. "It's because I see that way. I see the pictures; they are right in front of me," says Tillmans.[5] Anyone who thinks that his art has anything to do with random snapshots has not spent much time with his pictures. They are carefully selected and crafted artifacts that render an inimitable outlook, a distinct way of seeing the world around us. In fact Tillmans's signature view on things has become one of the most immediately recognizable and significant since the mid-1990s, influential not only within the confines of the art world but also in a much broader context of pop culture. It seems that his pictures, which actively avoid what he refers to as the "language of importance," have added an entirely new visual register to our perceptual apparatus. Life imitates art, as we know, and thanks to the "Tillmans effect" many of us recognize our own Tillmans pictures or situations *right in front of us,* out there in the world. It is worth mentioning that many of his pictures contain a "staged" element, without the artist ever having total control. The concepts of staged versus non-staged don't really capture what is typical of his approach to the people and the things he works with.

For an accurate understanding of his art and how it developed it is crucial to point out that the starting point has nothing to do with fashion photography in the commercial sense. Other photographers who emerged in the fashion world in the 1990s were embraced enthusiastically when they crossed over into the art context. This is not at all how Tillmans evolved as an artist, and the idea that he first emerged in the world of fashion and advertisement is a widespread misapprehension that has made a real assessment of his art more difficult. As a teenager Tillmans was collected newspaper photographs in a scrapbook, he experimented with a laser photocopier, he visited exhibitions and read art magazines, and he made his "picture

3–5 Ibid.

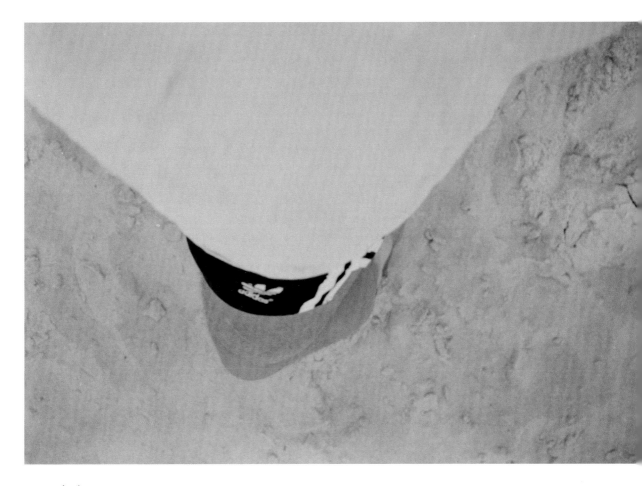

Lacanau (self), 1986

**A New Visual
Register for
Our Perceptual
Apparatus**

number one"–*Lacanau (self)*, 1986–at the age of eighteen and had his first solo exhibition the following year. His first appearance in *i-D* magazine in 1989 had nothing to do with the commercial fashion world but rather with his passions for clubbing, music magazines, and street culture. It should be seen as an attempt to expand artistically and to branch out into one more medium to reach other kinds of subculture audiences. The artist has in fact consistently stayed away from the fashion industry and has never accepted its lucrative offers. To a certain extent, the commodification generally ruling the worlds of fashion and advertisement represent the very enemy for Tillmans, and the will to convey the "complete identity of a person" was presented as a strategic part of the "biggest cultural fight": "I'm using my position in the magazine world to do exactly that, something that I believe in completely and something that I as an artist can only do with credibility, by doing it from within. The endless industry thirst for labels, trends, and fashions turns every style into another benign marketing plot. In a way I try to channel attention to the multi-layeredness of personality and identity…"[6] The insistence on the possibility of a richer diversity of life and for alternative forms of being together recurs regardless of medium. Through his parallel activities as a photographer producing images for the pages of magazines, for his own books, and for his heterogeneous installations that are shown in galleries and museums, Tillmans has in fact created a unique position for himself in the art world and beyond. Every new step and every new context required its own esthetic and moral considerations, every new opportunity demanded new political decisions.

Tillmans's early pictures of friends and his immediate social surroundings communicate a sense of political hope. An insistence on inventive, radical personal life styles and a new sexual politics obviously liberate these young people from repressive stereotypes, and the worlds of techno music, clubbing, peace rallies, and environmental demonstrations seem to suggest a different social order, perhaps even a "utopian ideal of togetherness," to use the artist's own words.[7] A streak of absurdity surfaces in numerous works, a keen sense for the possibility of transgression with simple means, as in *AA breakfast*, 1995, or *man pissing on chair*, 1997. Fundamentally, there is an optimistic tenor in much of Tillmans's work, but the harsh social realities are never far away, and occasionally the most grim aspects of societal control and "micro power" are scrutinized, for instance in *anti-homeless device*,

6 Quoted in "Neville Wakefield in Conversation with Wolfgang Tillmans," in *Wolfgang Tillmans, Portikus Frankfurt*, Brigitte Kolle, ed. (Frankfurt am Main: Portikus, 1995), 14.

7 Quoted in "Interview: Peter Halley in Conversation with Wolfgang Tillmans," in *Wolfgang Tillmans* (London: Phaidon Press, 2002), 13.

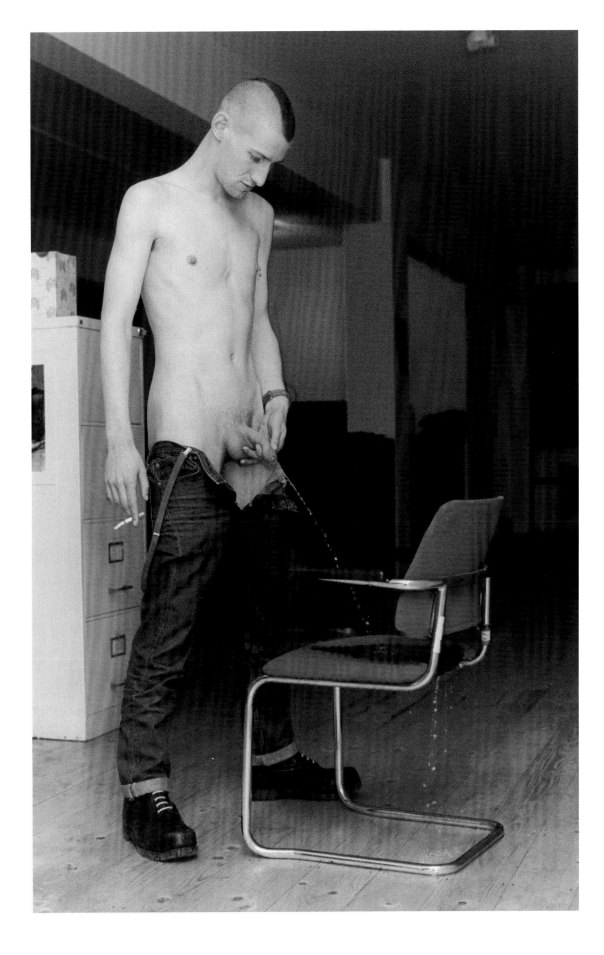

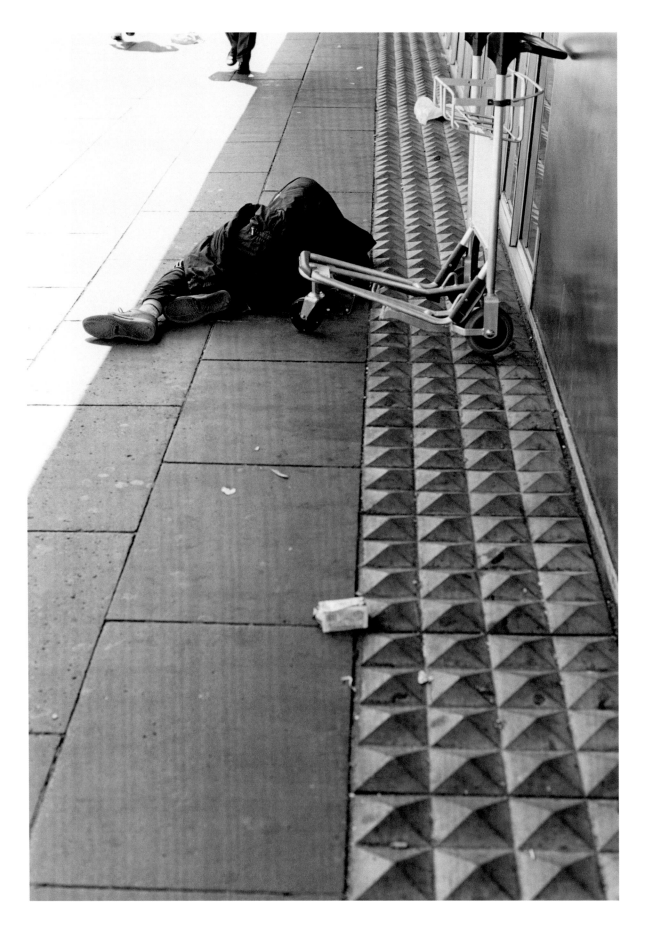

2000, relentless in its gray matter-of-factness. The most decisive notion of politics, however, is Tillmans's belief in the critical power of vision, in the eye as a "subversive tool" that we are free to use in ways that do not obey societal expectations. Tillmans's photographs are never educational in any limited sense, but they are vehicles of critical thinking, not just of sensual experience. That is the only notion of politics that really matters in art.

His installations (mixing portraits of greatly varying scale, still lifes, and abstract photographs with magazine pages, taped or pinned according to a rigorous logic) give expression to a sense of radical multiplicity and an embrace of life's diversity: "Each thing needs a different treatment."[8] Tillmans is an artist of the contingent, the ephemeral and the temporal, states critic Midori Matsui.[9] He makes us see the latent beauty in the peripheral, and in objects and phenomena the significance of which escapes the norms of high culture. Beauty, says Charles Baudelaire in "The Painter of Modern Life," is made up of something "eternal," and "invariable" on the one hand, and of a "relative, circumstantial element" on the other. I doubt that Tillmans would be willing to phrase things in these terms—eternity?—but I cannot see any other artist working today who lives up to Baudelaire's requirements, as in his opening remarks on beauty, fashion, and happiness, who also has as keen a sense for the "ephemeral, the fugitive, the contingent"—that is, for modernity itself as Tillmans does. In Baudelaire's time there was no question as to where one was likely to get a glimpse of the radically modern.[10] There was only one place: Paris, capital of the nineteenth century. A hundred years later it was no longer so clear, and in the early and mid-1990s Tillmans played a key role in at least four artistic contexts that were occasionally linked but still quite distinct: In Cologne he was part of the lively scene surrounding the Daniel Buchholz gallery and the music magazine *Spex*; in Paris he was connected to the group of artists and writers associated with the journal *Purple*; in London, where he lived most of the time, he became one of the key contributors to *i-D* magazine and a kind of bridge between the world of music and the YBA (Young British Artists) scene; and during the years 1994 to 1996 he quickly established himself in New York, where he became friendly with artist groups such as Art Club 2000 and Group Material and soon published work in *Interview* and *Index* magazines. There are many artists who feel at home

8 Ibid., 29.

9 Midori Matsui, "An Aesthetic of Indeterminacy," in *Wolfgang Tillmans* (Phaidon Press), 92.

10 Charles Baudelaire, *'The Painter Of Modern Life' and Other Essays*, J. Mayne, trans. and ed. (London: Phaidon Press, 1964), 3f.

Frieschwimmer 40, 2004
Unique C-print
16 × 12 in.
(40 × 30 cm)

in several cities, but I do believe that Tillmans's productive links to all of these artistic milieus are unique. The creative synchronicity between cities becomes truly visible only when atmospheric connections become concrete in the work of specific artists. In the first half of the 1990s the artist who more than anyone else could be said to represent the sensibility of an emerging generation was Wolfgang Tillmans.

In an attempt to summarize some central characteristics of his art, Tillmans points to two threads that seem to run through most of the works: the alchemy of light and the interest in our being-in-the-world with others and his own wish to relate to these others. Both of these interests tend to be present in his work; in some cases one of them dominates. The alchemy of light is never purer than in the abstract works that investigate the effect on light on photosensitive materials. In fact this really is a kind of painting practice with photographic means (with his hands, not with the camera): dark room interventions and manipulation of the exposure process bring forth images that do not depict reality but create their own abstract realities that appear strangely physical, visceral, and often erotically charged. In suites of images such as *Blushes, Peaches,* and *Freischwimmer,* one encounters bodily orifices, human skin, hair and muscle fibers — or so one thinks. Actually no pictures convey a stronger sense of *flesh* than these pure alchemical experiments in light, not even pictures of real naked bodies. Tillmans displays these large prints among portraits and still lifes and inserts them between other kinds of pictures in his books. Sometimes this practice produces an almost hallucinatory effect, as in the recent *Truth Study Center,* 2005, where fifteen ecstatic pages of cosmic flesh transport us from a series of portraits (ending with Tony Blair, Isa Genzken, Morrissey, and Richard Hamilton) to a black-and-white section of a young soldier displaying his machine gun. No one else edits this way.

The explosive abstract works make one thing clear: in Tillmans's world even the exploration of light has a bodily aspect. His work is always that of an embodied subject, even when the things depicted are celestial. A solar eclipse, the 2004 Venus transit, or the starry night skies are never rendered in a way pretending to be objective and detached. These phenomena are out there in the heavens, but they are also seen by someone, and this someone is a social being living in a body and relating to other humans. The fragment of the artist's own body that one gets a glimpse of in *Lacanau (self)* really is of symbolic importance for the entire oeuvre: although verging on abstraction, the picture captures the point of view of an embodied subject — a human being walking on the sand wearing a pink T-shirt and black Adidas shorts.

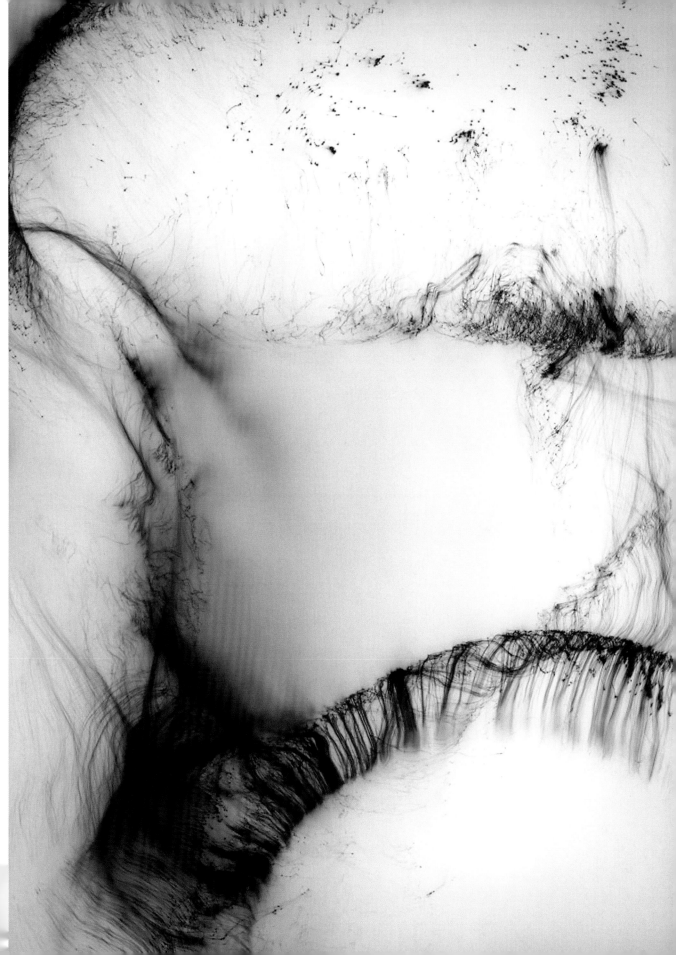

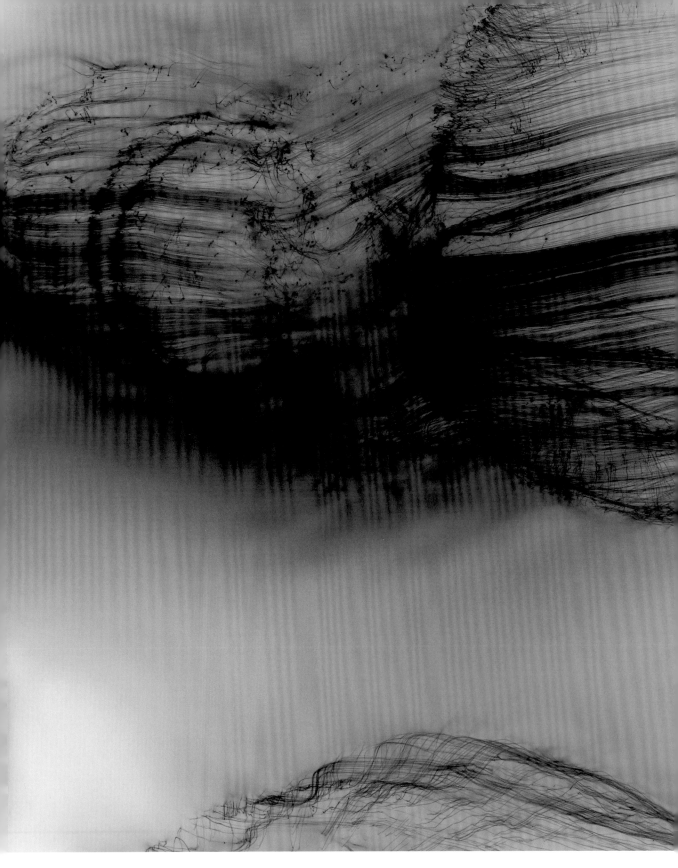

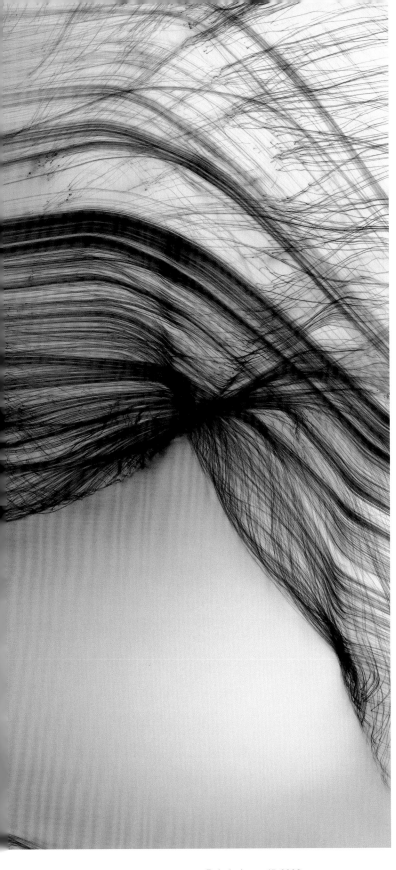

Freischwimmer 15, 2003
Framed C-print
71¼ × 93¾ in.
(181 × 238 cm)

Tillmans's interest in our basic being-in-the-world with others, the other "thread" he mentions, is of course most immediately visible in portraits and photographs displaying couples, gatherings, demonstrations, and clubbing. What he is looking for, says the artist in an early conversation, are "the complexities within people."[11] Asked about the cultural significance of the early *i-D*, he stresses that the magazine made clear that nobody has to subscribe to official rules of how to behave and how to look, rules formulated by others. Instead one can create a persona and identity of one's own beyond all commercial interests. (The *i-D* of the 1980s and early 1990s was quite different from that of today, which more strategically aims at the avant-garde end of the fashion industry.) For his portraits Tillmans looks for people who display the instability and vulnerability that are always an aspect of personal beauty. These photographs are radically different from the detached and neutral-izing portraits of, say, the Düsseldorf Becher school. The world of classification and taxonomy is of little interest to Tillmans. Fundamentally, his pictures are based on involvement and affection, even love.

Being together can sometimes create states of mind that liberate the individu-al from the experience of being confined and locked into finitude. "Paradise is maybe when you dissolve your ego—a loss of self, being in a bundle of other bod-ies," says Tillmans.[12] This dissolution can happen in moments of euphoria, of ec-stasy. There are certainly elated instants in Tillmans's work: dancing, sex, collective bliss. Sometimes these exceptional moments are not about being many: the DJ Mike Pickering alone with his music, 1989, or Paul on the roof with the bright lights of Manhattan in *Paul, New York*, 1994. Some of Tillmans's pictures convey a state of bliss that is difficult to describe, instants in which a different kind of light seems to break through and make the world shine in entirely new colors. Although the searchlight of helicopters hovering in the skyline normally should produce rather sinister associations, the picture *police helicopter*, 1995, rather gives me a sensa-tion of enhanced life. No people are to be seen, the big city itself is radiating a cosmic glow. This strange illumination recurs in other pictures, sometimes produc-ing a kind of hypertranquility, a calm that verges on the rapturous. The subtle but drastic shift can happen in seemingly simple pictures depicting the most ordinary of objects: flowers in everyday plastic bottles, fruit, or vegetables. (Tillmans has significantly contributed to the classic still-life genre.)

11 "Neville Wakefield in Conversation with Wolfgang Tillmans," 16.

12 Interview with Peter Halley, 13.

Astronomy was Tillmans's first obsession, and the "mechanics of the sky" remains an important sphere of reference even if scientific curiosity is no longer the prime driving force. A total solar eclipse no doubt brings forth singular forms of radiance, as does the spotless surface of solid gold when lit in a way that triggers new "alchemical" effects. In *Icestorm*, 2001, for me the most ecstatic of images, the supernatural light is not necessarily benign. In all its visual delight this "intervention piece" also conveys something truly ambivalent. This is dangerous. The landscape is interrupted by colorful stains and marks that produce an atmosphere of artificiality in which the very notion of something natural seems to be rapidly vanishing. What kind of storm is sweeping across this radiant forest? Fiery red explosions fill the poisonous sky.

Daniel Birnbaum is Director of Frankfurt's Städelschule
Art Academy and its Portikus gallery. He is a contributing
editor of *Artforum*. His most recent book is *Chronology*.

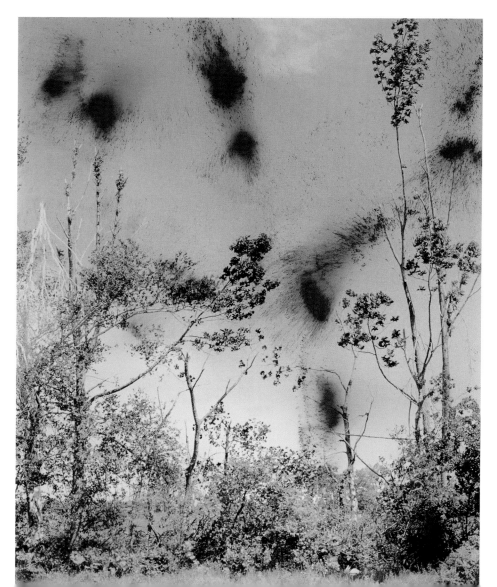

Icestorm, 2001

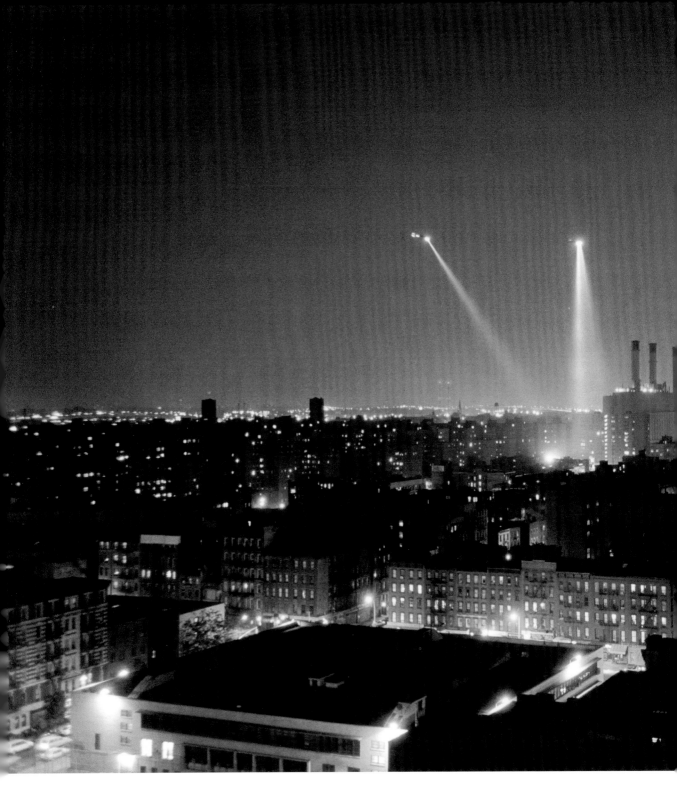

police helicopter, 1995

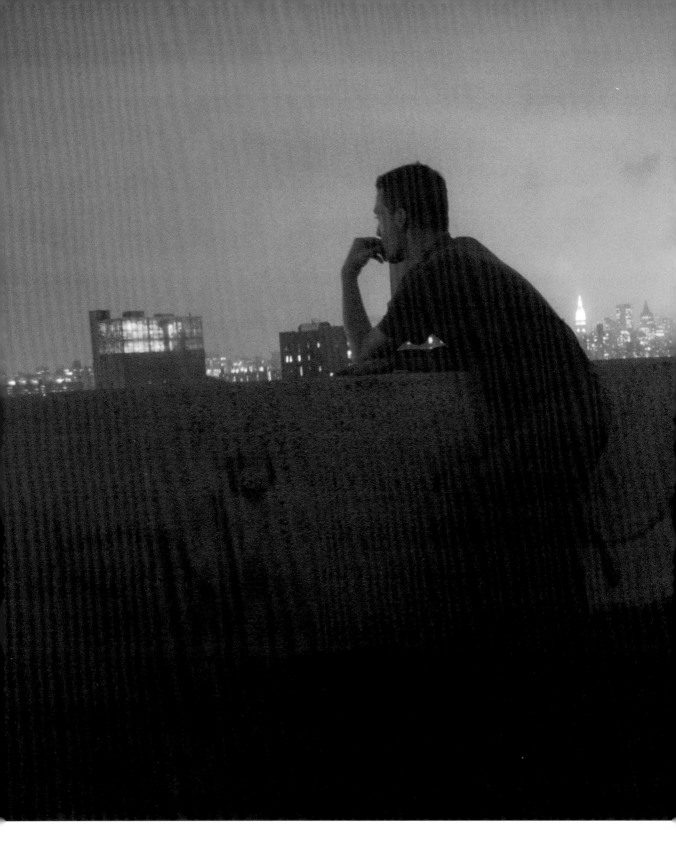

Paul, New York, 1994

Zuversicht, 2005
Framed C-print
71¼ × 81¾ in.
(181 × 223 cm)

A Pulse Within the System: Wolfgang Tillmans and Photoconceptualism

Dominic Molon

Bertolt Brecht's poetic assertion from the 1920s about photography curiously anticipates the attitude of conceptual artists in their use of the medium in the 1960s and 1970s. Bernd and Hilla Becher, Dan Graham, and Edward Ruscha, among

others, reduced the photographic image to a functional "zero-degree" by privileging its documentary properties of signification over its formal or aesthetic properties in their work. These and other conceptual artists exhibited photographs (often paired with texts) in orderly rows on the wall, in books or magazine spreads that resembled advertising spreads or displays that mimicked museum presentations, choosing conventional visual formats to emphasize information over expression. Photography's inherent capability of faithfully recording situations and events and its production of facile and disposable objects became central to this endeavor. Paradoxically, the status of the medium improved. Once artists rejected the photograph's aesthetic qualities in favor of its essential functionality, prevailing perceptions changed. It achieved equal footing with painting and sculpture when it was granted a singular status and purpose.

Gradually, artists began to infuse this function-over-form "aesthetics of administration" with more visually dynamic or emotionally invested content.[2] Bas Jan Ader's photographic images of the early 1970s, for example, documented conceptual performances dealing with romanticism, tragedy, and failure. A few years later, artists such as Richard Prince, Cindy Sherman, and Jeff Wall began to incorporate appropriated or original elements of mass media–based visualizations–cinema, television, magazine advertisements–into highly structured and deterministic photographic presentations. German counterparts such as Andreas Gursky and Thomas Struth expanded upon the typological methodology of their teachers–the aforementioned Bechers–in images that combined a dispassionate conceptualism with the lush color, dramatic composition, and heroic scale of history painting. By the beginning of the 1990s, the photoconceptualist prospect had been stretched to the point that it could accommodate further change to its program, with artists folding more intense emotionalism, passionate identity-based politics, and/or romantic pictorialism into its reductive sense of structure and strategy. Felix Gon-

1 Bertolt Brecht, "An Assertion," in *Bertolt Brecht Poems: 1913–1956.* John Willett and Ralph Mannheim, eds. (New York: Routledge, 1987), 149.

2 Benjamin H. D. Buchloh, "Conceptual Art 1962–1969: From the Aesthetic of Administration to Critique of Institutions," in *L'art conceptual: Une perspective*, exh. cat. (Paris: Musee d'Art Moderne de la Ville de Paris, 1989).

zalez-Torres, Sharon Lockhart, Glenn Ligon, Catherine Opie, and Wolfgang Tillmans were all instrumental in bringing a pulsating sense of human conviction, immediacy, and intimacy to the systematic approach to photography initiated more than two decades earlier.[3]

Of these artists, Wolfgang Tillmans is perhaps least discussed in terms of a conceptual art history of photography. The reception of his work, particularly in the United States, has been biased toward a celebration of his ability to create immediately affecting views of everyday life or searching portraits of friends, the famous, and the almost famous. Tillmans's practice has, however, been deeply informed by conceptualist methodologies from the outset of his career, demanding a more thorough contemplation of his relationship to the history of conceptual art photography. The sustained use of ephemeral inkjet prints in his installations; the presentation of his images within magazines and the subsequent presentation of those magazine pages (and other texts from the mass media) alongside his original photographs; and the use of such administrative visual techniques as serial presentation or institutional forms of display for the exhibition of his images—all of these reveal connections to conceptual practice. Tillmans's invocation of visual systems as both a frame for and contrast to his more emotionally affecting and sensual individual images suggests photoconceptualism's more "human" potential, reaffirming Adrian Piper's observation that "'conceptual art' is the most adequate way of liberating the creative process so that the artist may approach and realize his work—or himself—on the purest possible level."[4]

Tillmans's utilitarian attitude toward the reproduction and presentation of his photographs was clear even in his first serious project as an artist. As he explained in a recent interview:

In my last year in high school [1986–87] I discovered a Canon laser photocopier in my local copy shop, which was the first digital black and white photocopier that could really reproduce quality photographs at that time. You could enlarge them up to 400%. Then, when I lived in Hamburg, I approached this nice gay café to see if I could do an exhibition of these photocopies there. A few of [the

3 See Kate Bush's examination of the effect of the conceptualist approach to photography on recent artists, "The Latest Picture," in *The Last Picture Show: Artists Using Photography 1960–1982* (Minneapolis: Walker Art Center, 2003), 262–266.

4 Adrian Piper, "A Defense of the 'Conceptual' Process in Art," (1967), in *Conceptual Art: A Critical Anthology*, Alexander Alberro and Blake Stimson, eds. (Cambridge, Mass.: MIT Press, 1999), 37.

photocopies] were [my photographs], but others were taken from newspapers. I didn't even own a camera back then. I was zooming into photographs, destroying, dissolving their surfaces. They were displayed as triptychs of three A3-sized photocopies. I felt very strongly that was what I wanted to do, so I put on this exhibition.[5]

In his earliest work, Tillmans's use of photocopying and appropriation recalls such conceptual art precedents as Mel Bochner's photocopied drawings and Richard Prince's re-photographed magazine advertisements, as well as contemporary Felix Gonzalez-Torres' stacked paper works of the early 1990s (minimalist stacks of paper, often featuring mimeographed imagery, that viewers are encouraged to take and keep). His progression from the more crude visuals of these early black-and-white works to the more concise and aesthetically rich color images, however, has not made him any less sensitive to the situation of the photograph as a material object. Tillmans has said that "a photograph can never be stable and perfect and protected, and I like the way it's constantly in flux," recognizing both its fragility and the banality of its very existence.[6] Complicating this notion of the fluidity of imagery and photographic objects are his recent "paper drop" photographs, which demonstrate an appreciation of the sculptural materiality of

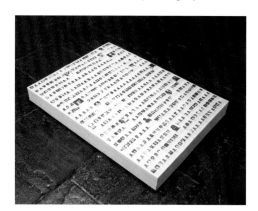

the photographic paper itself. His acute understanding of the photograph's fraught objecthood recalls Jeff Wall's description of the "anaesthetic" nature of conceptualist photography, especially in terms of its reduction of the photograph to the status of mere document and its emphasis on the implied "amateurism" of the artistic process involved.[7] A further implication of Tillmans's approach is that the material status of the photograph—its preciousness as an "original" object—is further compromised by his decision to keep the presentation of his images contingent upon a fluid sense of scale and personal relationship to the image at a given time.

5 Quoted in "Interview: Peter Halley in Conversation with Wolfgang Tillmans," in *Wolfgang Tillmans* (London: Phaidon Press, 2002), 28.

6 Ibid, 29.

7 Jeff Wall, "'Marks of Indifference': Aspects of Photography In, or As, Conceptual Art," in *Reconsidering the Object of Art: 1965–1975*, Ann Goldstein and Anne Rorimer, eds. (Cambridge, Mass.: MIT Press, 1995), 247–267.

This intensive focus on the materiality of the photographic image is matched by Tillmans's equally considered emphasis on process. For example, in the 1991 works *Adam, redeye, Faltenwurf (schwarz)*, and *Adam, bleached out*, images originally shot as Polaroids have been rephotographed using medium-format film. Tillmans's use of a high-definition process that heightens the visual effects of a lower-definition medium provides an early indication of his sustained interest in conceptually exploring the formal conditions and limits of photography. His *Impossible Color* images, made in 1997 and from 2001 to the present, also create a desired result, the formulation of irreproducible colors, from a deliberate misuse of the photographic process. Another picture, *Wake*, 2001, depicts the remnants of a dance party while demonstrating the subtle pictorial effect of a scene being shot using three different light sources—the lights of the space, the daylight coming through the window, and the nitrogen vapor lamp from the neighboring yard. As if to underscore the result of this photographic experiment, this image has been incorporated into the collaborative sculptural installation with Isa Genzken, *Science Fiction / hier und jetzt zufriedensein*, 2001, alongside two mirrored wall structures that extend an examination of the consequences of the play of light into the real space of the viewer.

One of the most distinctive and original aspects of Tillmans's practice is the presentation of his images as variously sized inkjet prints hung with binder clips or tape on the wall. While allowing for a more visually dynamic and spatially determined display of his photographs (as well as a seamless incorporation of other printed matter), this format is primarily motivated by the artist's understanding of his entire body of work as part of a larger archive of lived experiences, some of which assume different levels of personal significance for him at different times. This gesture in and of itself finds precedents and equivalents in such conceptually based works as On Kawara's general meditations on memory and the passage of time or Douglas Gordon's ongoing project *List of Names, 1990–present*, in which he presents a stark visual list of every person he can remember having met in his life. While the framed image has become an increasing presence within his installations, and a definitive master print is retained for every image despite its ephemeral presence in his installations, Tillmans's fluid and variable approach to the presentation of his images evokes the complicated relationship between conceptual artists and the art object.[8] Tillmans—whose comprehensive 2003 exhibition and catalogue for the Tate Britain was titled *If One Thing Matters, Everything Matters*—creates a stalemate

8 See Lucy R. Lippard and John Chandler's "The Dematerialization of Art" (1967), in *Conceptual Art*, 46–50.

in his installations between the emergence of more definitive and "iconic" images (and his constant desire to make these more immediately affecting images) and their being subsumed into the larger spatial and situational gestalt experienced in the gallery.

Tillmans's use of magazine pages as part of his installations and frequent designing of spreads featuring his images for periodicals are both another critical link to a conceptualist tradition and an indication of how he continues to redefine aspects of that tradition. His engagement of magazines as presentational venues reflected a similar attitude among his peers. As Tillmans has explained, "they'd gone through the object-driven 1980s, and young artists were really not interested in that anymore; they were questioning why or how we exhibit at all and how objects can still be meaningful. My taking magazines seriously as a platform for my work as an artist came from that sense of urgency."[9] His comment resembles an observation by art historian Melanie Mariño regarding the conceptualists' use of magazines in the 1960s and 1970s. She noted that their pieces not only disputed the autonomy of the art object by mingling the photographic and the textual and by exploiting the suspension of the photograph and the magazine between mass culture and high art, but effectively turned that status to social use by figuring, in different ways and to different degrees, the everyday conditions that impinge on the re-presentation of art in late capitalist culture.[10] Dan Graham's magazine works of the 1960s, such as *Homes for America,* 1966–67, combined image and text in a manner to produce a photo-essay somewhat similiar to the typical features in a magazine, yet with the key difference of being an oblique examination of the structural logic of everyday life under consumer capitalism and an intentionally aesthetic gesture. It is thus intriguing that a similar sense of crisis in

Faslane Peace Camp,
Magazine spread, *i-D,*
July 1993

Like brother like sister,
Magazine spread, *i-D,*
November 1992

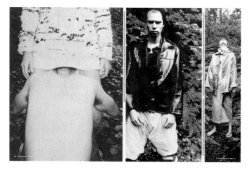

9 Interview with Peter Halley, 18.

10 Melanie Mariño, "Disposable Matter," in *The Last Picture Show,* 201.

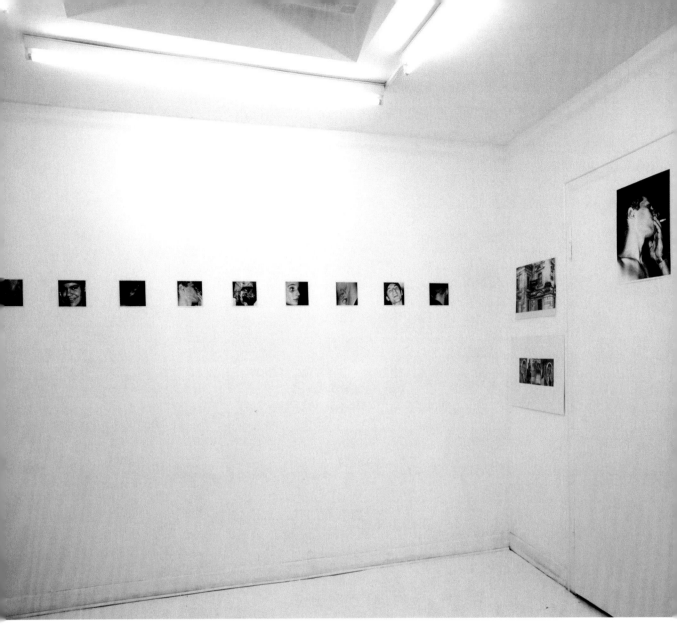

Installation view, Buchholz +
Buchholz, Cologne, 1993
From left: *Chemistry
squares*, 1992

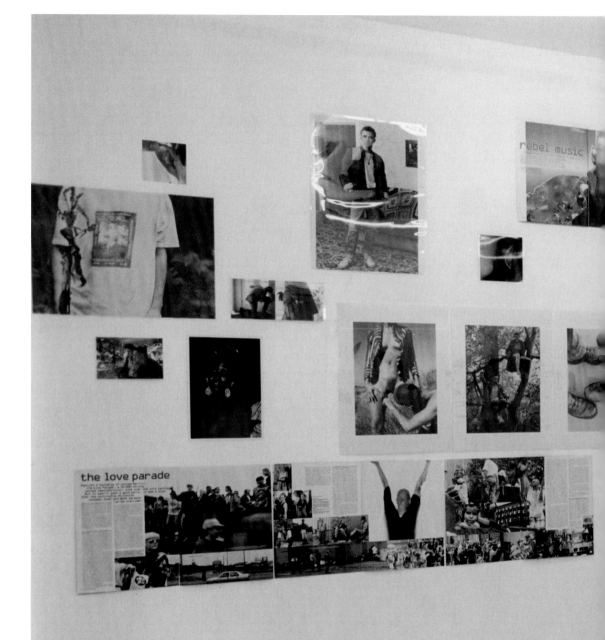

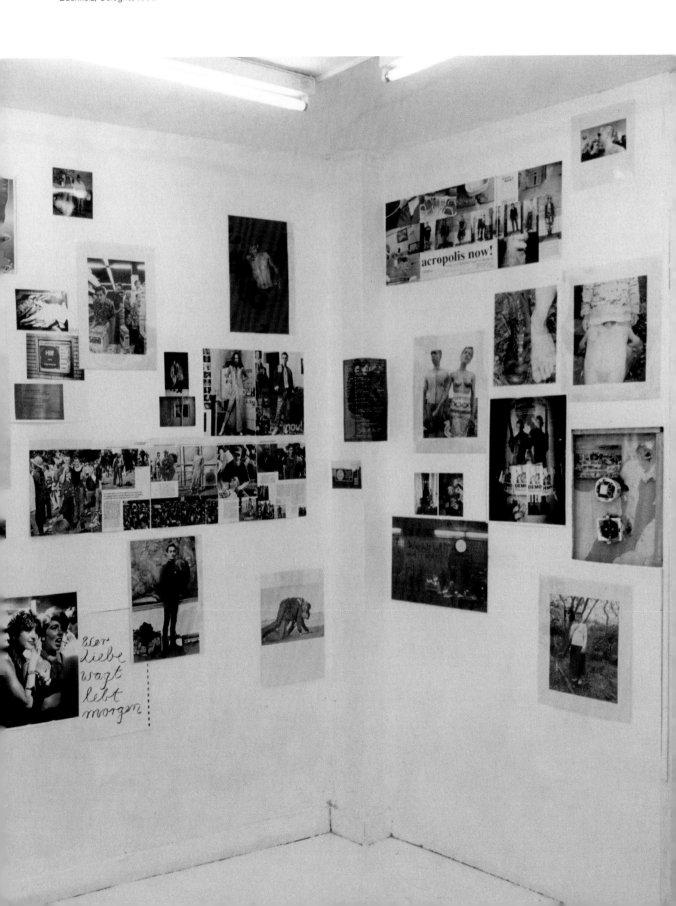

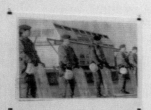

Herald
PUBLISHED WITH THE NEW YORK TI

Frankfurt, Friday, Febru

Israeli soldiers carrying a fellow soldier as part of a drill. They wore masks designed for protection against chemical or biological attack.

Herald INTERNATIONAL T
PUBLISHED WITH THE NEW YORK TIMES AND THO

Newspaper ** R London, Friday, February 26, 1999

Loses
illion
e of
ar

Seeks Ties
hi for
in Japan

U.S
On

WASHI

A soldier of the Kosovo Liberation Army standing guard near Pristina on Thursday.

NATO Troops Move Closer
To Kosovo to Counter Serbs

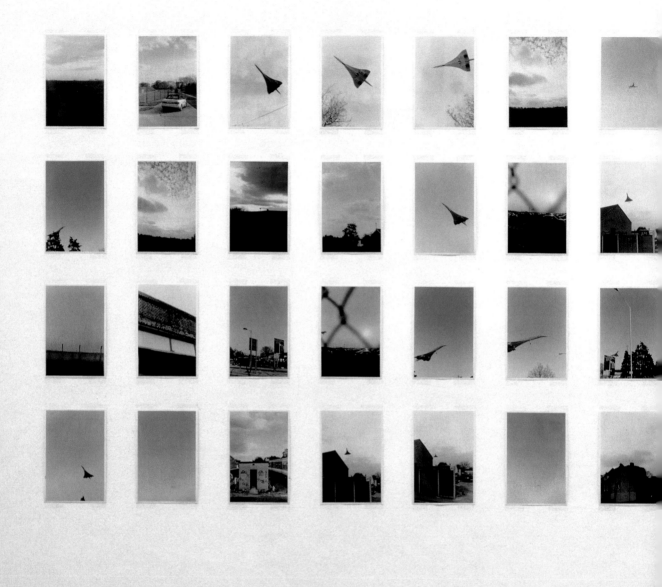

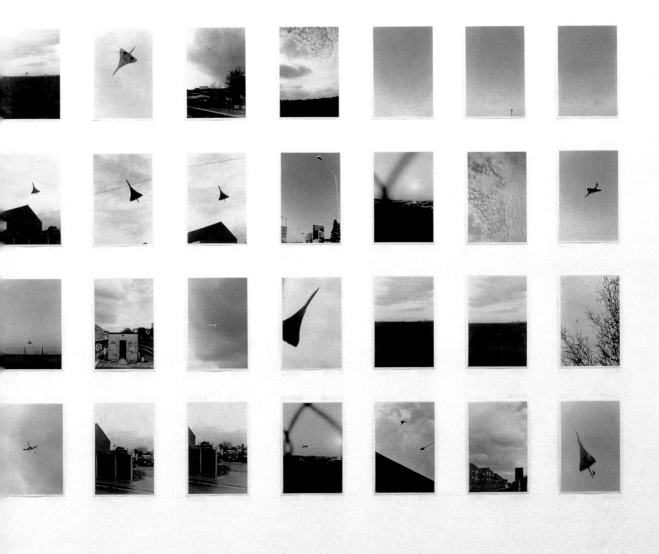

Concorde Grid, 1997
56 C-prints
Overall size 64½ × 182¾ in.
(164 × 464 cm)

relationship to the overemphasis on the status of art as object should not only recur in the early 1990s but also prompt a renewed interest in conceptualist strategies of de-emphasizing the material qualities of the art object. Tillmans's magazine spreads, unlike Graham's, obviously feature a more dynamic presentation of image and text in keeping with their subjects—reportage of gay pride parades, love parades, or prominent pop-cultural figures—and within the context of magazines such as *i-D*, which aim to capture the energy and style of a youth-based cultural scene. The shared impulse to render art-as-object problematic by engaging the transient nature of periodicals, however, demonstrates a strong degree of conceptualist affinity despite the wildly different content and tone of Tillmans's and Graham's projects.

Tillmans's presentation of his magazine spreads as part of a larger installation of original photographs foreshadows the use of rephotographed pages from newspapers and other temporary publications in his discrete installation and book from 1999, *Soldiers—The Nineties*. In this work, Tillmans brings together mostly appropriated images depicting soldiers from various countries in times of both peace and conflict. His cropping of the pictures varies, and the captions and surrounding texts are often retained, yet all of the photographs (in the installations at least) are presented in different sizes. The submission of these very particular and widely

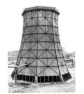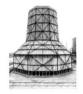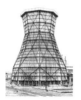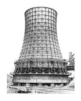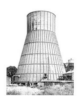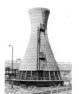
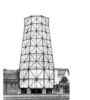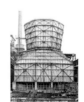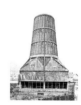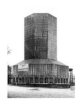

TWENTYSIX

GASOLINE

STATIONS

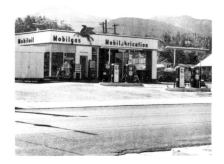 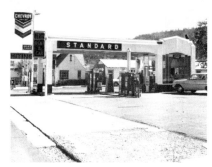

variegated images to a larger organizational structure reveals subtle pictorial conventions in the mass media's depiction of this socially fraught figure—particularly the dearth of representations of the soldiers in active combat or in compromising situations. As Jan Verwoert observes, "through the juxtaposition of these seemingly diverse images of soldiers Tillmans brings out the basics of an ideological rhetoric that occludes the cruelties of war by projecting the image of a soldier as a heroic yet civilized professional."[11] Tillmans's subtitling the project "The Nineties" emphasizes its historical sense of intentionality, further shifting the viewer away from the soldiers as individuals and toward a more detached study of the appearance and demeanor of the military man during this particular decade. The inclusion of original images that provide a softer and more intimate view of the soldier (or "soldier-type") complicates the formal and conceptual rigor of the overall work by prompting an appreciation of these men based on the faint glimmer of personality or their physical presence as represented in the various pictures. This work in particular calls to mind German photo-artist Hans-Peter Feldmann's presentations of generic images of everyday phenomena culled from newspapers and magazines and arranged in a loose, scrapbook-style format on the wall such as *Sonntagsbilder*, 1976–77, or *Postcards of Paris* from the 1970s.

Concorde, 1997, another discrete installation and book project, features images of the Concorde airplane departing and arriving at London's Heathrow airport. The work presents fifty-six views of the famous supersonic jet airliner from various positions and proximities at ground level, shown in installation as a grid of uniformly sized images. The grid format is a preferred presentational mode for conceptually based photographic artists such as Eleanor Antin, Bernd and Hilla Becher, and Sol LeWitt, among others, providing a rigid sense of order and structure to

Edward Ruscha
Twenty-six Gasoline Stations, 1962
Artist's book
1st edition
7 × 5½ in.
(17.8 × 14 cm) closed
Courtesy Gagosian Gallery, New York

11 Jan Verwoert, "Picture Possible Lives: The Work of Wolfgang Tillmans," in *Wolfgang Tillmans* (Phaidon Press), 80.

A Pulse Within the System: Wolfgang Tillmans and Photoconceptualism

impossible colour (green), a, 1997
Unique C-print
24 × 20 in.
(61 × 51 cm)

impossible colour II, 2001
Unique C-print
16 × 12 in.
(40 × 30 cm)

facilitate either a measured and controlled visual situation in which different images may be compared and contrasted, or a sense of temporal progression from one image to the next. Tillmans's use of the grid in *Concorde* renders this understanding of its functionality problematic by displacing obviously sequentially shot photographs into various quadrants of the structure. According to critic Midori Matsui "the aesthetic of indeterminacy in *Concorde* is a dialogue between accident and design, the mutability of time and the materiality of the picture."[12] As seen in the installation format, the plane's iconic status is emphasized rather than the particularities of where and when it was photographed. Furthermore the connotative effect of looking at these particular pictures—suggesting anything from the photographic documents of

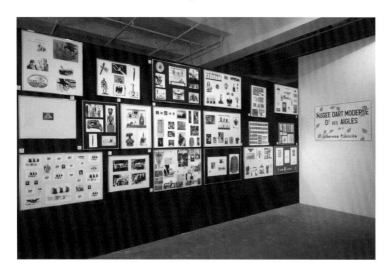

Marcel Broodthaers
*Musee d'art Moderne,
Départment des Aigles,
Section Publicité,*1972
Installation, mixed media
Courtesy Marian Goodman
Gallery, New York

a geeky "planespotter" to a romantic longing for the travel and life transformation implied by air travel—is complicated by the stratified display.[13] The book, conversely, retains much of the chronological order of the shots, providing for a more acute appreciation of the spaces, structures, people, and natural and meteorological phenomena in the same frame as the airliner. As with *The Soldiers* project, the use of the book as a complementary gesture calls to mind the similar use of books by conceptually oriented artists such as Roni Horn, Richard Prince, and Edward Ruscha.

Numerous other examples of serially presented groupings exist within Tillmans's oeuvre, including *Chemistry Squares* from 1992, *Total Solar Eclipse Grid*, 1998, and *Snow Ice Grid*, 1999. In the first series, fifteen 5½-inch square black-and-white photographs each present close-ups of the faces and bodies of young people at the Chemistry Club in London. The uniform dimensions and strict formal presentation of the images diffuse their affecting intimations of joy, exhaustion, uncertainty,

12 Midori Matsui, "An Aesthetic of Indeterminacy," in *Wolfgang Tillmans* (Phaidon Press), 100.

13 "Planespotter" is a reference to the odd and uniquely British hobby "trainspotting," an obsessively tautological recording of the times, dates, and numbers of trains as witnessed by an observing "trainspotter."

and eroticism in an intense social situation, privileging a consideration of the logic of the whole (in terms of possible temporal, formal, or personal connections between the pictures) over an appreciation of the parts. *Total Solar Eclipse Grid* and *Snow Ice Grid* both apply a similar formal order to depictions of natural phenomena in a manner reminiscent of Dutch conceptualist Jan Dibbets's similar photographic investigations of the early 1970s and Danish artist Olafur Eliasson's more recent (1990s – present) photograph grids representing various aspects of the physical world. Tillmans's grids depart from those of predecessor and contemporary alike. (Dibbets's landscape images create variously shaped pictorial forms, and Eliasson's work features detached and nearly identical views of similar natural structures.) Tillmans's grids, with their more impressionistic (rather than studied or formally motivated) views of the outside world, also differ from those of Dibbets and Eliasson in their complication of a sense of temporality (the *Total Solar Eclipse Grid* specifically varies time and place from image to image). Yet despite Tillmans's consistent use of a more arbitrary and immediately intuitive approach to presenting his photographs, the reoccurrence of the grid or serial format in his practice does demonstrate his keen awareness of how a stratified visual approach creates a sense of detachment and remove from otherwise emotionally engaged or affecting images.

The installation *Truth Study Center*, 2005, provides a more recent indication of conceptualist structure in Tillmans's presentational aesthetic and ethos, in this case employing a system of vitrine-like tables to display images, objects, and informational texts. In doing so, he makes pointed connections between texts and images, or more allusive relationships, or, once again, sets up serially experienced visual situations of a formal, thematic, or temporal nature. The project in its entirety is intended as a more or less epistemological exploration of how we continue to define and search for "truth" in an era defined by hypermediation, an endeavor recalling the title of conceptual artist Joseph Kosuth's book *Art after Art after Philosophy* and echoing the generally conceptualist impulse toward an examination of the intellectual structures that create and disseminate meaning. Perhaps more significant is Tillmans's use of the table-structures that, despite retaining a peculiar identity (there are four different heights and three widths, and the tabletops are repurposed new doors), gives the entire installation a strongly museological feel. The incorporation of museum-style presentations or the active engagement of the museum space was critical to conceptualists such as Michael Asher, Christian Boltanski, On Kawara, and especially Marcel Broodthaers, whose installation *Musée d'Art Moderne, Département des Aigles*, 1972, was a fictional museum project that mimicked the administrative forms of display to interrogate and critique that

institution's authoritative role in constructing notions of history and aesthetic sensibilities. *Truth Study Center* is informed by such precedents yet possesses a more personal array of visuals and materials that occasionally make reference to issues and events in the world outside, once again demonstrating how conceptual models have been stretched and re-imagined to incorporate more intimate and subjective content.

The influence of Tillmans's redefinition of photoconceptualism's expressive potential is palpable in the work of younger artists such as Aleksandra Mir—for example, her ongoing *HELLO* project, 2000–present, in which original and found images are placed side-by-side in a "daisy chain" of pictures connected by the people who appear within them—or Shirana Shahbazi's presentation of her documentary-style photographs of life in Tehran in a magazine-style format on the wall. Tillmans's synthesis of what Henri Cartier-Bresson dubbed "the decisive moment," the affecting situation plucked from ethereal arbitrariness of existence, with the anaesthetic attitudes and formal structures of conceptual art, has created an intriguing tension between visual detachment and engagement.[14] Acknowledging the conceptualist appropriation of socially or mechanically developed techniques of depersonalization as a "system" unto itself, Tillmans seeks to provide a more personal and intimate dimension to it in order to create an ideal balance between visual order and discipline and the sublime and often beautiful intangibles and ambiguities of everyday life. Tillmans ultimately produces a curiously dialectical relationship between a sensual, emotional, intellectual, and romantic experience of the world and the limiting social constructs that inevitably frame it.

14 The shift from this pictorialist approach of Cartier-Bresson and other photographers to a more conceptualist sensibility is discussed on pages nine and ten of Douglas Fogle's eponymous introductory essay to the catalogue that complemented his critical exhibition *The Last Picture Show: Artists Using Photography 1960–1982.* (Minneapolis: Walker Art Center, 2003).

Dominic Molon is Pamela Alper Associate Curator at the
Museum of Contemporary Art, Chicago.

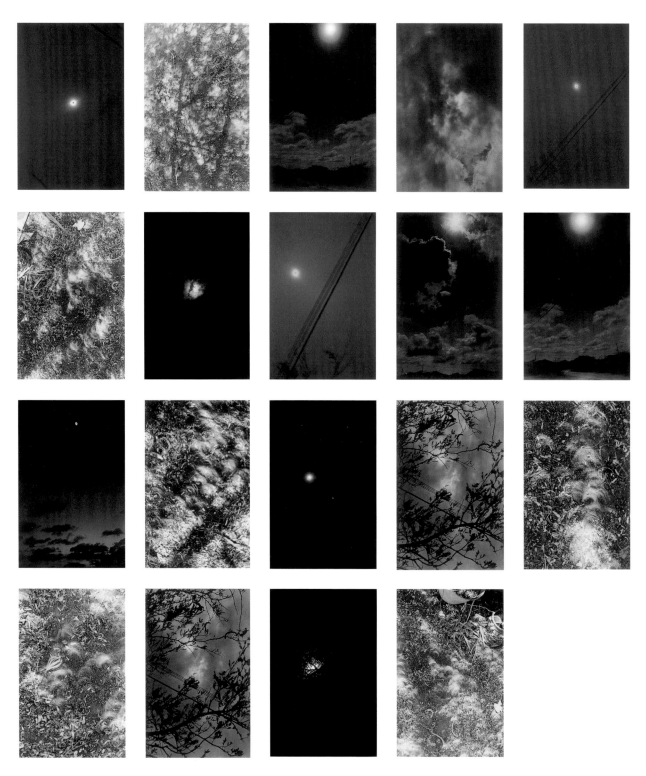

Installation view, Kunsthalle Zurich, 2003
*Isa Genzken/Wolfgang Tillmans: Science fiction/hier
und jetz zufrieden sein* (collaboration)

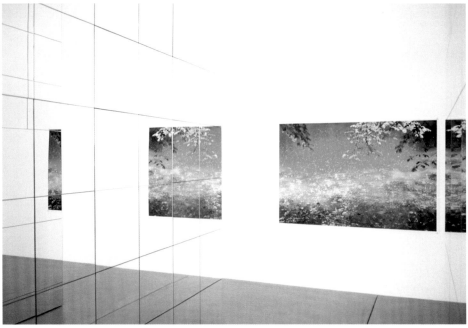

we summer, left, 2004

we summer, right, 2004

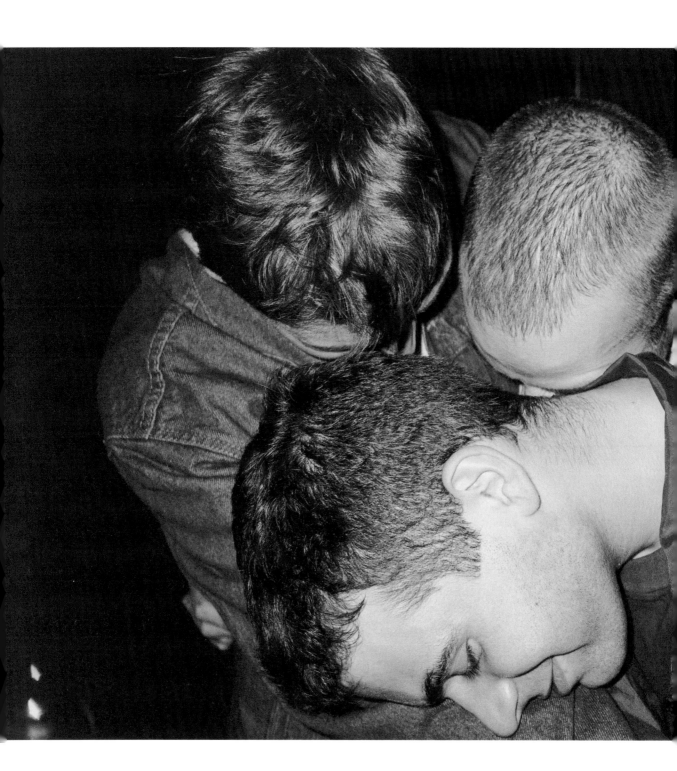

Arkadia I, 1996

Faces in the Crowd

Russell Ferguson

The apparition of these faces in the crowd;
Petals on a wet, black bough.
− Ezra Pound[1]

Wolfgang Tillmans has consistently pushed back against whatever perceptions of his work seem most current. If he is thought of as a casual, snapshot photographer, he produces a book of formal portraits. If he is thought of as a photographer of people, he works on *View from Above*, 2003, with no people visible at all. Or he will make abstractions. Sometimes he will mix all the work together. At other times he will carefully divide it up. His recent book *Truth Study Center*, 2005, is sorted by category, he says, "but in a non-systematic way."[2] There are undeclared categories, non-categories. The flow from one to another is continuous.

Portraits, however, are something of a constant. As he said in 2001,

All of last year I took more portraits again and it's something I guess I won't ever really tire of − sometimes I don't feel I have anything to contribute to portraiture, and then, suddenly, after a year or two, I find I have a renewed, refreshed interest in people. Growing tired of people in general would be a terrible thing to happen to me. Making a portrait is a fundamental artistic act − and the process of it is a very direct human exchange, which is what I find interesting about it. . . . The actual dynamics of vulnerability and exposure and embarrassment and honesty do not change, ever.[3]

Who does he photograph? The answer he gives is "people that I love in some way, that I want to embrace." This sense of intimacy is perhaps most evident in the photographs of Tillmans's late partner, Jochen Klein. *Jochen taking a bath*, 1997, for example, is a quintessential Tillmans photograph, combining personal intimacy with a casual elegance of composition. But Tillmans's portraits also radiate out from this one-to-one intimacy, documenting friendship and love between other people in his circle, as in his extended series of photographs of his friends Alex and Lutz, and further out to include public figures about whom he feels fascination or curiosity: an eclectic group that includes, for example, the actress Irm Hermann, the architect Rem Koolhaas, and the rock singer Morrissey. And, of course, these

1 Ezra Pound, "In a station of the Metro," in *Lustra* (London: Elkin Mathews, 1916).

2 Wolfgang Tillmans, in interview with the author, London, September 29, 2005. All quotations from Tillmans are from this interview unless otherwise attributed.

3 Quoted in Nathan Kernan, "What They Are: A Conversation with Wolfgang Tillmans," in *View from Above: Wolfgang Tillmans* (Ostfildern: Cantz, 2001), 9.

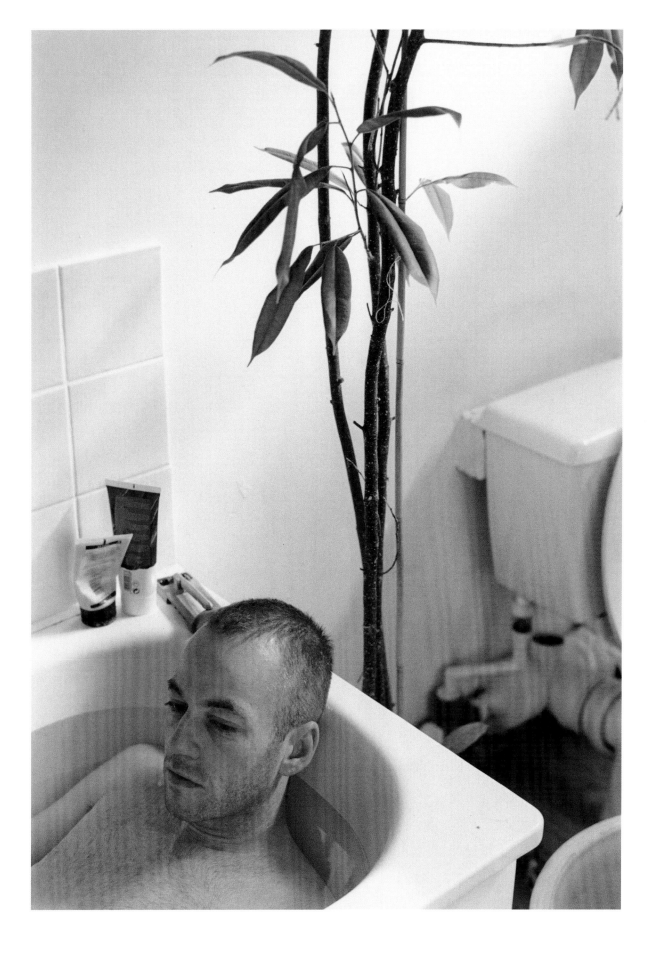

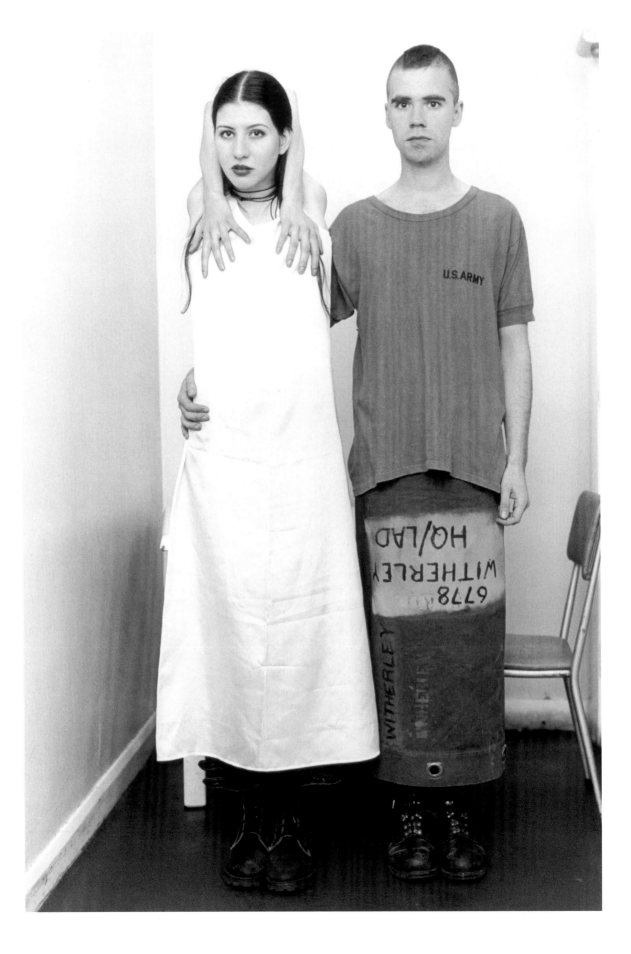

Suzanne & Lutz, white dress, army skirt, 1993

categories themselves are somewhat fluid. Aphex Twin and Moby are famous musicians now, but they were not when Tillmans first photographed them.

Although many of his portraits are highly memorable, even iconic—such as *Corinne*, 1993; *Suzanne & Lutz*, 1993; or *Supergrass II*, 1997—they remain fundamentally untheatrical and rooted in a social context. It is important to remember that when Tillmans began making portraits, the dominant form of photographic portrait was the intensely theatrical work of Richard Avedon and Irving Penn, whose subjects were routinely isolated and in a sense removed from the world. As Benjamin Buchloh has written disdainfully of this work,

> *Their emphasis on the persistence of the photographic and pictorial category of the portrait is as desperate as that of the depicted "subjects" themselves, whom they retrieve in the desperate forms of eccentricity and transform into spectacle as freaks and the victims of their own attempt to shore up traditional bourgeois conceptions of originality and individuality.*[4]

stripped, 2003

Tillmans's subjects—although they do often make an extreme assertion of their "individuality"—are always social subjects. His portraits blur the distinctions between public and private people, public and private situations, but his subjects are never removed from the specificity of their milieu. Whether other people are present or not, they are always implied. There is always another petal on the bough. This rootedness in a social context can result in confusion about Tillmans's aims. He is not a documentarian of subcultures, for example. "I never set out to be the photographer of the nineties, the techno generation," he says, "but these were the people I felt close to." The documentary aspect of his work is a secondary effect of the pursuit of emotional responses, but those responses take place in a specific social context.

If Tillmans rejects the ostentatiously stagy quality of portraits by Avedon and Penn, it is not necessarily a given that he is striving, instead, for some kind of completely unmedi-

4 Benjamin H. D. Buchloh, "Residual Resemblance: Three Notes on the Ends of Portraiture," in Melissa Feldman, *Face-Off: The Portrait in Recent Art* (Philadelphia: Institute of Contemporary Art, 1994), 59.

ated record. He is not naïve enough to believe fully in that possibility. Tillmans's portraits actually blur the question of authenticity, complicating the widespread assumption that an apparently straightforward photograph of someone is a record of them "as they really are." He works instead at various points along a hypothetical line between a totally found image and a totally staged one. Many of his portraits are conceptual works executed in collaboration with his sitters, and they play with the relationship between constructed and so-called authentic identities, and how these are intertwined. Most represent their subject in a relatively straightforward way, but some of these people are to a certain extent acting a part; both aspects can be present at the same time. This is particularly clear in a number of photographs made in the mid-1990s, including *Felix outside The Lure, Gillian, Bernadette Corporation, Smokin' Jo, Rachel Auburn*, all 1995, *Nan reclining*, 1996, and the photographs of Kate Moss from 1996.

Of course, the people he represents are individuals, with their own styles, their own vulnerabilities, their own self-confidence and sense of how they want to present themselves. But they are also components of a larger picture. Their images become part of a mobile network, constantly rotating, shifting, recontextualizing, and generating new meanings from new juxtapositions. Tillmans's distinctive installations reinforce this idea of a kaleidoscope of images. The photographs can be experienced like a conversation between friends, shifting focus all the time, but also returning to certain themes, to certain faces.

While any particular photograph can be taken as an individual work, most compelling is the larger dialectic between the image as a document and as evidence of Tillmans's own specific aesthetic. I hesitate to describe any artist's work as poetic, but the accumulation of apparently neutral and straightforward images in the end inescapably suggests a very precise way of looking at the world. In early twentieth-century poetry, the imagist movement rejected the sentimental tone and elaborate vocabulary of the Victorians in favor of precise images and straightforward language. Ezra Pound and William Carlos Williams were among the best-known poets associated with the movement. Tillmans, comparably, rejects a self-conscious aestheticism and makes the claim that a direct vision can be as powerful. His deceptively straightforward images, often mistakenly thought of as casual, work in this tradition, inviting their audience to accept direct communication, and at the same time to take it seriously as art. Like Pound's faces in the subway, "Petals on a wet, black bough," each person who appears in Tillmans's photographs might or might not have a striking individual presence, but they also form part of a larger composition. Any single image might seem slight, quotidian. In the accumulation of details, however, a highly specific vision emerges.

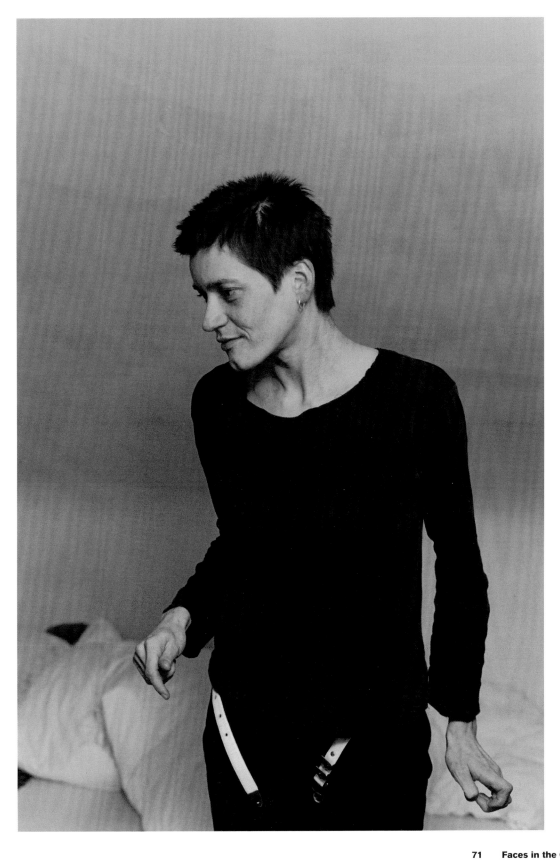

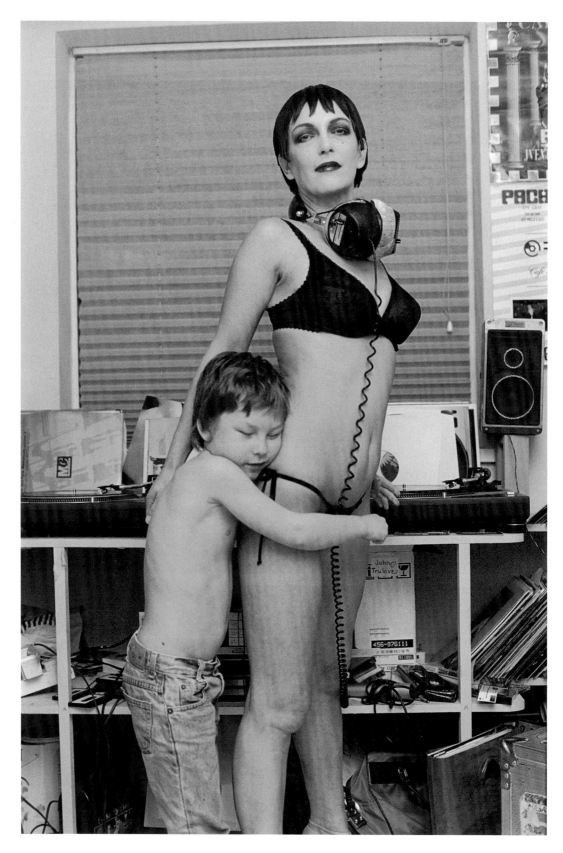

Rachel Auburn & son, 1995

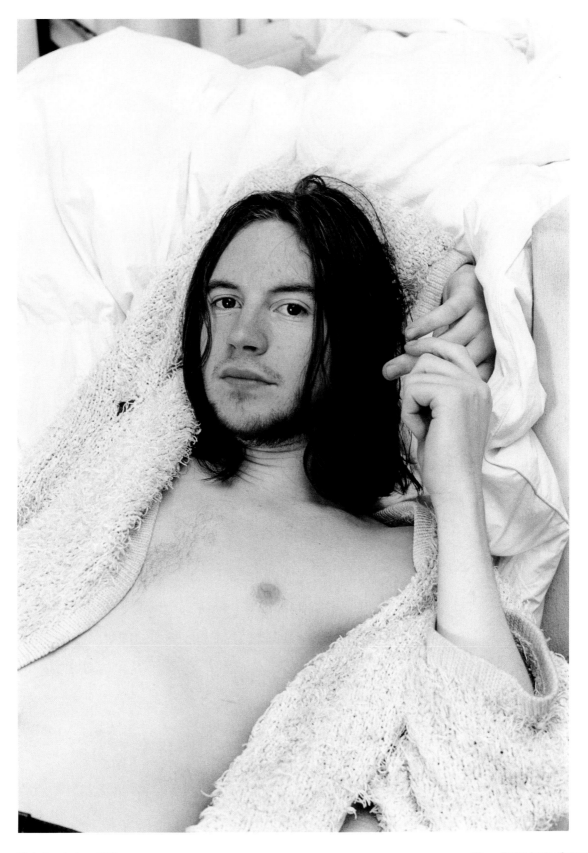

Chris Cunningham, 1998

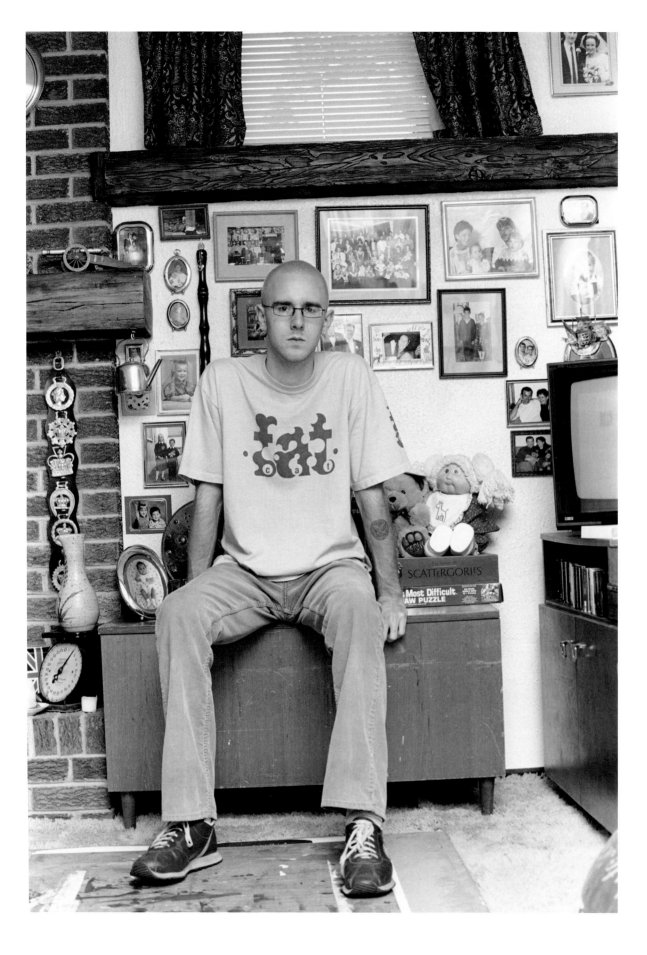

In the end, the portraits are not easily separable from the rest of his work. Is a photograph of an unknown person seen for an instant in a nightclub a portrait? Is it a portrait if you can't see the person's face? Is *Socks on radiator*, 1998, a kind of portrait? Anyone who has seen one of his installations knows that portraits are often to be found mixed with landscapes, still lifes, abstractions, and every other potential genre. As Tillmans accounts for this,

> *When we see a person, we don't think "portrait"; when I look at my window-sill I see fruit in a bowl and light and respond to them, I don't first see "still life." That's how I want to convey my subject matter to the viewer, not through the recognition of predetermined art historical image categories but through enabling them to see with the immediacy that I felt in that situation.*[5]

This is not to say that the categories are meaningless. It means, rather, that we must see the portraits as part of a much more extensive set of relationships. As Tillmans has said of his work in general, "I am interested not in individual readings, but in constructing networks of images and meanings capable of reflecting the complexity of the subject."[6] The portraits, thus, not only represent a set of relationships among the various people depicted; they also form part of a dialogue with Tillmans's work as a whole, and with the various connections that individual viewers may bring to any given image. It is possible to see all of Tillmans's photographs as a kind of ongoing, extended *self*-portrait, a record of his passage through the world. "Within me it is all one continuum," he says, although he insists at the same time that the photographs are not in any way random. "I'm not just drifting around, taking a picture here and there. Each type of work is carefully considered in its own right. On the other hand, the great advantage is my liberty to do all these things."

In the background of Tillmans's portrait of the techno DJ Richie Hawtin (*Richie Hawtin, home, sitting,* 1994) at his parents' home, we can see the board game Scattergories lying next to him. The name seems apposite, suggesting categories that exist, but which can nevertheless be scattered randomly around. And, of course, Tillmans does not typically make a body of work in one category, and then move on. Lines of inquiry are picked up, put down, and taken up again later, over many years. And whatever categories might seem to exist are always subject to reexamination and fragmentation.

One category that has been a consistent source of confusion about Tillmans's

5 Quoted in "Wolfgang Tillmans in Conversation with Mary Horlock," in Wolfgang Tillmans, *If One Thing Matters, Every thing Matters* exh. cat. (London: Tate, 2003), 303.

6 Quoted in David Deitcher, "Lost and Found," in *Wolfgang Tillmans Burg* (Cologne: Taschen, 1998), unpaginated.

work is its relationship to fashion photography. There is a persistent and widespread misconception that Tillmans began as a commercial fashion photographer and somehow crossed over into the world of art. Remarkable as it is that such a characterization could still be held against anyone who did in fact follow that trajectory, in this case it is not even accurate. True, some of Tillmans's work has appeared in a fashion context. Some of his early photographs appeared as fashion features, but this work was initiated by Tillmans himself, not commissioned. Rather, its publication in that context reflects an openness on the part of publications such as *i-D* to publish work that was difficult to categorize, in some ways paradoxically offering Tillmans more autonomy than the art context of the period.

Tillmans has never had anything resembling a conventional career as a fashion photographer. He has never shot for any advertising campaign, and he does not allow his work to be used for advertising. His subjects are rarely wearing high-profile logos or brands, except perhaps the ubiquitous and inescapable Levis and

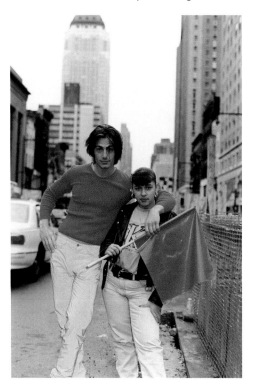

Michael Bergin and fan holding flag, 1995

Adidas. While style and a consciousness of style, sometimes high style, are widely present in his work, specific purchasable items are not. Tillmans knows that trying to preserve this distinction leaves him open to criticism and misunderstanding, but he insists on it nonetheless. Although it is true that his photographs themselves have become commodities of a sort, a resistance to commodification is nevertheless a leitmotif of his work overall. His recurrent themes—quiet observation of nature and everyday things; hanging out with friends; sex; political activism; dancing—are all free. None of them involves buying or selling.

This does not mean, however, that he avoids the fashion context altogether. That would be to play into the assumption that work done in that context is inherently inferior to other photography, which would completely contradict the anti-hierarchical impulse that runs throughout his work. And in any case it would be futile to deny the penetration of a fashion consciousness into everyday life. A case in point is a photograph from 1995, *Michael Bergin & fan holding flag*. Bergin, a Calvin Klein underwear model, was approached by a young woman on the street—herself wearing a CK T-shirt—who told him she had a poster of him in her room. The whole

Russell Ferguson 76

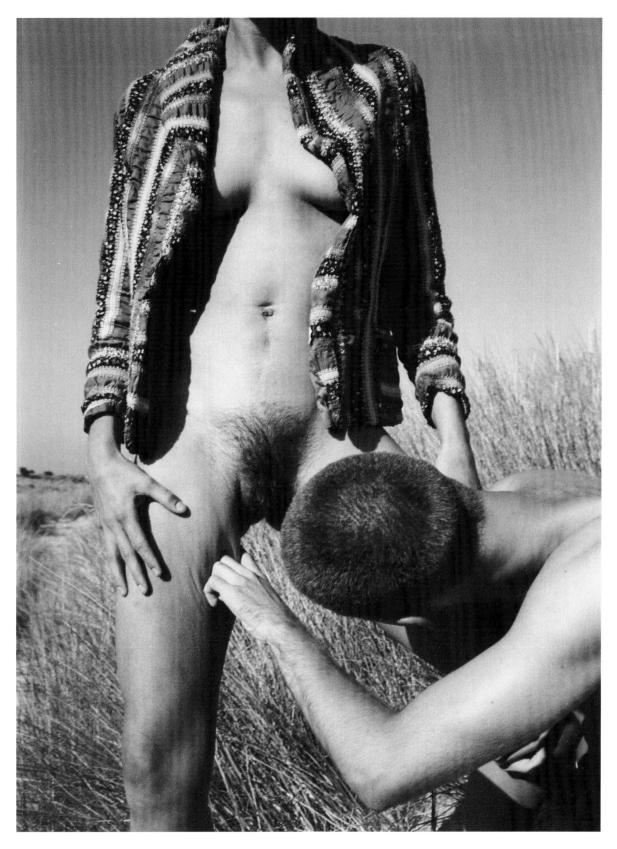

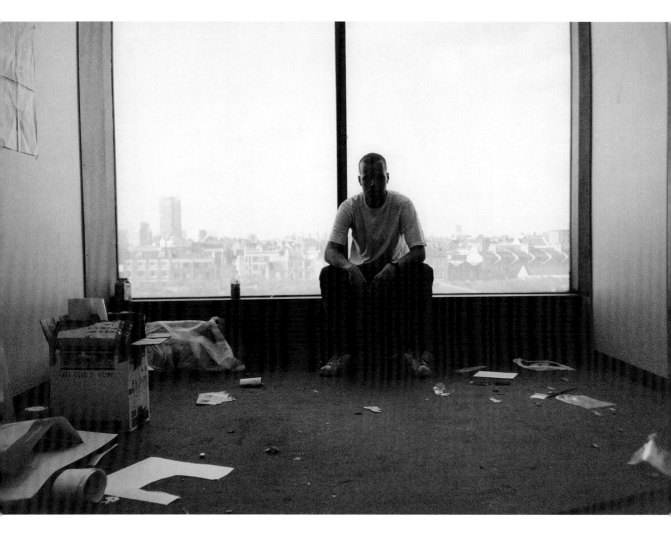

o. M., 1997

encounter between the two is entirely framed by the blended commodification of product, image, and identity. Both Bergin and his fan pose like models for Tillmans, yet the resulting photograph seems anything but staged.

In 1996 Tillmans quite consciously cut against the "countercultural" tendency in his work by agreeing to make a series of photographs for American *Vogue*. He accepted on the condition that he could work with Kate Moss, "the only *Vogue*-class model that I felt enough about." Although these photographs were the result of a single sitting, they are among Tillmans's best-known photographs and have contributed to the ongoing misunder-standing of his work. Any such assignment for a glossy fash-ion magazine, of course, ran the risk of undercutting Tillmans's credibility as someone resistant to the world of consumerism, and instead marking him as vulnerable to the blandishments of a world that is always in search of a borrowed sense of authenticity. Yet it was in part the very counterintuitive nature of this project, and Tillmans's desire not to limit himself in any way, that led him to accept it. In using Tillmans, *Vogue* no doubt expected photographs that appeared casual, bo-hemian, or spontaneous. But while Moss does appear relaxed, the photographs are quite formal, even classical. There is also an extended pun in them, since in this portrait "sitting" Moss is literally sitting in every shot. Of the five photographs from this session that Tillmans considers works of his, *Vogue* used only one.

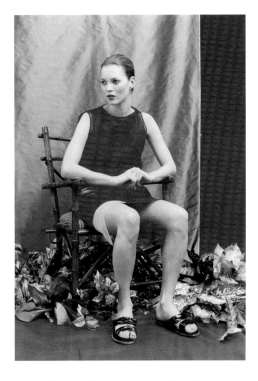

Kate sitting, 1996

Magazine work of all kinds, however, not just fashion, continues to be a productive catalyst for Tillmans, offering access to unexpected new situations that may or may not lead to photographs that he will consider his own. Thus we have portraits of people such as Tony Blair, Richard Branson, Goldie, or Jude Law. He photographed Blair for the English gay magazine *Attitude*. While in many contexts Tillmans is now recognizable as a well-known figure in his own right, for the prime minister he was simply the photographer who came with the interviewer. Such anonymity can be productive and would not be possible without the cover of the magazine assignment. "I have every intention," Tillmans says, "of keeping the 'photographer' role." His magazine work, whether for *The Big*

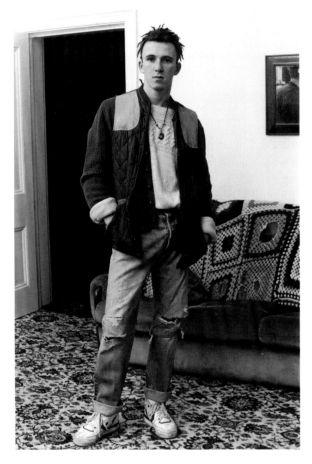

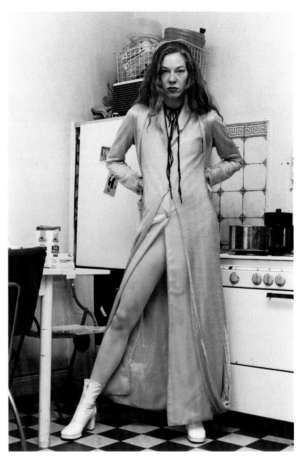

Adam, 1991

Julia, 1991

Issue, Butt, or *i-D*, is one way of projecting his work beyond the confines of the art world and reaching people who have never set foot in a gallery.

The overlapping of bodies of work that Tillmans has made over lengthy periods, combined with the apparently casual, spontaneous feel of many of the photographs, has largely obscured the degree to which he is quite consciously pursuing certain ideas. "It's not that I get a visual tickle and then press the shutter," he says with some frustration. "I have certain things that I'm looking for." His lack of a showy, signature style also contributes to the sense that his images simply fall into place by chance. He has also become among the most imitated of photographers. Traces of his style can be seen everywhere. Yet somehow we can tell almost instantly that a photograph is by Tillmans, despite his legion of imitators. It can be hard to articulate just why that is, given his resistance to a conventional signature.

Part of the answer is technical: the lighting of his photographs. His lighting is antitheatrical; indeed it is all but invisible, but it is very important. He generally keeps it flat, most often by bouncing a hand flashgun intuitively into the room, preferably off a white wall somewhere. This technique largely eliminates shadows, thus giving the picture a clarity and a directness that is understated but unmistakable. We tend to edit out shadows from our consciousness of what we see in daily life. Tillmans keeps them mostly out of his photographs, too. Paradoxically, they thus seem all the more immediate. This low-key formal technique was developed as early as 1991, with the portraits he made of his classmates at Bournemouth College of Art and friends from Germany. These photographs, such as *Adam,* or *Julia,* he considers his first successful portraits.

> *I got rid of everything that's artistic in portraiture: interesting lighting, recognizably "special" techniques, and all the different styles that divide us from the subject and are usually considered to be enhancements of the subject or the picture. I found a way of indirect lighting that looks like the absence of artificial light. That's often been misunderstood as a lack of formality, and dismissed as the dreaded "snapshot aesthetic." I know what people are referring to when they say that—the immediacy they feel from my pictures—but what's mistaken about the term is the lack of composition and consideration that it implies.[7]*

The compositional simplicity of the 1991 photographs came from a reconsideration of what it was that he really wanted to achieve with them: "Before that I

7 Quoted in Gil Blank, "How Else Can We See Past the Fiction of Certainty?" in *Influence 2* (Summer 2005), 112.

tried to make *interesting* portraits." But then, in a kind of breakthrough that was personal as well as artistic, Tillmans realized that he did not have to demonstrate that he and his friends were interesting. He began, that is, to take himself seriously, and realized that his own circle offered more than enough material for him to work with without theatricalizing it. His developing confidence in his own aesthetic judgment also went along with a growing sense of the legitimacy of self-representation. To the extent that he felt that others did not properly represent him and his generation, and that he would take it upon himself to rectify that, we can see a connection to the identity politics of self-assertion that were already well established in the eighties. Tillmans wanted to give a certain dignity to the friends that he was photographing, and thus his antitheatrical lighting and apparently casual composition went hand-in-hand with a respect for the integrity of his subjects. "For me," he says, "a good portrait shows the fragility and humility of the person, and at the same time a strength, a resting in themselves."

I suggested earlier that one way of looking at Tillmans's work is as an extended self-portrait, in which a portrait, a landscape, a still life all become part of a larger body of work, united through Tillmans's own sensibility and biography. Thus an ecstatic scene in a nightclub can take its place alongside the tranquil contemplation of nature in a Shaker village. There is a humanist simplicity and a clarity of vision that runs through everything he does that makes it unequivocally a single body of work.

Having begun with one imagist poet, Ezra Pound, I want to end with another, William Carlos Williams, in whose poem "The Red Wheelbarrow" each apparently inconsequential detail gradually takes on a crystalline significance:

so much depends
upon

a red wheel
barrow

glazed with rain
water

beside the white
chickens [8]

8 William Carlos Williams, "The Red Wheelbarrow," in *Collected Poems: 1909–1939, Vol. 1* (New York: New Directions, 1938), 224.

In Williams's poetry, as in Tillmans's photographs, the desired effect is produced in large part through an accumulation of details. Each element depends on and enables the next, whether in a farmyard or nightclub, in a portrait or landscape, and in the end informs the totality of the work. Each image communicates an existence at once singular and connected, an individual in a moment, an entire body of work over time.

Russell Ferguson is Deputy Director for Exhibitions and Programs, and Chief Curator, at the Hammer Museum, Los Angeles.

blood dancer, 1992

armpit, 1992
C-print
6 × 6 in.
(15.24 × 15.24 cm)

*chemistry square, neck &
chest*, 1992
C-print
6 × 6 in.
(15.24 × 15.24 cm)

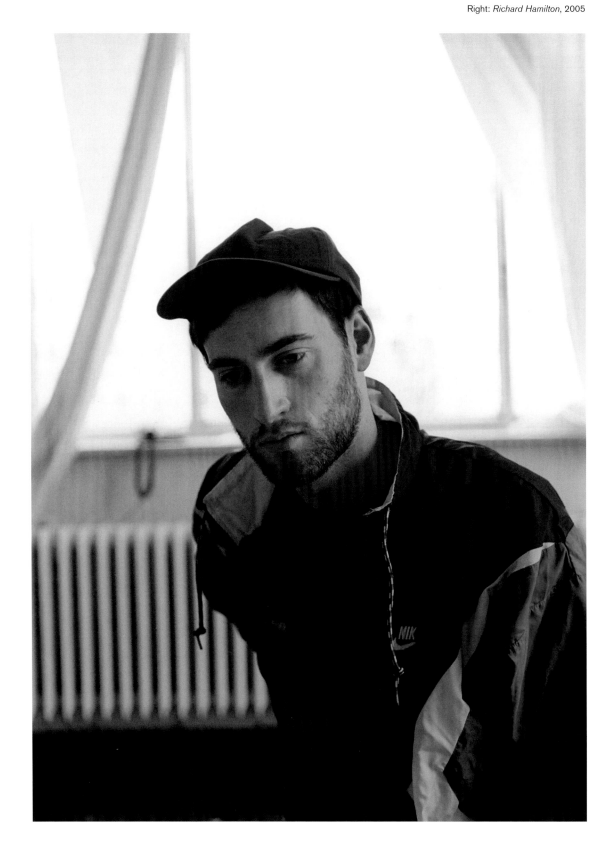

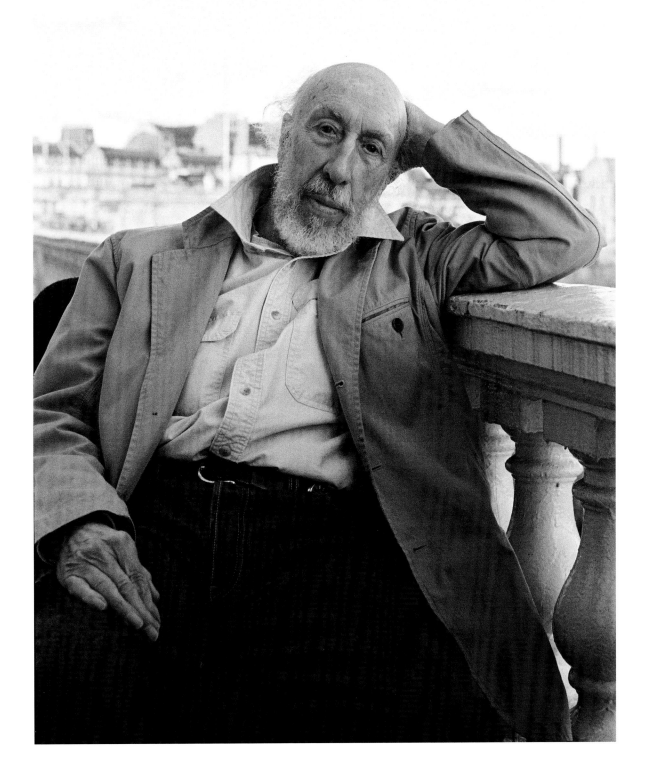

Silver installation (detail), 2005

Photography's Everyday Life and the Ends of Abstraction

Lane Relyea

I have been asked to write on Wolfgang Tillmans's abstractions. That is, my task here is to abstract one aspect from Tillmans's much larger overall practice. The job seems to call for a specialist, perhaps even for abstraction to be treated as a kind of specialty. But I want to resist that role, mainly because it flies in the face of Tillmans's most basic leitmotiv, which is to treat pictures, including abstract ones, not as isolated phenomena but as always already interrelated. Tillmans is, after all, very much a generalist. Just look at his sprawling installations (over 300 works at the Tate in 2000, 150 in a 1998 private gallery show), the work's encyclopedic array of subject matter (still life, genre, portrait, landscape and beyond, all handled both conventionally and unconventionally, preciously and casually). Look at the different functions he performs (magazine photographer, book editor and designer, curator of his own shows)

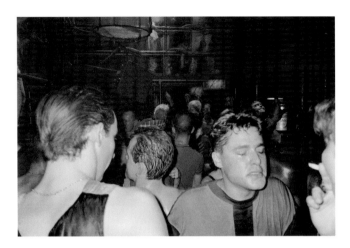

Chemistry (view), 1992

and how effortlessly his practice segues from studio time in the darkroom to post-studio forms of engagement ("The work only half starts with the pictures," he says).[1] So to the question of what might be the meaning of abstraction for Tillmans's larger enterprise, and what might Tillmans's work mean for abstract art in turn, one possible answer is this: abstraction aids in Tillmans's quest for generality, for a broadness of scope and vision, while Tillmans's generality aids in recovering abstraction from its current status as an overly narrow artistic specialization.

I. It has been argued that negotiating the specific and the general is the defining preoccupation of modern art. "Modernity is the transient, the fleeting, the contingent," is how Baudelaire wrote out the equation; "it is one half of art, the other being the eternal and the immovable."[2] Tillmans has often been said to epitomize Baudelaire's ideal "painter of modern life." He has been applauded for faithfully documenting gritty social reality, for capturing with insider authenticity the existential facts of alternative youth culture. But he just as often will shift his view to the perimeters of

1 Quoted in Vince Alleti, "Wolfgang Tillmans: A Project for Artforum," *Artforum* 39, no. 6 (February 2001), 129.

2 Charles Baudelaire, "The Painter of Modern Life" (1863), in *Charles Baudelaire: Selected Writings on Art and Litera-ture*, P. E. Charvet, trans. (New York: Viking Press, 1972), 403.

such representational scenes, zooming in or out on underlying and overarching pattern, governing visual syntax, material substrata. His focus will lock on subjects too close up or too far away, until specifics begin to dissolve into general schemes and abstract formal arrangements. His camera will tilt down at the ground or up at the sky, as if he were brought to a sudden standstill, his gaze snapped loose from its connection to an active social horizon.

It's no coincidence that Tillmans's earliest works were made by enlarging found photos on a laser copier, and that his childhood interest was astronomy. Finding pattern and meaning by looking straight down or straight up, close in or far away, have proved foundational for him. And this also helps explain why Tillmans has been able to so seamlessly expand his practice into the realm of abstraction, especially with those works resulting from darkroom experiments that make no use at all of the camera and the film negatives it produces. Tillmans's interests extend beyond the camera, which can be thought of as a social instrument at base, small and light enough to bob and weave easily through everyday life, where it mechanizes and extends the eyes of social actors as they look and point and wink in passing at the world and each other. Equally of interest to Tillmans is the more isolating and remote darkroom and its primary equipment—the enlarger and its bulb, the photo-sensitive paper, the mechanical drums and belts and liquids such paper passes along and through while being developed and fixed. Against the horizon-scanning orientation of the camera, privileged here is the vertical action between overhead illumination and impressionable material below. Sky, stars, passing airplanes, and dancehall lights on the one hand and landscape, puddled or spread materials, discarded clothes, and exhausted bodies on the other. The switch in orientation itself points the way from realism to abstraction.

At times the journalistic and the abstract will overlap in a single image, especially when the subjects on display closely hew to some shared aim or set of imposed rules, when the elevation view of social interaction adheres tightly to the bird's-eye view of the master plan. Examples are certain photos of uniformed police and soldiers, of grouped friends lying on a secluded beach, of protesters marching in solidarity—or, most strikingly, the pictures taken inside crowded, throbbing dance clubs. Most often, though, Tillmans doesn't try to manifest all these concerns and interests in any one single picture, but chooses instead to modulate through them across scores of prints that he then relates dialogically in his constellated installations. Paradoxically, this strategy has opened the way for critics to at times selectively overlook certain classes of photographs and emphasize others as the most representative of Tillmans's world. Indeed, Tillmans's work has been criticized for

being either too aesthetically overworked or too amateurishly underworked, for being too exclusively personal or overly preoccupied with subculture or too beholden to the fashion and entertainment wings of the mainstream culture industry. Such biased and divergent readings are only possible because Tillmans's work encourages the public gathered before it to follow its example and enter its own negotiations between the general and the specific.

Artists and critics have often chosen between generality and specificity, privileging one to the exclusion of the other. Partisans of photography tend to value the medium precisely for its heightened specificity, how every photograph exactly situates its object, indexically stamping it with a particular time and place and point of view. The photograph is said to capture a truth too singular and specific to be reduced to, or absorbed by, some vague and instrumentalizing generalization. Think of the critical outcry against Edward Steichen's attempt to generalize about photographic representation in his 1955 exhibition *The Family of Man*.[3] And this same argument has been applied to not just photographs but abstract art as well. Donald Judd famously promoted artworks that couldn't be assimilated to the general categories of painting and sculpture but instead had to be approached as "specific objects." At the other end of the spectrum, Baudelaire himself, as well as subsequent critics like Clement Greenberg, considered photography incurably handicapped by its inability to transcend the journalistic and "literal," while Michael Fried accused Judd's art of much the same, of being too "literalist." Both Greenberg and Fried also chafed at much abstract expressionist painting, or at least its popular reception, for overly accentuating the autobiographical and personal. The two modernist critics instead championed a type of abstract art that manifested an experience or emotion too broadly valid in its claims to be pigeonholed within the narrow bounds of the private and anecdotal. The idea was succinctly put by T. S. Eliot, in a line both Greenberg and Fried admired: "The emotion of art is impersonal."[4]

Transcending the privations of the strictly personal, broadening and intensifying feeling and vision by generalizing them, pervading the whole of society with the poetics of art as free creative human activity—such have been the ends of much modern abstraction. The modern era has always sensed in art and aesthetic experience the promise of stemming not only the social dispersion encouraged by the

3 *The Family of Man* was subjected to harsh criticism immediately upon its opening at the Museum of Modern Art and the subsequent venues to which it traveled. See, for example, Hilton Kramer, "Exhibiting the Family of Man," *Commentary 20* (1955), 364–367 and Roland Barthes, "The Great Family of Man" (1956), in *Mythologies*, Annette Lavers, trans. (New York: Hill and Wang, 1972), 100–102.

4 T. S. Eliot, "Tradition and the Individual Talent" (1919), in *Selected Essays* (New York: Harcourt, Brace & World, 1960), 11. The ideal of impersonality is also embraced by much house music (of the kind played at the dance clubs frequented and photographed by Tillmans). See Simon Reynolds, *Blissed Out: The Raptures of Rock* (London: Serpent's Tail, 1990), 176.

perpetual stoking of private appetites under capitalism but also the social over-integration brought about through the bureaucratic administration of all of social life. It was hoped that art could save the individual not only from total privacy on the one hand but from the false communities of ideology and rationalized consumption on the other. Take for example the socialist program that Piet Mondrian claimed to advance through his paintings, a project greatly admired and shared by Ad Reinhardt. Greenberg admired it as well: "One of the aims of culture is to transform the private into the public," he explained. "Culture enables individuals to communicate and appreciate inwardness, and make it objective."[5] Many have testified to a somewhat similar cultural politics operating in Tillmans's art. "Individuality, sexuality, camaraderie, liberty, experimentation and self-discovery," lists one ecstatic critic, as if witnessing in the artist's work a condensation of nearly all modern utopian ambitions.[6]

But it is also true that such politics have always been highly weary of the downside to generalizing art and aesthetics and merging them with life. Especially weary, that is, of the prospect that it is society, not art, that will end up dictating the terms of such a merger, with free creativity being the one remade in conformity with the ruthless unfreedom of current social arrangements. Achieving the right balance between the specific and the general has proven an urgent yet seemingly impossible dilemma under modern conditions. This is what modernity largely means: the isolating of people, the intensifying of individual experience, the sharpening of immediate sensation, but always through standardizing, massifying, and ultimately alienating means. Modernist critics famously warned of a "dissociation of sensibility" exacerbated by over-specialization, which rendered people incapable of amalgamating the entirety of their thoughts and feelings, an inability that only hurried the conversion of individuals into consumers and masses, for whom amalgamated experience and well-rounded lives arrived as prepackaged commodities through various media and commercial outlets. "In surrendering the totality of oneself to a professional role," Greenberg shook his head, "you give up being a friend, a lover, a gossip, an attractive person, the life of the party, in order to be that much more poet, actor, boxer, doctor, businessman. Instead of completing yourself by work you mutilate yourself."[7]

5 Clement Greenberg, "War and the Intellectuals: Review of *War Diary* by Jean Malaquais" (1944), in *The Collected Essays and Criticism. Vol. 1: Perceptions and Judgments, 1939–1944*, John O'Brian, ed. (Chicago: The University of Chicago Press, 1986), 193.

6 Aaron Schuman, "Master of the Universal," *Art Review 2*, no. 7 (July–August 2004), 49.

7 Clement Greenberg, "Review of *Blood for a Stranger* by Randall Jarrell; *The Second World* by R. P. Blackmur; *Lyra: An Anthology of New Lyric*, edited by Alex Comfort and Robert Greacen; *Three New Poets* by Roy McFadden; and *Ruins and Visions* by Stephen Spender" (1942), in *Collected Essays Vol. 1*, 117.

Freischwimmer 83, 2005
Framed C-print
71¼ × 93¾ in.
(181 × 238 cm)

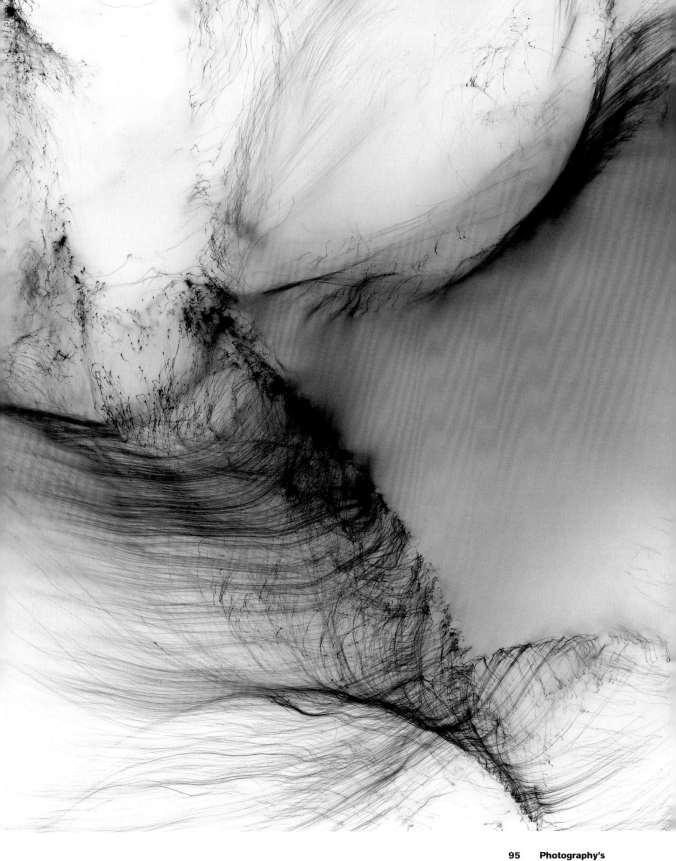

How then to reconcile modern art's contradictory demands, its call for both experiential particularity and symbolic unity? Modernists have looked with suspicion on not just representation for being too easily instrumentalized for state or commercial ends; even an abstract work that wagers everything on material intensity, such as a sculpture by Donald Judd, threatens not only to privatize experience but to do so for too wide an audience, offering up cheap sensory thrills to be had by any shock-craving viewer. On the other hand, an artwork more exacting in the kind of audience it anticipates and summons, that tightly specifies a cogent set of communal values, runs the risk of being overly narrow and exclusive, just one more specialization in an overly professionalized culture. And this is precisely the accusation leveled at 1960s color-field painters like Morris Louis, Kenneth Noland, Jules Olitski, and Larry Poons, artists who like Mondrian and Reinhardt attempted a depersonalized and common modern abstraction. Greenberg's swaddling of this art in a theory of medium-*specificity* was already a way of circling the wagons in defense against outside encroachments. The position Fried took in relation to such work was even more pointedly political and elitist. "The modes of seriousness established by the finest painting and sculpture of the recent past," he wrote in 1967, "are hardly modes in which most people feel at home, or even which they find tolerable."[8] In Fried's reworking of Baudelaire's equation, abstract art should become more generalized and impersonal, but only if it does so for a very specific audience, for a chosen few.

Kenneth Noland

Springs: August Light,
1961
Acrylic on canvas
Panel: 45⅝ × 45⅝ in.
(115.9 × 115.9 cm)
Collection Museum
of Contemporary Art,
Chicago,
gift of William J. Hopkin
Art © Kenneth Noland /
Licensed by VAGA, New
York, NY
Photograph © MCA,
Chicago

8 Michael Fried, "Art and Objecthood," *Artforum* 5, no. 10 (Summer 1967), 16. Interestingly, Thomas Crow has not only discussed Fried's conception of modernist art in terms of the tight community it presumes as its proper audience (in "These Collectors, They Talk about Baudrillard Now: The Life and Death of the Public Sphere in Recent Art," *Discussions in Contemporary Culture*, Hal Foster, ed. [Seattle: Bay Press, 1987], 1–8), but has also investigated early twentieth-century avant-garde art movements through the rubric of subculture analysis (in "Modernism and Mass Culture in the Visual Arts," *Modernism and Modernity*, Benjamin Buchloh et al, eds. [Halifax: Nova Scotia College of Art and Design, 1983], 215–264). It's possible to consider Tillmans as mobilizing both of these conceptions of a cultural public, the modernist and the subcultural, and perhaps Steichen's much more populist conception as well, so as to enter them all into dialogue.

II. Tillmans's abstractions, to name just one of their biggest differences from color-field painting, do illuminate properties specific to their medium but in ways that can only be considered expansive rather than reductive. They are, for one thing, a sizable elaboration of the artist's already incredibly diverse pictorial vocabulary. One of the best things about Tillmans's abstract pictures is that it is nearly impossible to talk about them by themselves: like all his works, they most often appear mingled with other photos in the branching sequences of his installations. Manifesting both the constitutional ground and the summation of pictorial convention, the abstractions are usually (though not always) complemented by the parliamentary tussle of Tillmans's representational photographs with their back-and-forth dialogue of specific perspectives. At the same time, the abstractions do that work of generalizing that Fried and Greenberg spoke of; they help broaden Tillmans's overall artistic concerns beyond the particular represented subjects to his medium in general. Emphasized in the abstractions is a plasticity all the works share, a pliability that Tillmans brings out when reusing the same image in differently sized formats (from small to medium to large) and in differently shuffled installations. The very fact that they get talked about as "abstractions" highlights how all of Tillmans's pictures carefully instantiate and manipulate genre (still life, portrait, landscape, and so forth), how they are pictures first before they are pictures of some *thing*. Indeed, against the often solitary and abstracting nature of what Tillmans chooses to photograph, it is the gregarious thronging of the prints themselves, their restlessness, the fact that many are not framed and nailed down but rather taped or clipped in place temporarily, that most evokes a sense of community and public interaction.

All the same, many of Tillmans's abstractions—especially the images that comprise the *Blushes, Peaches, Starstruck*, and *Freischwimmer* series—share a strong family resemblance to the color-field paintings that Greenberg and Fried rallied behind. (This distinguishes Tillmans from other photographers like Andreas Gursky and Jeff Wall, whose computer-assisted practices overlap in certain ways with traditional figurative painting but not with mid-century color abstraction.) The resemblance grows stronger still when Tillmans produces these images as inkjet prints in large formats (sometimes over 12 by 8 feet). Here color runs in thin, animated strands across the length of the paper's textured, unglossed surface; these strands, like tiny rivulets of liquid dye spreading over and into water-soaked fabric, condense to the point of semi-blackness at the center of the individual dribbles and disperse at their edges into hazes and scrims of brighter, softer hue. The formidable size, restricted palette, and smoldering quality of the color when it turns densest and darkest—all this lends the work a grand and somber, even elegiac feel.

But the work also possesses the elegant lyricism of drawing, albeit without the strenuous carving and chiseling into space that usually results from drawing's line. Tillmans makes color and line appear as one indistinguishable substance; instead of color being confined by and filling in drawn profile, here color seems to thicken and extend into its own tendriled shapes, arriving at forms and fields that look organically spawned.

Morris Louis was said to achieve this same effect through pouring heavily watered-down acrylics into unprimed canvas, and what led Fried to praise such paintings for their generality, for "seeming to have come into existence as if of their own accord," for donning "the appearance, or illusion, of a sovereign impersonality."[9] But what is there to look at if Louis removes himself, negates his managerial role in the artwork's making, bows out in deference to the materials themselves, as if ceding their right to self-determination? There is a very non-elitist political idea here, barely glimpsed, that a batch of art supplies already possess on their own vast potentials for creativity and beauty; and that genius, rather than a divine gift innate to those lucky enough to emerge from the womb as artists, instead wells up in this — in the historical, material, public gathering place of an art medium, a set of materials and techniques and their varied past precedents hypothetically available to all. Tailored to an individual with two hands, possessing a plasticity hard enough to withstand being worked but also malleable enough to yield form, these artisanal tools and substances comprise an expandable vocabulary that helps "transform the private into the public and make it objective," to repeat Greenberg. Put another way, Louis, by emphasizing less his own agency than that of his medium, makes impersonal and general artistic agency *per se*; he shows the medium for what it really is — common inanimate stuff, raw and mutely objective materials — while also showing the capacity of those materials to divulge vast regions of expressivity and meaning. The result is the modern image of creativity itself, of brute facts tipping into majestic pictures, of found givens both acknowledged and transcended, of necessity reconciled with freedom.

But what exactly is this medium being so worked and transformed? Is it even painting anymore? The fact that Tillmans shares so much with these 1960s artists, who wielded not paintbrushes but buckets and trays of pigmented chemicals, who printed ultra-thin colored washes into bare canvas that they handled like stainable paper, is a pretty sure indication that the medium has grown increasingly difficult to define, that it is more dispersive than "pure." Indeed, even Fried acknowledged

9 Michael Fried, "Some Notes on Morris Louis," *Arts Magazine 36*, no. 2 (November 1963), 25.

this dispersion, pointing to a strong kinship between Louis's color-field work and the symbolist poetry of Stephane Mallarme, going so far as to describe Louis's largest and barest canvases, the *Unfurleds*, as exhibiting "the blankness of an enormous *page*."[10] Tillmans, who often chooses to realize his art across the double-page spreads of books and magazines, manages to endow his abstractions with a similarly expansive sense of scale, one that spans and encompasses both the hand-held paper sheet and the wall-sized mural. On exhibit, then, is a hybrid of photography and painting, as well as book and textile design, but also watercolor and printmaking and drawing—and perhaps even poetry, too. The medium, when treated specifically, is shown to facilitate rather than exclude a broad range of metaphoric associations.

Connections between Tillmans and 1960s abstractionists don't stop there. It was the color-field painters who themselves initiated a dialogue with photography back in their day. They prized their staining technique, or what they called "one-shot" painting, for the spontaneity and quickness of the process, its direct employment of materials, all of which lent the resulting image a tremendous sense of immediacy. There was never any prior sketching involved, nor could the painting be gone back into afterward for correction and adjustment. As if with a shutter click, the finished image emerged suddenly, whole and all at once, with a continuous, even integrity from edge to edge and top to bottom—"color on the thinnest conceivable surface, a surface sliced into the air as if by a razor," as Noland put it.[11] Nothing broke up this seamlessness, no scissoring out of shapes with drawn line, no pushing around and arranging of preconceived forms; the only outside form imposed would be the crop—or profile drawing—of the framing edge. "Cropping was something new," claims Noland, and "it came from photography."[12]

Tillmans's prints come as if automatically with a hard, sharp white border running along their four edges, which marks out the field as a strictly visual event, an arena for deliberate and focused eyesight, the very kind of cut edge that color-field painters sought by not only tautly stretching their canvases but often, against the dominant tendency in painting at the time, by placing them within frames (typically metal shadowbox frames). Tillmans will also mount his abstractions in frames, but not always; the fact that his inkjet prints possess a taut edge without stretching

10 Michael Fried, *Morris Louis, 1912–1962*, exh. cat. (Boston: Museum of Fine Arts, 1967), 21. Italics in the original.

11 Kenneth Noland, in Philip Leider, "The Thing in Painting Is Color," *The New York Times*, sec. 2, 25 August 1968, 22.

12 Kenneth Noland, in Karen Wilkin, *Kenneth Noland* (New York: Rizzoli, 1990), 23.

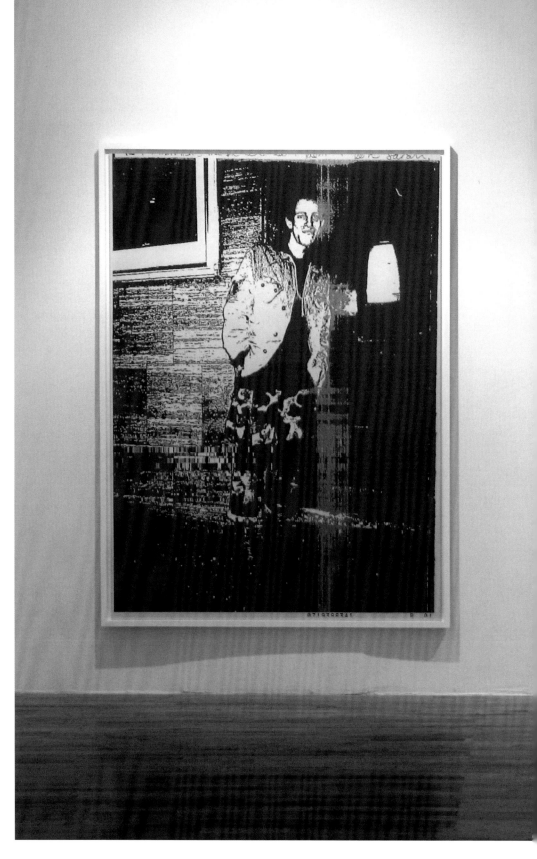

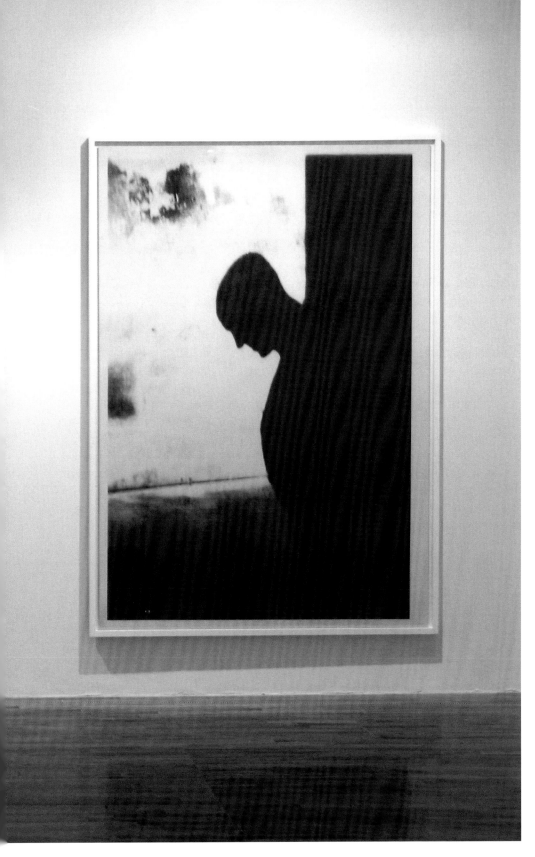

Installation view, Freedpm From The Known, PS1,
New York, 2006
Left to right: *Empire (Punk)*, 2005, framed C-print
71¼ × 95¼ in. (181 × 242 cm); *Empire (Christ)*, 2005,
framed C-print 71¼ × 98¾ in. (181 × 251 cm)

allows him to hang them by paperclips so as to highlight their bodily materiality and weight, so that they appear to us both as visual events for our eyes to consume and as sculptural objects with a sovereign physical existence. Critics have noted how these large-scale abstractions often resemble magnified wisps of hair, but actually it is the sense of the color wisps being combed smooth by the physical tooth of the paper that really brings out the global consistency, the edge-to-edge evenness that photosensitive film and paper can so effortlessly give to an image. This is how, paradoxically, Tillmans's inkjet prints come closest to painting, by emphasizing the capacity of such printing technology to expand both the literal size and the quality of that even photosensitivity. For it was this evenness of the whole image field, as well as the fact that such a field seemed to surface into vision as if immediately, in a camera flash, that the color-field painters wanted to import from photography and also expand. "If only one were more acute," Fried wrote, again in 1967, about such painting, "a single brief instant would be long enough to see everything, to experience the work in all its depth and fullness, to be convinced of it forever."[13] If only, it sounds like he's saying, one were as visually acute as a camera.

III. The desire to be a camera—how different is this from the desire expressed by Andy Warhol only a few years earlier, when he said that he wanted to a machine? Like Tillmans, Warhol was a generalist who moved effortlessly between the realms of art, commerce, and subculture, who made work for galleries and also worked on a magazine. Instead of Xeroxing, he started with silk-screening and developed a use of photography that likewise spanned from celebrity portraits to photojournalism. In many ways Warhol could be thought to represent Tillmans's doppelganger, a dark counter-figure to the Baudelairian flaneur. Warhol is more the shell-shocked urban denizen who, in Walter Benjamin's famous description, is only capable of experiencing either modernity's standardized and predictable banalities or its traumatically unpredictable flux, but who lacks the flaneur's prowess in dialectically negotiating the two in search of larger, more lasting meanings.[14]

If medium specificity was used in color-field painting as a defense to protect it against dissolution and kitsch, assuming this guarded posture also constricted the medium and ultimately narrowed its range of expressivity. Unfortunately a democratizing impulse was never among the things such painting found admirable about

13 Fried, "Art and Objecthood," 22.

14 See Walter Benjamin, "On Some Motifs in Baudelaire" (1939), in *Illuminations: Essays and Reflections*, Hannah Arendt, ed. and Harry Zohn, trans. (New York: Schocken, 1968), 155–200.

photography. On the other hand, Warhol took a much more expansive approach to the interbreeding of painting and photography, with his conception of the latter shading toward photomechanical reproduction and finally into media *per se*. And he too can be thought of as extrapolating his art out of what he deemed the historically conditioned possibilities embedded in this "mixed-medium." The difference is that Warhol studiously avoided any transformations of mute materials into meaningful pictures, of fleeting events into enduring art. Especially in his first two years of silk-screening on canvas, he separated the two and exhibited them in alternation, mounting canvases bedecked with assembly-line commodities and celebrities alongside other canvases stuttering with repetitions of wreckage and riots and death. Excerpts of spectacle on the one hand, shocking reality on the other, that which only ever exists as pictures next to that which was never meant to be a picture. The capaciousness of photography, its unbiased welcoming of both the commercial and the journalistic, the prepackaged and the raw, Warhol translated as not democracy but utter indifference, not global sensitivity but a blank stare. The surplus of images available to the medium was revealed to be a deficit; not only was photography unable to reconcile harsh reality with the creations of culture, it was blind and impassive to the very distinction.

How Warhol updated the Baudelairian equation of art's relation to modern life was to replace art with culture industry fetishes and life with trauma. Only a medium as indifferent as a machine could cope with an irreconcilable whiplashing between the two. The view of photography as just such a machine was canonized within the art world of the early 1980s, supported by art and criticism that figured and theorized photographs as either passive handmaidens to hulking corporate media interests or as utterly raw documents so objectively indexical that they bequeathed to culture only alien skid marks left by an otherwise inaccessible reality. But Tillmans's art doesn't belong to that period. Perhaps because he took up art toward the end of the 1980s, and with a Xerox machine—just as copiers became the favored medium of an emergent do-it-yourself culture of fanzines, club flyers, and protest rally invitations—Tillmans was able to not only acknowledge and assimilate the connections between photography, reproduction and media but also see them as empowering rather than alienating. It is as if Tillmans were rehearsing many of Warhol's moves only to reverse their effects and redirect their consequences. Most significantly, Tillmans works through and breaks down Warhol's stark dividing out of the photographed world into spectacle and trauma, the forever new versus the incurably damaged, by reintroducing the excluded middle, the realm of everyday life and common material exchange. Mystifying images of high

fashion are secularized by the material practices of street fashion, the hands-on bricolage of thrift store shopping; worn clothes, cooked food and casual friends now fill the space between celebrities and soldiers.

In all this there are subtle but important adjustments Tillmans makes to his inherited medium, to the range of possibilities seemingly open to it. No doubt his experience with the copying machine had a big influence, making photomechanical reproduction seem not virtual and pacifying but plastic and malleable, something inviting creative manipulation. ("A lot of my work is actually three-dimensional," Tillmans says.[15]) But all these adjustments are most straightforwardly, dramatically declared by his abstract pictures. These, after all, are mostly pictures of process and action rather than of things, with an emphasis on drawing and the movement of materials by hand. Like most modern abstraction, here Tillmans will use his medium in ways that would seem improper were the goal to serve some greater representational end. Instead, in these works the medium is allowed to test and expand its own properties and limits, traversing its expressive range before it is ever introduced to an outside world through the opening of the camera's eye. The medium as Tillmans reveals it is no longer Warhol's machine, to be sure, but neither is it entirely the artisanal trade worked by 1960s abstractionists. The photographic is still foregrounded in even the most painterly of the large inkjet prints, with their smoky hues redolent of dissolving or accumulating sulfurs, halide salts, and potassium crystals, of the way chemical developers and toners thicken and fog up from overuse. Even the lyricism of the drawn color trails evoke the phalanx of ink-spraying nozzles in the printer, as if the paper were advancing through the machine erratically or the nozzles were clogging up. And unlike the color-field painters, who carefully chose where to "crop" their canvases according to their refined aesthetic sensibilities, Tillmans will often (as in the *Super Collider* series) frame his compositions using the standardized dimensions of mass-produced photographic and printer papers. Present in all this is the feeling of heavy equipment, of industry and technology. That the work also feels individually created, handmade, gestural rather than geometric, and ultimately deeply romantic is a credit to Tillmans's ambition, his efforts to keep open negotiations between personal emotion and agency and a medium that has grown to such industrial scale.

But it should be remembered that these negotiations flow both ways. Preindustrial or artisanal forms of art still abound today, and too often they're championed as a last refuge of the exclusively personal, a safe haven for artists to indulge idiosyncrasies and purely self-absorbed pursuits. The same holds true for much current

15 Quoted in Rita Vitorelli, "The Spirit of a Time Is in Fact the Spirit of a Time," *Spike* 6 (Winter 2005), 44.

painting, even abstract painting. It's an old problem, as old as modernism itself, and was encountered early on by Baudelaire: "Individuality—this right of small property—has eaten up collective originality," he wrote; "...for our time the painter has killed painting."[16] Too little abstraction today aims for generality; instead there is a continued territoriality and defensiveness, and stark warnings issued by self-appointed guardians against any mingling with outside forces, including the photographic, for fear of diluting the medium's mystical "purity."[17] Now not only the painter but painting itself is killing off painting. The results are not unlike the impasse reached in the 1960s, with painting as an entirely self-enclosed project on the one hand and idiosyncratic objects each purporting its own entirely unique identity on the other. Either way, the bottom line is a withering of the broader dimensions of art and its powerful claims on modern experience. Against the fixed, narrow category of paint or the supposedly uncategorizable and quirky, Tillmans accommodates and privileges disparities and complexities within identity; he uses photography as an expression of curiosity and participation in broader fields of everyday life, a means of looking widely onto the world. But his abstractions are just as broadly oriented, perhaps even more so, since they present instances where common materials make contact with our basic cultural meanings, and in this way picture expression as if not yet reduced and assigned, as still a field of open possibility, one that seemingly any of us, all of us, could seize.

16 Baudelaire, "The Salon of 1846," in *Selected Writings*, 104.

17 For instance, Robert Storr expresses concern that painting today is becoming "increasingly graphic," as if "impatient with, or uninterested in, the material aspects" of its medium, "its primitive physical realities," in "Thick and Thin," *Artforum* 41, no. 8 (April 2003), 238, 241.

Lane Relyea is Assistant Professor of Art Theory and Practice at Northwestern University. He is the author of numerous essays in contemporary art and of the monograph *Vija Celmins*.

Approach (road), 1987

Das Problem mit den Löchern, 2005
Framed C-print
71¼ × 117¼ in.
(181 × 298 cm)

Blushes #3, 2000
Unique C-print, 24 × 20 in.
(61 × 51 cm)

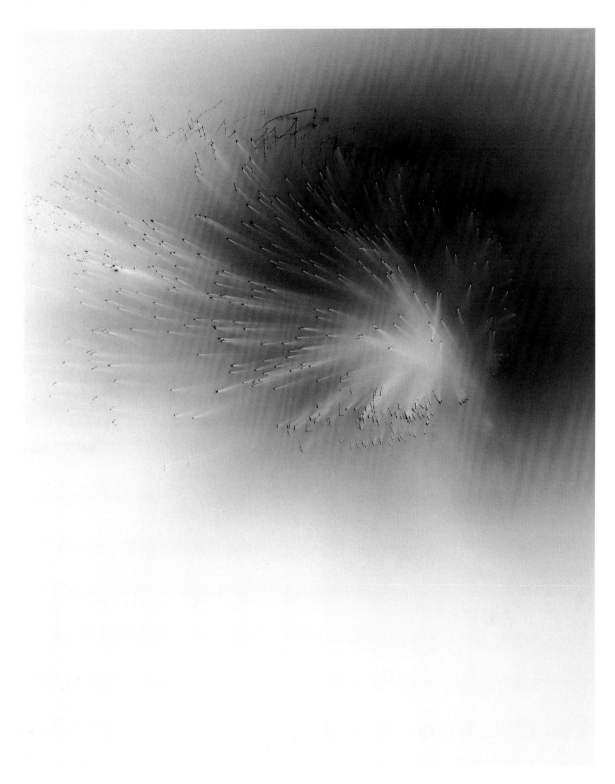

Blushes #59, 2000
Inkjet print
65¾ × 52½ in.
(167 × 133.6 cm)

Einzelgänger IV, 2003
Framed C-print
93 × 71 in.
(236.22 × 180.34 cm)

Installation view, *Freedom From The Known*, PS1,
New York, 2006
Left to right: *Antony*, 2005, *Tiga,* 2006, *Integral/PSB*,
2005, *Isa*, 2005, *Deliverance/People Like Us Feat.*
Cindy Dickinson, 2005, *Marte*, 2005
Unique C-prints
24 × 20 in. each
(61 × 51 cm)

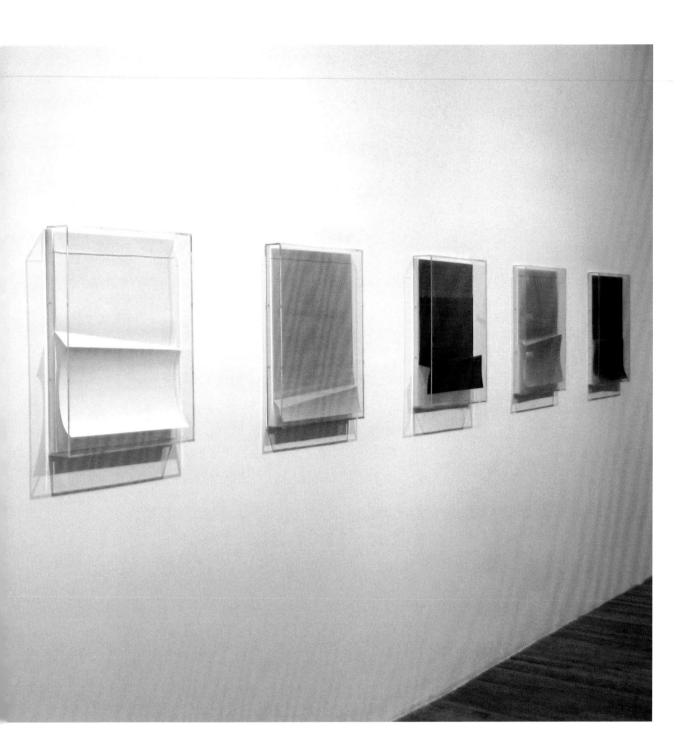

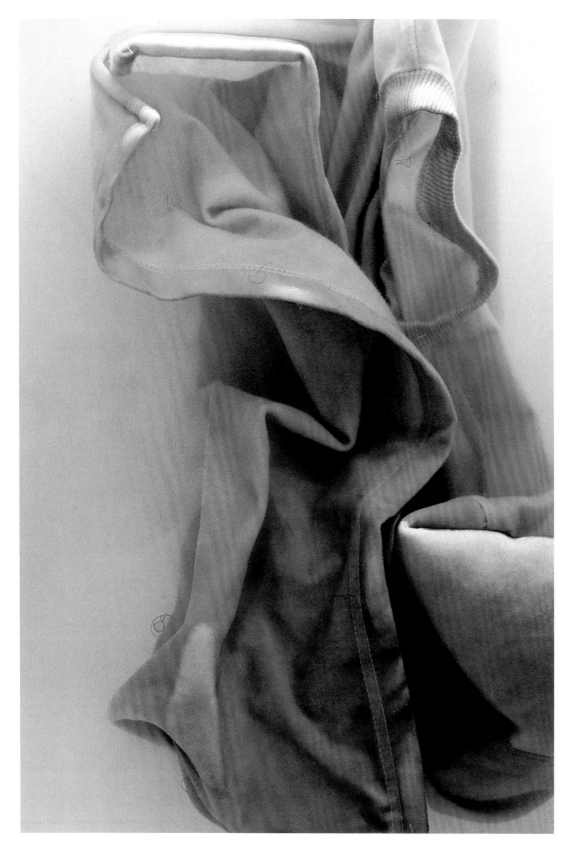

Faltenwurf (submerged) II, 2000

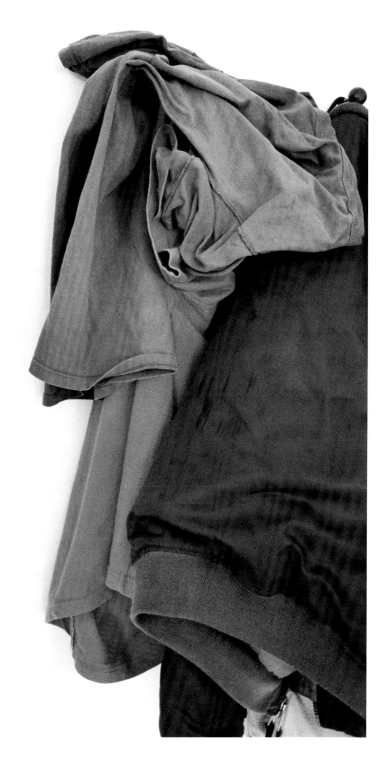

Faltenwurf Bourne Estate, 2002

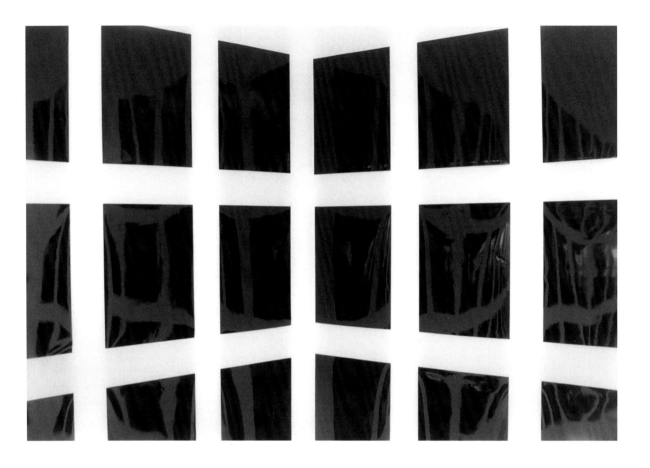

inner sense, 2005

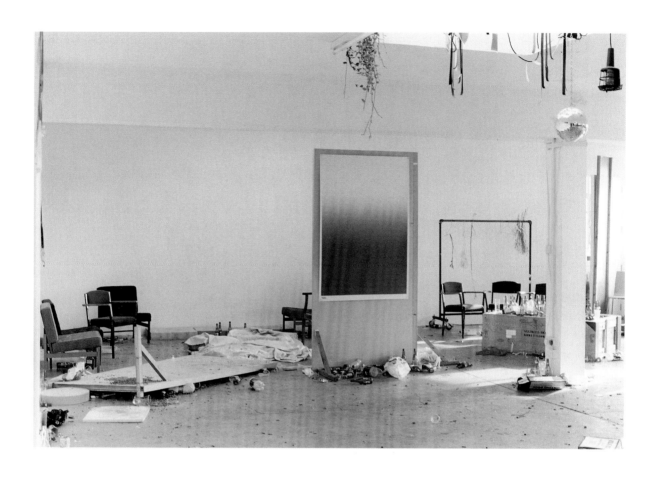

end of winter (a), 2005

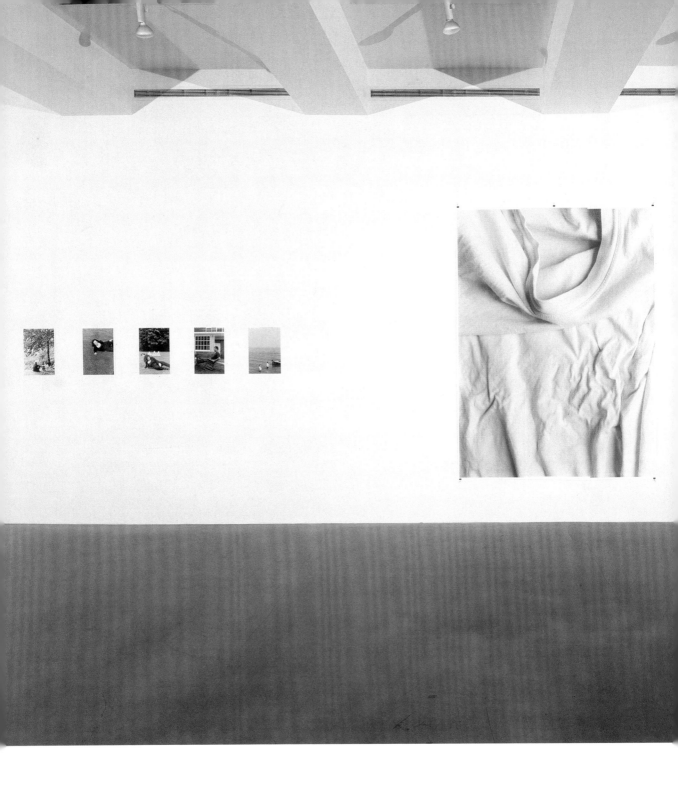

Installation view, Andrea Rosen Gallery, New York, 1996
Center: *Sportflecken*, 1996
Inkjet print
93 × 71 in.
(237 × 178 cm)

The Subject
Is Exhibition

Julie Ault

It is a truism that labels are a cultural inevitability and that they have power. Art practices are no exception and are commonly assigned shorthand designation. Such classification bears the hazard of dislocating foundational aspects of an artist's work, particularly when that practice is compound. Consider for instance, "Wolfgang Tillmans is a photographer." Factual yes, but this abbreviation constructs a representation that locates Tillmans's practice in image making, obscuring the information that photography *and* installation are employed by the artist as virtually inseparable mediums.

It's all one song.
—Neil Young to a fan's shouted request at a concert

Conscious at a young age of how cultural forces can define one's practice and identity in the world, Tillmans empowered himself. Using an informed critical approach to distribution venues and the models for access they embody, and maintaining an ever-active relationship to participation within the formats of exhibition space and print media, Tillmans enacts his right to complex mediation. The artist's cultural participation extends beyond making images to include the activities of curating and presenting as he explicitly engages editorial and installation processes that determine anew each public manifestation of his work. Through exhibitions and publications, the artist materializes a specific condition of exposure that is essential to his art and offers a critical commentary on the ways in which presentation bestows value and addresses constituencies. Through combining production modes of making and presenting (at once creative, analytic, interpretive) and by inhabiting the roles of photographer, curator, designer, critic, and historian all under the rubric of artist, Tillmans occupies a rare if not singular position in the field of contemporary art.

The power of display permeates cultural venues from museums to car dealerships. Display embodies the capacity to generate points of access, the potential to make meaning, to encourage or discourage specific experiences, to confer value, and to create and focus desire.

As contemporary art has become increasingly institutionalized, as the art industry has consolidated itself into a marketplace, and as popular culture has influenced the field in countless ways, demarcating art from "common" products is considered a necessary means to shore up its symbolic value and protect the category of fine art. In distinction to the crowded repetition-based arrangements in a supermarket, spaciousness deployed in galleries and museums communicates an authority of uniqueness and invokes aura. Adherence to the formality of modernist-style presentation, which has been adopted so widely by artists, curators, and gallerists,

frequently results in forms of dispassionate display.[1] Abundant spacing, uniform pacing, and, relegating wall works exclusively to a median-eye-level sightline are among the devices used to position artworks as masterpieces and the curator/institution as judge, offering spectators the relatively passive role of witness.[2]

Artists who leave dispersal and presentation to other agents—intentionally or not—affirm traditional divisions of cultural labor. To disregard the nuance of display and distribution as integral aspects of art practice speaks of a belief in an art object's autonomy and capacity to communicate "itself" despite context, suggesting persistent faith in a particular notion of modernism.

Wolfgang Tillmans's relationship to his authority as an artist, to institutional authorization and to that of viewers, operates according to a different philosophy. Although he is invested in aesthetic majesty as well as the eloquent potential of photographs on paper, via democratic orientation to subject matter (a topic much discussed elsewhere), and by using auto-curatorial processes and installation methods (my focus here), Tillmans proposes a reconfiguration of art(ist)/institution/viewer relations.

By assuming a curatorial role as an aspect of his artistic practice, Tillmans dislodges any clear-cut boundary between curator and artist. For instance, curators primarily select which of an artist's works will be included in a museum exhibition. Whenever Tillmans's work is shown, he determines the exhibition focus and scope and decides what to include and how. Of course to varying degree curators work with artists on an exhibition's content just as Tillmans's decision-making process includes discussion with curators. Yet he retains a great deal of control in this domain by having made curatorial activity fundamental to his practice. Tillmans creates exhibitory contexts with his photographs. Actively engaging in these situations interrupts the imposture of objectivity and disrupts the codes by which

1 See Mary Anne Staniszweski, "Aestheticized Installations for Modernism, Ethnographic Art, and Objects of Everyday Life," in *The Power of Display. A History of Exhibition Installations at the Museum of Modern Art* (Cambridge, Mass.: MIT Press, 1998), 59–139. Staniszweski's book is a primary source for this topic within museum display. Crucial to the significance of Staniszweski's investigation is her position that considers "installation design as an aesthetic medium and historical category," rather than accessory. It is in similar fashion that Tillmans's practice is understood here, as medium.

2 See Brian O'Doherty, "Context as Content," in Brian O'Doherty, *Inside the White Cube: The Ideology of the Gallery Space* (Berkeley, California: University of California Press, 1999). In his famous tract, O'Doherty locates ideology in the codification of modernist display practice, which he regards as an interlocking development of the reproduction of the gallery space as white cube. O'Doherty, "The way pictures are hung makes assumptions about what is offered. Hanging editorializes on matters of interpretation and value, and is unconsciously influenced by taste and fashion" (24). He goes on to argue that the white cube produces particular kinds of art and that much art is "site-specific" in that it is imagined for presentation in the white cube.

Installation view, *Freedom From The Known*, PS1,
New York, 2006
Left to right: *Das Problem mit den Lochern*, 2005,
impossible colour V, 2001, *they are this way*,
2005, framed C-prints

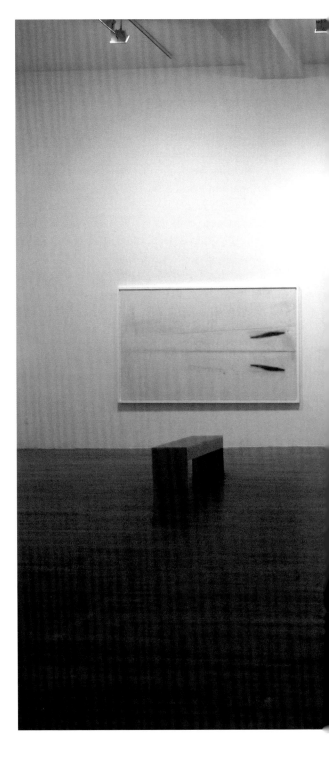

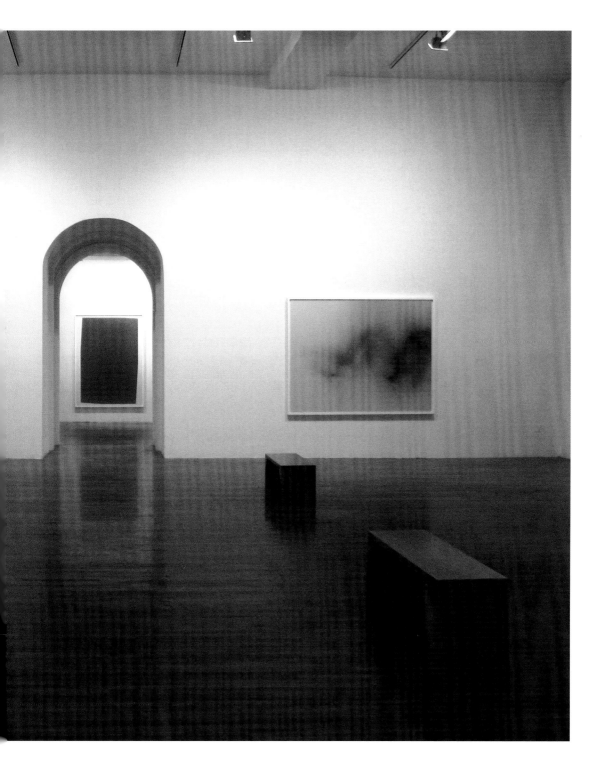

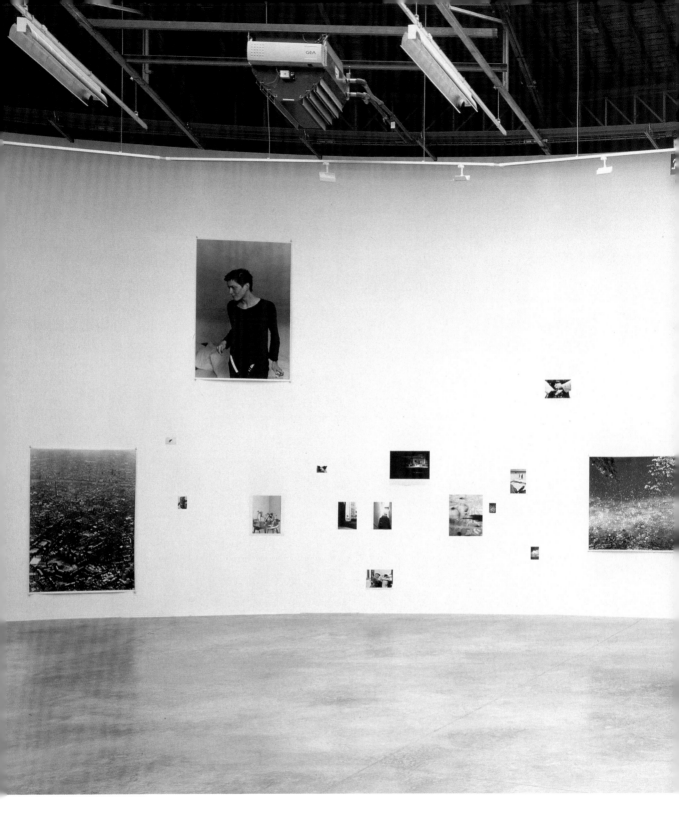

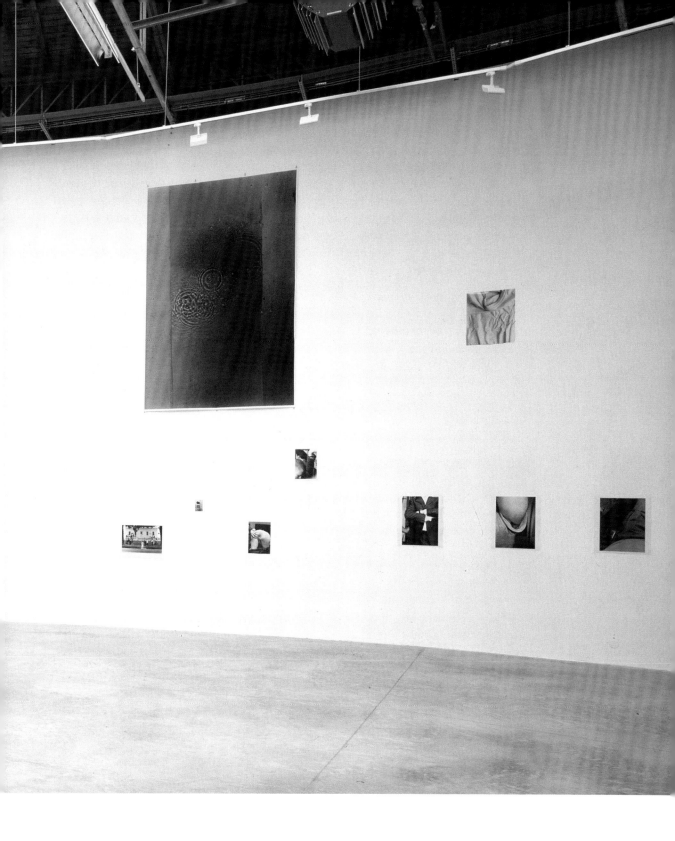

Installation view, *Vue d'en Haut,*
Palais de Tokyo, Paris, 2002

The Subject
Is Exhibition

many art institutions disseminate art to publics. Tillmans's belief in his own complex, flexible subjectivity—and the extension of its validity to one and all—inspire his methods, which subtly decenter institutional installation authority and redistribute display.

Identity is irresolute. Self-construction, deconstruction, and reconstruction are vital dimensions of Tillmans's artistic formation. His practice reflects continually shifting subjectivity, necessitating that design always be new. The artist's conviction that identity is flexile and unclassifiable, and his concomitant repertoire of display stratagems, make it possible to sustain an active relationship to his history—through his images—and to presentational formations that mediate meaning. As David Deitcher has aptly observed:

> Tillmans's installations, with their elaborate recombination of old and new photographs, demonstrate his belief in the capacity of such networks of images and of meanings to suggest the multivalent complexity of a life. . . . In these situations Tillmans has found, not just a new and challenging way to work with photographs in the spaces of galleries and museums, but to underscore the depth of his engagement with contingency. By "contingency" I mean the way in which meaning, but also subjectivity, sexuality, gender and identity, are all the unstable and temporary results of dynamic processes at the heart of which is difference.[3]

Tillmans's conviction that subjectivity is supple and intricate is demonstrated through broadcasting his empowering model of representation. Heterogeneous subject positions are engendered by his presentation methods: the singular subject position moving obediently along an exhibition path constructed by modernist display methods is replaced. Tillmans intends his work to have a liberating, authorizing effect on people. Viewers are invited to cross a boundary into a space within which their subjectivity becomes a navigational tool.

Tillmans evades the sermonic, the lure to hierarchize his production through positioning of individual images as triumphal showpieces. "Avoiding what I call a language of importance was a key choice I took in 1992, feeling that I wanted to use the gallery space as a laboratory in which I can put my pictures and see how they react to being with each other, being in public, as well as being just naked sheets of paper." Another desire for the artist is "to convey as much information

3 David Deitcher, "Lost and Found," in *Wolfgang Tillmans Burg* (Cologne: Taschen, 1998), unpaginated.

and do justice to the complexity of how I see life, by creating my own context for the individual parts of my work." To this end he orchestrates an "ongoing ever-changing laboratory situation for studying and questioning the way one attributes value to people and objects as well as to the art objects we look at."[4] The laboratory Tillmans sustains is one in which he can indefinitely chart and comprehend personal as well as social change.

Each photograph Wolfgang Tillmans takes and prints is part of a collective, which provides a framework for difference and dialogue. An ever-growing community of images is the dynamic repertoire from which various pictorial and symbolic alliances and juxtapositions form, disassemble, and reform in his installations and publications over time. This is not to say that the individual element is unimportant, but that the artist's conceptual and visual processes expand to making accessible the solidarities that exist concretely as well as ephemerally between photographs. Tillmans's belief in collectivity is reflected in a multiplicity of images *as form*, which engages viewers' subjectivities through multiple points of entry and their navigation of relational dynamics between images. Such configurations encourage active audience engagement and require viewers to identify and project themselves into the visual and ideational world that Tillmans carefully orchestrates. Viewers' focus is not overdetermined; understanding is not scripted. "The viewer should be encouraged to feel close to their own experiences of situations similar to those that I've presented to them in my work. They should enter my work through their own eyes, and their own lives—not through trying to piece together mine."[5]

For Tillmans the exhibition space is an arena: a threshold is crossed upon entering. Exhibition rooms are treated entirely, articulated by photographs with attention to their pictorial and sculptural dimensions and their relations to the architecture. The effect may be spectacular, but rather than becoming a spectacle the result is subtle, inviting perception over reverence. The artist's installations bid us to maneuver physically, visually, and mentally and to derive illumination and pleasure as active visitors keenly addressed. The capacity to engage, experience, and relate to his photographs—and the spaces that they open in and around them—is galvanized. By presenting photographs unglazed, simply as paper in all its vulnerability, they also function as minimal sculptural elements. This ephemeral, sculptural quality of

4 Wolfgang Tillmans, correspondence with the author, December 2005. All quotations from Tillmans are from this source, unless otherwise attributed.

5 Quoted in "Interview: Peter Halley in Conversation with Wolfgang Tillmans," in *Wolfgang Tillmans* (London: Phaidon Press, 2002), 33.

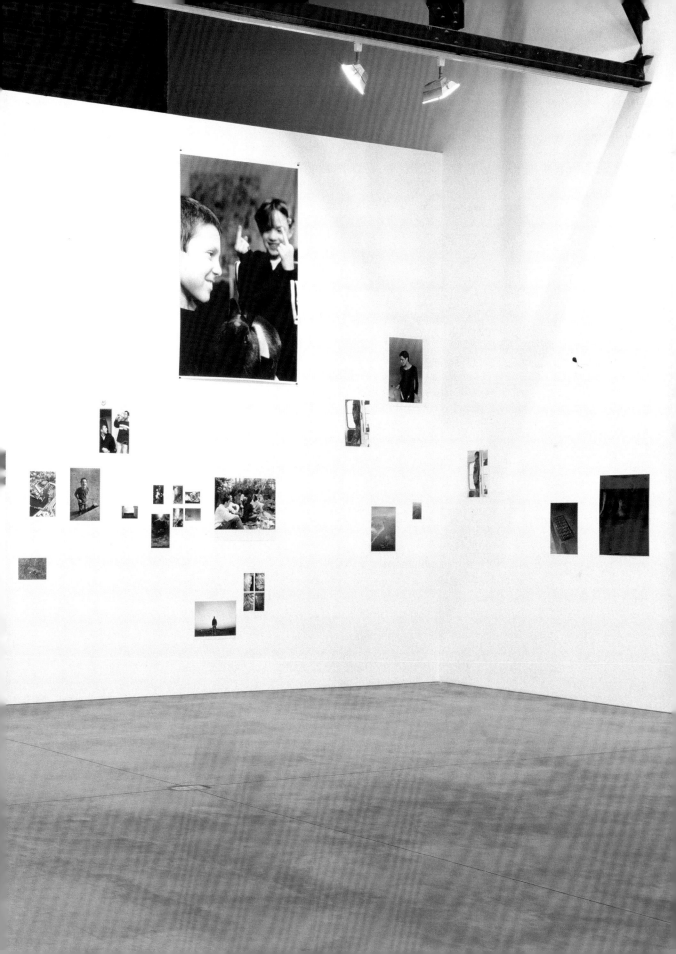

Tillmans's installations contributes to their effective, intimate atmosphere of trust and respect.

In terms of intention as well as effect, I am reminded here of the contemporary artist Roni Horn. Horn and Tillmans use overlapping methods for creating specific exhibition environments that embrace the pleasures of visuality as they subtly reclaim the circulation structure of fine art and its system of display. In their investigations of difference and identity they use key strategies of multiplication and recasting. In a Tillmans installation, the same picture may reoccur at different scale and with variant presentational means, reminiscent of Horn's *Pair Object* series, in which identical metal sculptures are displayed in adjoining rooms. Consider the sculptural presence of Tillmans's *Faltenwurf red* and *white jeans on white*, 1991 (both show clothing just worn and left behind), aside Horn's *Gold Mats, Paired—for Ross and Felix*, 1995, two identically scaled sheets of gold laid together on the floor. Vulnerable sheets of paper and slight sheets of gold, made to speak volumes. Ultimately the relation between these artists is not only about technique but is an impression of ambience and communion.

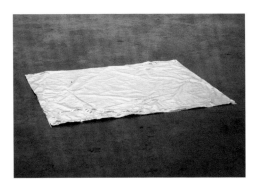

Roni Horn
Gold Mats, Paired—for Ross and Felix, 1995
Pure gold (99.99%)
49 × 60 × .0008 in. (each);
124.5 × 152.4 × 0.002 cm. (each)
Edition of 3
© Roni Horn, Courtesy Matthew Marks Gallery, New York

Historical models relevant to the installation style Tillmans employs include the image- and information-dense exhibitions of Charles and Ray Eames, also known for their democratic perspective, and the photographic exhibitions staged by the Museum of Modern Art in the 1950s and 1960s.[6]

However the most strikingly relevant milieus are vernacular ones. Consider a teenager's room, a constellation of images and things installed floor-to-ceiling, edge-to-edge in order to articulate, claim, and control every inch of space. The kind of bedroom-as-universe I am thinking of is by design in symbiotic relation to the rest of the house; it is a private space within a family home, yet it is also intended to publicize cultural choices, as well as style. Such "installations" are usually not emulated in the first autonomous space one makes after leaving home. There is a danger in mentioning teenagers in relation to Tillmans, considering that early in his career the artist was often labeled spokesperson for his (youthful) generation. But that is not the association I wish to conjure. The significance of the affiliation is on

6 For description and analysis of photography exhibitions notable for their display see "Installations for Political Persuasion," in Staniszweski: *The Power of Display*, 207–259.

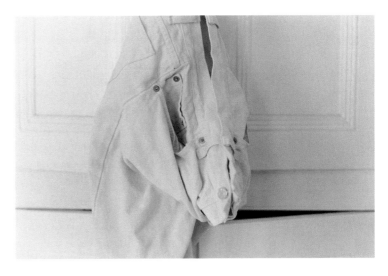

white jeans on white, 1991

the basis of active design with constant change and democratic display as guiding principles. Similar formats can be found in workplace backrooms, or on a smaller scale, office bulletin boards. These are all specially adorned places within a larger spatial configuration of authority that organizes daily living and working structures, not unlike the room of one's own an artist temporarily inhabits when staging an exhibition in an art institution.

The installation system with which Tillmans authors his exposure of continuity and change is structurally evocative of a constellation or universe. This analogy is fitting; he had a youthful obsession with astronomy. The subject matter of astronomy is the universe as a whole, an investigation of the positions, dimensions, distribution, motion, composition, energy, and evolutions of celestial bodies and phenomena, as well as the influence they exert upon each other. Tillmans's universe consists of images. Exhibited photographs are arranged in configurations that flow into one another, determined by points of contact that range from formal features such as a color or shape, to symbolic connections, to ephemeral qualities derived from the artist's internal formations, including memory. He investigates how, over time, and differently at various moments and in diverse places, these bodies change, and act upon one another. In Tillmans's exhibitory system, fluidity and relational associations are vital.

Tillmans performs the installation of his work as subtly calibrated orchestrations within which every conceptual and concrete feature is engaged specifically and holistically. Determining layers consist of the particular material to be exposed, the site of exposure and communication (with all the term site implies), and the artist's introspection regards to both photographic pool (history, genre, memory, meaning)

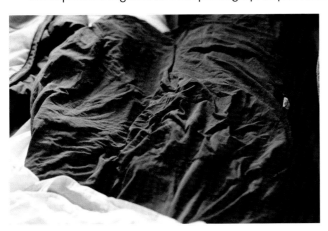

Faltenwurf (rot), 1991

and site (as interior space, institution, city, metaphor). Tillmans explains, "Some days before an exhibition I make the final selection of all the

works that can be in the show; that is determined by thinking about what did I do in this city last and when. What has the audience seen, what's the political/public context like (i.e., this fall I made an "activist" installation during the first gay and lesbian action week in Macedonia) and what is currently my interest, what do I want to test out and see how it works." Speaking to Peter Halley about his thoughts as he places photographs on the wall, the artist explained:

It comes largely from a very personal approach — things that are meaningful to me at this point, in that room or in that month. I usually spend about a week on an installation, which includes day and night shifts. I'll work on it, then leave, then come back fresh, have a new angle on it, change the whole thing, and so on, until the installation settles into a shape that gives me the sense that I can't add to it or change it; only then do I feel it's finished. Underlying decisions regarding content there are, of course, formal decisions about colors, shapes, sizes and textures.[7]

Imagination needs exercise, as does perspective, and eyes. Tillmans takes these issues into account using several installation strategies. Viewing rhythms are set by use of spaciousness in and around individual images that alternate with denser arrangements — pairings, groupings, grids, and image clusters. Boundaries of images are alternately protected and interrupted. Some photographs even touch one another. Jan Verwoert describes the effect this has on his viewing experience:

When you become absorbed in the montaged clusters of images, you can sense how your gaze picks up speed, how you make connection and close in on significant details and puns. However the visual maze is suddenly opened again through the single large prints. For a moment your eyes relax and remain set on one image, before eventually being diverted again by the surrounding cluster of pictures.[8]

Scale shifts within the pictorial spaces of photographs are mined; the interplay of various perspectives guides the eye and moves the viewer from one place to another. Scale differences are also articulated by various use of postcard-size prints (4 by 6 inches, which are recently included) and small (12 by 15¾ inches), medium (1½ by 2 feet), and large (4½ by 6¾ feet) formats that Tillmans has printed in throughout his career. Using the small and medium elements Tillmans forms the

7 Interview with Peter Halley, 33.

8 Jan Verwoert, "Picture Possible Lives: The Work of Wolfgang Tillmans," in *Wolfgang Tillmans* (Phaidon Press), 67.

grid that is a constant design device underlying his exhibitions—a visual system for all other variability to take place in. Exploiting, construing, and inverting common interpretations of format are intrinsic to Tillmans's installation approach. Scale is a tool for creating rhythm and emphasis. Yet the connotations of each format remain unfixed, dependent on specific contextual relations: "small" does not denote intimacy any more than "large" denotes dominance. Beginning in 1992, Tillmans makes large format inkjet prints that do however register impact through scale (for instance *Smokin' Jo* shown at Portikus in 1995 was 11¾ by 7¾ feet; *Police Helicopter* exhibited at the First Berlin Biennale in 1998 was 13 by 19¾ feet) and provide a counter form (materially) to the authoritative language of outsized, high-production, Plexi-mounted, framed photographs circulating in art beginning in the late 1980s. "I wanted the experience of the ink in front of your eyes, the special intense yet washed out feel of colour; a big photo that doesn't become a mirror, a big photo that doesn't reek of mimicking painting." There is a paradox inherent in a gigantic unprotected inkjet print inserted into the vocabulary of longevity that museums and private collectors buy into when acquiring works of art. Unframed inkjet prints are seductive, immediate, and ephemeral. Though reproducible they are not everlasting.

This paradox speaks to an overarching contradiction at work. Tillmans's populist orientation guides his decision making about how to participate in the art world, which is clearly an arena he cares deeply about being in as well as influencing. The artist courts a wide audience for his work through its dissemination and also by pricing his prints at relatively low cost in a costlier-means-better cultural economy. Furthermore, unlike many successful contemporaries who expand and even industrialize their production in order to meet increasing demand for their work, Tillmans maintains his own means of production in order to give the making of each and every print specific handling, care, oversight, and insight. Staying current with technology through a hands-on approach allows Tillmans an understanding of what is possible to achieve with a specific medium, and fosters experimentation, at times leading to a pushing of the limits, as happened in charting new terrain with his gigantic inkjet prints.

No single design principle guides Tillmans's installations. Rather, he alternately uses methods of symmetry and asymmetry, linearity and undergridding, and hierarchical and non-hierarchical positioning throughout, emphasizing the characteristics of each condition. Sometimes, the same picture is repeated in different scale, sometimes side-by-side. Sometimes images continue into another room, or around a corner, merging with the architecture. Monochromatic images picking up a color from a nearby photograph are inserted into some arrangements. Abstraction

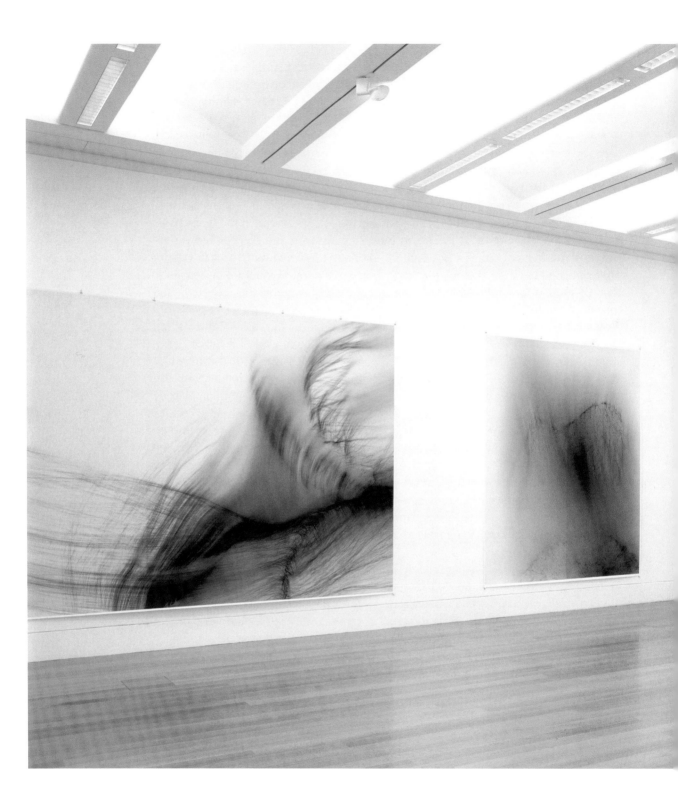

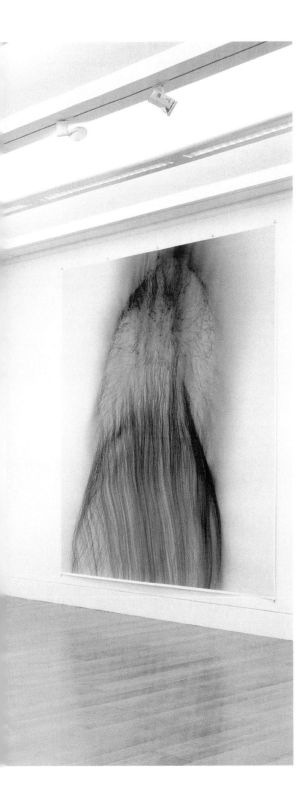

Installation view, *if one thing matters, everything matters*, Tate Britain, 2003
Left to right: *Peaches VI*, 2001, inkjet print, 104 × 140 in. (264 × 355 cm); *Blushes #82*, 2001, inkjet print, 128 × 104 in. (325 × 264 cm); *Zero Gravity III*, 2001, inkjet print, 141 × 104 in. (358 × 264)

and depictive images intermingle to express how the camera (and paper) lies and tells the truth, even simultaneously. Images of former installations may appear within installations, visually cross-referencing the artist's exhibition history.

Tillmans's visual sensibility is attuned to apprehending the three-dimensional quality of what he photographs and continuing that emphasis on dimensionality and objects within gallery rooms advanced by installation nuance. He has said that his installations derive from an "interest in the object of the photograph in its many physical forms," and therefore sustains a discerning, provisional attitude about the possibilities of what images on paper can produce spatially. Paper variations amongst photo paper, inkjet prints, magazine and print media, and recently postcards,[9] which Tillmans considers another form of high-edition original multiple, emphasize fragility and endurance, circulation and access. Ephemerality and permanence are likewise highlighted by way of presentation methods, which include unmounted photographic paper attached to the wall with tape, pins, or clips, and framed photographs. Tillmans has devised a unique method of hinging prints so that their surfaces are not touched or obstructed by tape—they hang unblemished. Since 1999 he has increasingly presented framed C-prints in his exhibitions, the volume of which is now relatively equal to unframed. Within a single space this combination accentuates the connotations of each device, the paradox of photography, and the ways in which distance and intimacy, conservation and access are all negotiated. Framing is also used intermittently to emphasize photographs as constructed objects. Prior to installation, Tillmans often works through layout possibilities by arranging small, scaled versions of images on simple wooden tables. He introduced similar tables with photographs atop them (under glass) in his 2005 exhibition at Maureen Paley in London. The tables took up a room of their own, transforming the space three-dimensionally with two-dimensional images and shifting the viewing perspective from the verticality of the wall to a horizontal angle.

The abovementioned display methods appear with varying continuity in Tillmans's exhibitions. Some exhibitions, or sections thereof, bear visual similarities. Upon closer study it is apparent that the artist's commitment to a fluid installation approach, stemming from his awareness that viewers' experiences can be short-circuited or even deadened when seeing something they think they've seen before,

9 Tillmans says, "The postcard inclusion is more conceptually driven since there is no design difference from the original photo. What interests me here is that the postcard is an end form of a usually highly successful picture having gone through many stages of showing, printing from its original first time being on paper in the form of a 4-by-6-inch small C-print (snapshot-size) when I pick up my processed film from the minilab. That's how I see the picture first, as a postcard-sized print from the minilab."

involves introducing differences, sometimes subtle, that prevent formulaic solutions. For instance, using a different installation strategy for *Freedom From The Known*, 2006, at PS1, which features many large-scale C-prints interspersed with smaller pieces and likewise framed black-and-white photocopies all installed at eye level, Tillmans framed the entire show. The combination of frames and non-reflective glazing transformed each photograph on paper into a solid image/object. Through vigilance the artist has circumvented converting his installation methods into a personal canon, just as he has refused to participate in a construction of his greatest hits.

Within the continuing history of Tillmans's exhibitions, each installation exists as a version of his art, of temporal conditions, and of himself. Like a songwriter performing his playlist over time, each situation is inflected in relation to here-and-now circumstances drawn from the profuse range of temperaments, motivations, thoughts, emotions, and contextual conditions that inform any given moment. With each exhibition, Tillmans performs its installation, communicating anew the possibilities and potential meanings of his work.

Julie Ault is an artist and was cofounder of the collaborative Group Material, which was active from 1979 through 1996. She is the editor of *Alternative Art New York, 1964–1985* and *Felix Gonzalez-Torres.*

Installation view, Galerie Juana de Aizpuru, Madrid, 2005

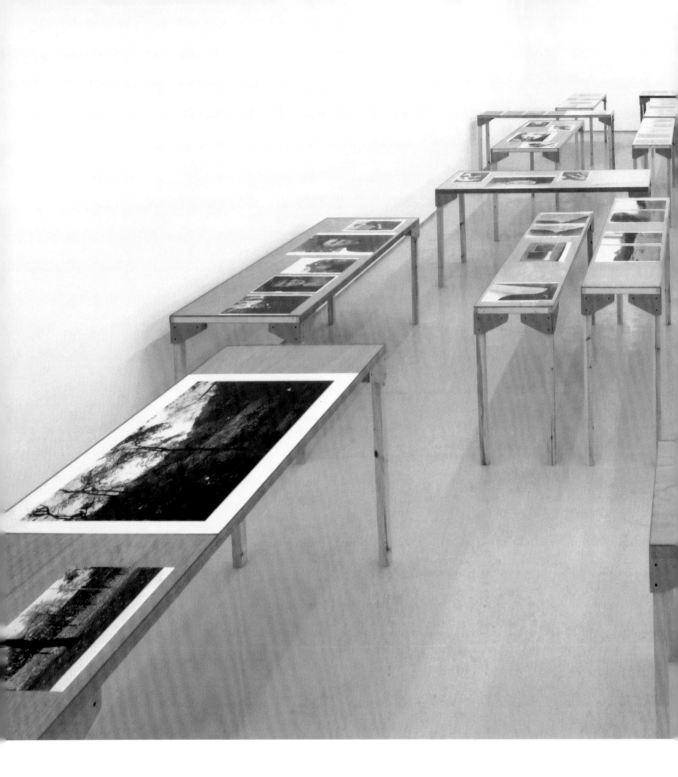

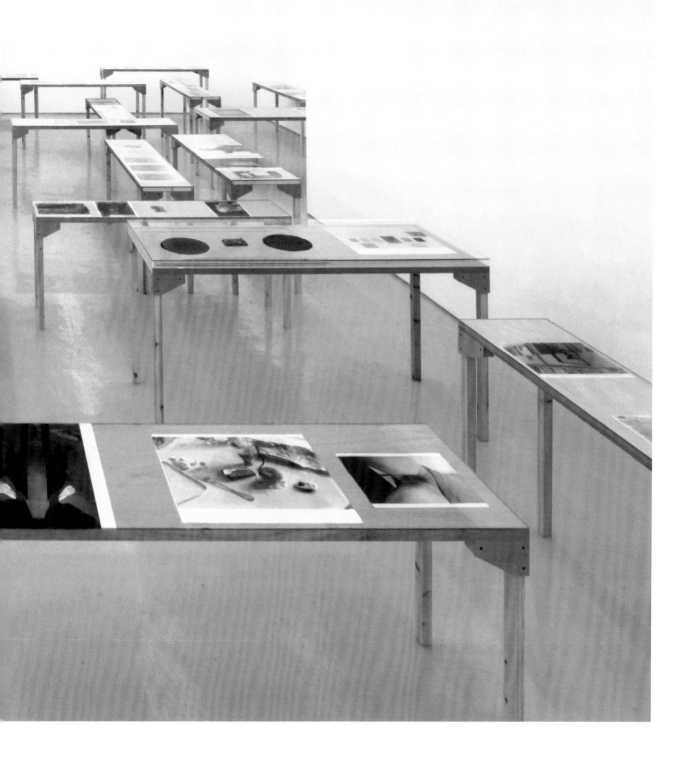

Installation view, *Truth Study Center*, Maureen Paley,
London, 2005
23 tables with C-prints, photocopies, and objects
Courtesy Maureen Paley, London

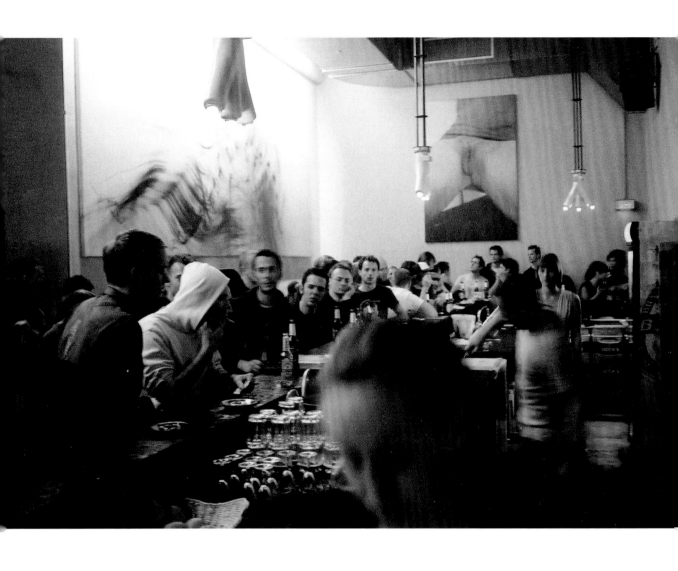

Installation view, Panoramabar, Berlin, 2004
Left to right: *Ostgut Freischwimmer*, 2004, inkjet print,
78¾ × 240 in. (198 × 609 cm); *nackt*, 2003, inkjet print,
52¾ × 79½ in. (132 × 200 cm)

Installation view, *AIDS Memorial*, Munich, 2002
Outdoor sculpture, 157½ in. (400 cm) concrete column
with tiles and two granite benches

himmelblau, 2005
Framed C-print
82¾ × 57⅛ in.
(210 × 144 cm)

Installation view, *Markt* (1989–2005),
Galerie Meerrettich, Berlin, 2005

The Space of Exposure

Mark Wigley

The label reads "*New Family*, 2001." There's no family in sight, but it's a very famil-iar scene: looking through a car windshield toward an ordinary roadscape on a gray day. It's wet, but not necessarily raining. Water squirts up to clean the glass. The wiper sliding through the spray may be moving left or right. The car itself may or may not be moving. In the ambiguity of it all, everything seems emphatically still. The pattern of the spray hitting the glass dissolves the landscape beyond. The blur of the wiper matches the blur of the out-of-focus roadway and terrain. The thick dark wiper is frozen on the exact diagonal angle of the perspective of the road edge and suddenly dematerializes when it meets the sky, as if it is actually part of the landscape. The undulating line of water that it leaves behind uncannily matches the undulating horizon of the terrain. The landscape has become melded onto the glass surface. The glass is no longer between us and the landscape outside. It has be-come the landscape. We don't see the frame of the windshield except for a hint of its bottom edge. There is only the landscape of the glass. The eye is lured into the surface itself, into the thin image dissolved by the water and attached to the other side of the glass. It is at once an abstract composition—a precise play of shape, color, texture—and an ordinary roadway scene.

The greatest density of detail is found in the pattern of spray that blots out the vanishing point of the roadway perspective and binds the road to the sky, as if the form momentarily taken by the liquid is the real end point of the journey, the ultimate target. The sky itself seems to have become a liquid sprayed onto the glass. The perspectival view down the road, an emblematic image of three-dimensional space, of depth itself, has been compacted into a two-dimensional surface and somehow inverted. What is closest to us will take the longest time to reach. It is the window, the supposedly neutral glass dividing us from the outside, that has been thrown into the distance, becoming the whole world—at once an intimate close-up and the widest field. The photograph is a straightforward image of something that is not straight. The extraordinary in the ordinary. Without pretension, yet full of precisely balanced ambiguity. Beautiful.

The image is unframed. We see it in the gallery from more or less the same distance as we would be behind the windshield in a car, the same distance the photographer had, sharing his view of the landscape clinging to the glass. It is just a beautiful still, a quiet photograph of a familiar scene. Yet it might also be a photo-graph of the scene of photography itself—an image of the world being suspended in the minimal depth of an image.

Writing about photographs is a risk. The first sign of a good photograph is that it makes you want to say something about it. The second sign is that it makes

whatever you say seem inadequate. The best photographs entice commentary then demean it, stimulating reaction and then cutting it off, producing noise only to extinguish it. The image actively silences the viewer. Writing about photographs is destined to become the victim of its subject. It is a necessarily disposable genre. If to respect an image is to expose one's words to its force, most photography writing, even by the photographers, is a futile attempt to resist the image being discussed. In the end, all one can write about is the way that particular images dispose of one's words.

This is not to say that photographs operate beyond words, or that they are worth so many thousands of them that any formulation would be insufficient. On the contrary, they operate within words, within our endless conversation with each other and our own thoughts, but do so as a silencing gesture. Photographs have their effect in the very moment of silencing us, the instant in which the words are extinguished, while we still have the, as it were, afterimage of the thought that has just been cut off. As the thought hangs in the air, fading quickly, the image, equally quickly, arrives. New thoughts arise in response to this sudden intensity, only to be extinguished again. A strong image arrives many times. It flickers. A newspaper picture animates then stills the sea of words that it floats within. The images and words in an advertisement vibrate. A photography exhibition punctures a room with flickering light and silence. The loudest image poses no threat to the viewer or the room. A loud image is not even an image in the end. An image begins precisely when the noise stops. In the silencing moment, an intimacy is established, an intimacy with space. And when a photographer's work involves a reflection on space itself, this intimacy is magnified. The more subtle the reflection about space, the more intimate the exposure. Finally, photography itself is exposed.

Such is the case with the photographs of Wolfgang Tillmans. At first, it is the absence of a singular theme that is so striking. There seems to be no characteristic subject matter, composition, or technique. Nothing seems to be off limits. The images are in this sense promiscuous, defying classification, posing a direct threat to conventional narratives about photography as an art. This heterogeneity is polemically deployed when Tillmans carefully designs the layout of his images in exhibitions, books, magazines, articles, spreads, or music videos. When more than 400 images appear in an exhibition, or the same images appear in different sizes, resolutions, media, and combinations in different exhibitions or publications, the relationship between the images becomes more important than any particular image. Typically shown without frames, each image is framed by the other images. The crucial effect is that of the evolving array. Yet each image has to be able to

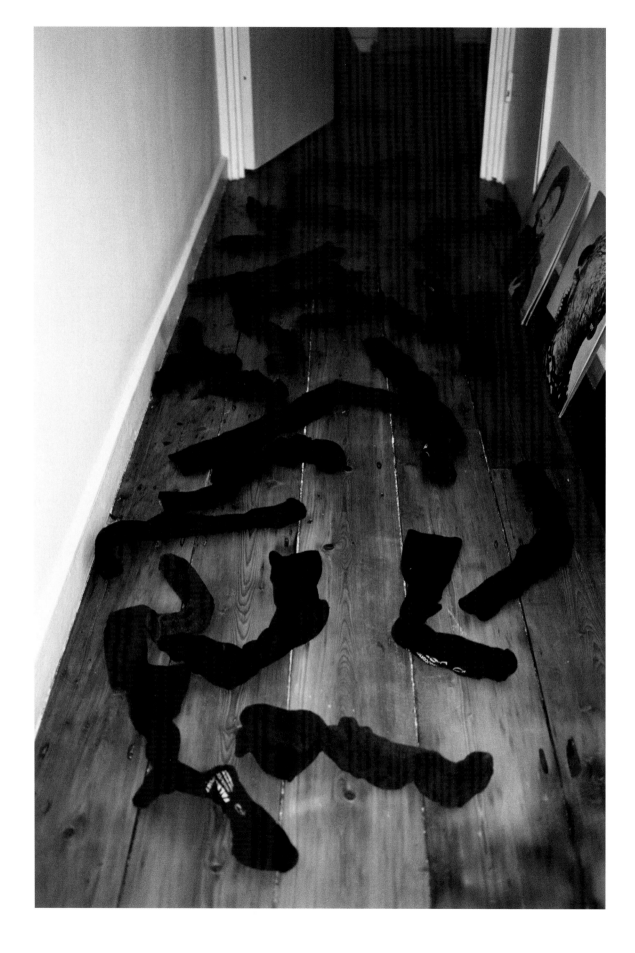

survive outside the others. It is precisely the fact that the individual images are so strong when isolated that makes their subordination to the array so striking.

Overwhelmed by the quantity and variety, the instability of medium and content, the viewer has to choose, zooming in on some images, and thereby curating a personal exhibition – plucking it out of the array. There is an immediate sense of beauty with each image before it is clear what is in front of us. The image nudges us. "Do you see this?" A small delay. "Ah . . . yes, I do." The delay is fostered by limiting the clues. There is a space and time for the viewer to react. A generosity. Again the question, more insistent now. "Do you see where this is?" Another delay. "Ah . . . yes, I do." It's nowhere extraordinary. "I could be there, have been there, will be there again." Then again the sense of beauty. Beauty now ordinary, but no less intense. A shocking beauty found everywhere at every scale at every time. Round the clock, round the planet beauty. Relentless beauty, as if the world is so much more interesting than we had realized.

The images don't preach. They don't bother to explain their strength or virtue. They simply share an experience. What is clear is that the photographer is in the scene, taking pleasure in it, offering pleasure to it, sharing that pleasure. If Tillmans encourages us to see with a "free eye," it is a loving eye, and sharing it is understood as a political act. And the generosity is never taken for granted. It has to be constructed afresh with each image, and it is in that construction that the art of these images lies.

The free eye spins, looking in every direction – up, down, out a plane, through a telescope – but never oblique or squinting. The view is direct, stark, and open, embracing endless colors, forms, faces, and light from every hour, season, and location. An affectionate surveillance of the planet. Everything fresh, as if seen for the first time. A sense of smiling but restless youth. No longer an embedded report on youth culture because the images are actually getting even younger.

While the restless eye is constantly on the move between images, the images themselves are devoid of movement. Making literal the camera's most basic gesture, the ability to stop things, almost every image is still. It is as if all Tillmans's images are still lifes. People often appear, filling the image, occupying the ordinary scenes but never in an ordinary way. Even in the most energetic club scenes, there is almost no sense of movement. On the contrary, the stillness is accentuated. Everything, especially people, becomes an object. The body is clearly understood in a sculptural sense – angles, creases, joints, folds, etc. – but not as a sculpture differentiated from the space it appears in. The overall spatial scene, including people, is no longer the backdrop to an action. It is the action. In the stillness and the absence of ready-

made social conventions, the viewer is invited to enter. In all of Tillmans's thousands of still lifes, it is the viewer that moves, or is at least offered an invitation to do so. The photographer's right to look, the license to scrutinize and enter any scene, is shared as a right to act.

This is promiscuity with precision, nothing casual about the images. The free eye is not relaxed. On the contrary, it is deeply involved. Loving. Working. Thinking. The effect that nothing is off-limits actually requires that a huge amount be edited out. The sense of "everything" can only be produced by a limited set. The seemingly open-ended heterogeneity is the result of a very particular control. What is most precise and hyper-controlled in the images is their architecture. In each and every photograph there is a sensitivity to space, a sculptural, if not architectural, sensibility. Space might be the only underlying theme of Tillmans's work. This architectural space is not simply found in the world. The majority of Tillman's images are in some way staged. Scenarios are set up with people and objects. Something is invented, whether it is the rearrangement of objects, the positioning of friends in particular clothes and scenarios, or the abstract effects of images produced in the darkroom. In each case, all evidence of rearrangement is removed so that the staged scenes are experienced as found, and the found scenes are experienced as precisely arranged.

These photographs relentlessly blur found and constructed – carefully remaining ambiguously between the capturing of an available instant, as in Henri Cartier-Bresson's work, and the slow labor of total constructions, as in Jeff Wall's work, to cite a couple of too obvious paradigms of the extremes. If photographers like Cartier-Bresson steal the image and those like Wall painstakingly build it, Tillmans drifts ambiguously between taking and making, and places the viewer in the same mode. No clue is offered as to the choreographing of each scene, preserving the sense of a rich found world. So each image appears halfway between the world and the photographer, an image not simply received from the world onto the sensitive film in the camera, but an image just as much coming out from the sensitive photographer – an image, in the end, of the photographer in the world. As much projected out through the film onto the world as received onto the film from the world. The construction begins with the seemingly transparent but actually distorting glass of the lens itself. When pressed on this point, Tillmans remarks that "photography always lies about what is in front of the

Jeff Wall
Diagonal Composition,
1993
Silver dye-bleach
transparency and light box
19½ × 22½ × 5 in. (49.5 ×
57.2 × 12.7 cm)
Collection Museum of
Contemporary Art,
Chicago, partial and
promised gift from
the Howard and Donna
Stone Collection
Courtesy of the artist and
Marian Goodman Gallery,
New York

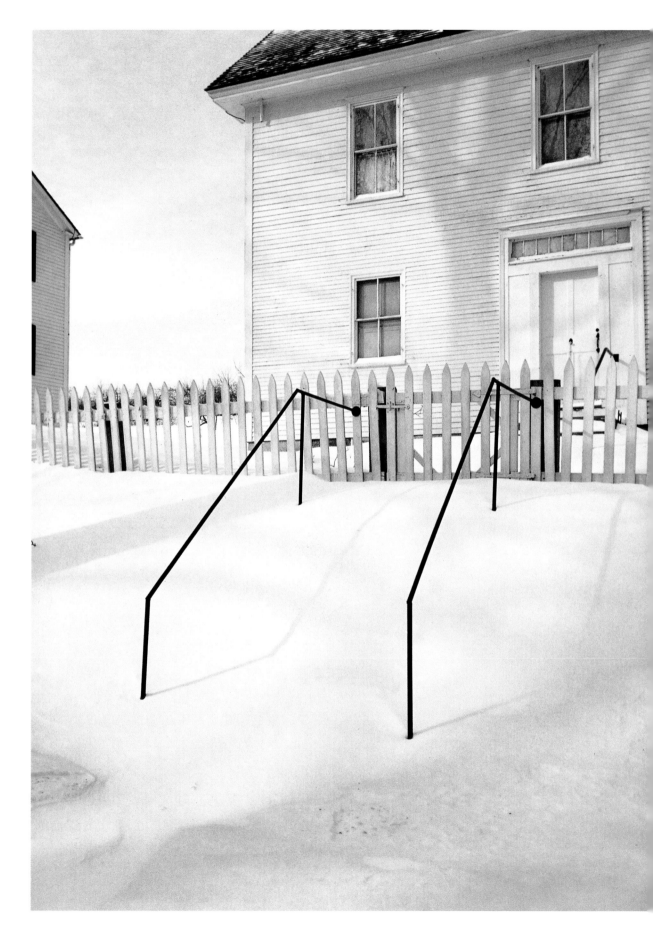

camera but never lies about what is behind."[1] It captures the experience, the thinking, behind the image. Photography is a psychological rather than a technological medium. It is a way of projecting thinking into the world and sharing that experience.

The film is exposed to Tillmans. But to ask exactly how he technically or socially produces his images is to resist their force by trying to add a more traditional sense of depth to their surface. It is to try and pin them down and seal up the openings they offer, adding substance to the images, as if they are in some way insubstantial or inadequate – to nervously look away from what is happening in the surface. What counts is what is right in front of our eyes.

What is taken / made in these photographs is architecture, the disposition of objects in space. Tillmans works with an architectural eye. There must be space in every photographer's work. Only space can offer a pattern of light to the film. But it is possible to make space the tangible content of the image in a way that subtly exposes the medium itself. Tillmans brings space out of the background, without simply turning it into the foreground, as happens most obviously in so-called architectural photography. What he offers is images without an opposition between foreground and background, images with no depth precisely, images that locate depth in the surface. The photographs are in close relationship to fashion, but also, for the same reason, with architecture. Photographs of actual buildings come as quite a shock in the array because they suddenly make literal the underlying spatial theme, expanding out the depth that in most of the images has been compacted into the surface or found within it. The two-dimensional photographic print absorbs all the architecture. Ultimately, the work tends toward the architecture of the print paper itself. Tillmans increasingly goes deeper and deeper into the surface, working in the darkroom to produce abstract images, intense gelatinous surfaces or pale, almost washed away traces, soft curves, or folded rigid surfaces. There is no longer a camera, or a world outside the camera. Or, rather, there is only the camera, in the original sense of a closed room. There is no clear line between these seemingly abstract images and seemingly realistic ones. They bring realistic scenes to mind just as the others bring abstract spatial relationships to the surface. The work is no less architectural. Depth now is in the surface itself rather than between surfaces. The photographic film and the print paper have collapsed into each other.

The work keeps reaching toward an exposure of the medium itself, as becomes most explicit in *Time, Action and Fear* of 2005, a huge vertical abstract landscape

1 Wolfgang Tillmans, in conversation with the author, December 12, 2005.

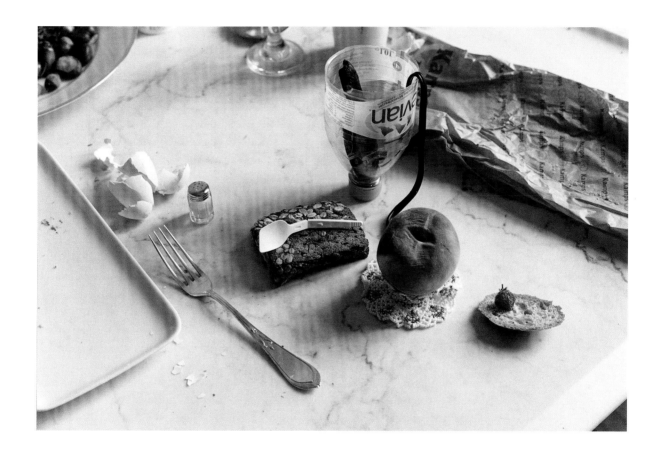

produced in the darkroom where the crystals at the heart of the photographic process are enlarged to such a scale that they drift at the bottom of the image in a web of flowing streams that grow into diaphanous liquid sheets of brown and green color, which rise up the piece of paper and gradually thin out with a few ghostly figures drifting laterally through them. This chemical landscape does not fill the whole surface. A hard-edged strip of unmarked white remains on the right of the sheet of paper, a sharp reminder that what we are looking at is still an exposure, a photograph. For all its sensuous beauty, the image is a laboratory test, a forensic exposure of the raw materials of the art. As the basic chemicals of the medium finally appear in a kind of endgame of the relentless pursuit of the sensitive surface, it is unambiguously photography itself that is being photographed, simultaneously embraced and put to the test.

This was anyway the case from the very first images on. Tillmans's reworked Xeroxes of newspaper images already began the exposure of exposure. The reverence for the surface was there in his acceptance of the generic sizes of paper, the generic spray of the inkjet printer, the default Canon copier, the standard magazine format, and the mobility of images between these ready-made sizes, machines, techniques, and media. Maintaining such default settings, the most ordinary commercial means of generating, modifying, and circulating images, actually widened and mobilized the point of view. To embrace the ordinariness of the medium was paradoxically to expose it differently. The restless mobility of this wider eye actively refused so many disciplinary limits. It is photography without guilt or shame, a systematic threat but irresistible in the end, now occupying the very spaces that it has so relentlessly challenged.

These photographs don't just sit on a wall or on the pages of a publication waiting to be looked at. When the images come from behind the camera as much as from in front of it, the viewers are placed into the camera itself—put in intimate contact with its sensitive surface. To get some distance, the viewer has to move, leaning back to resist the force of the image. Faced with an ever-growing array of guiltless photographs, we are obliged to act, to take responsibility for these images we now find ourselves pressed up against, to take a shot, to make a look, to dive freely into the surface and enter the wet landscape that clings to the other side of the glass.

Mark Wigley is Dean at the Graduate School of Architecture, Planning and Preservation at Columbia University and the author of several books, including *Constant's New Babylon: The Hyper-Architecture of Desire*.

Installation view, *Freedom From The Known*, PS1, New York, 2006
Left: *Time, Action and Fear*, 2005, framed
C-print 121¼ × 71¼ in. (308 × 181 cm),
Haus Esthers Haus Lange, 2005, unique photocopy
16½ × 11¾ in. (42 × 30 cm)

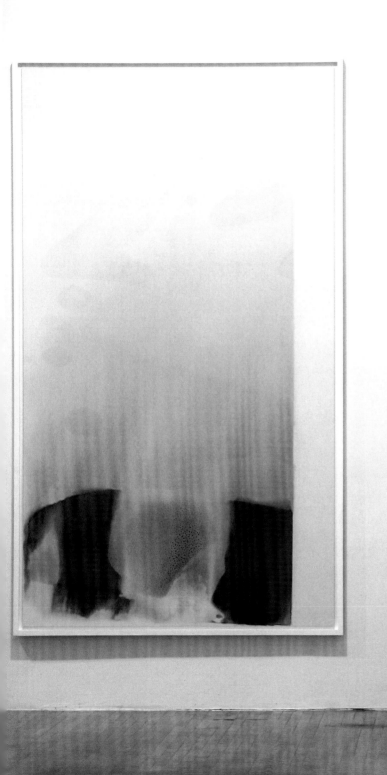

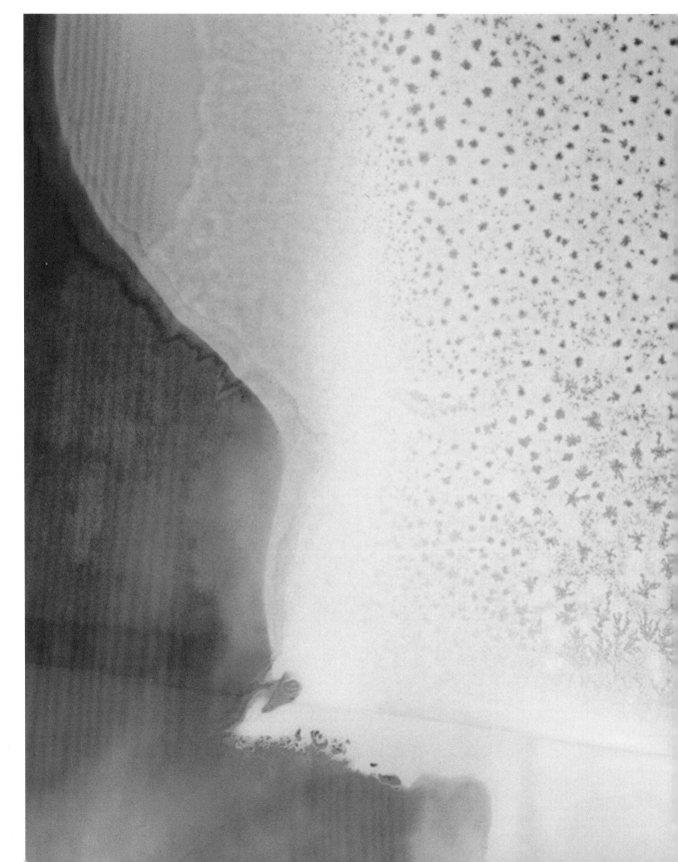

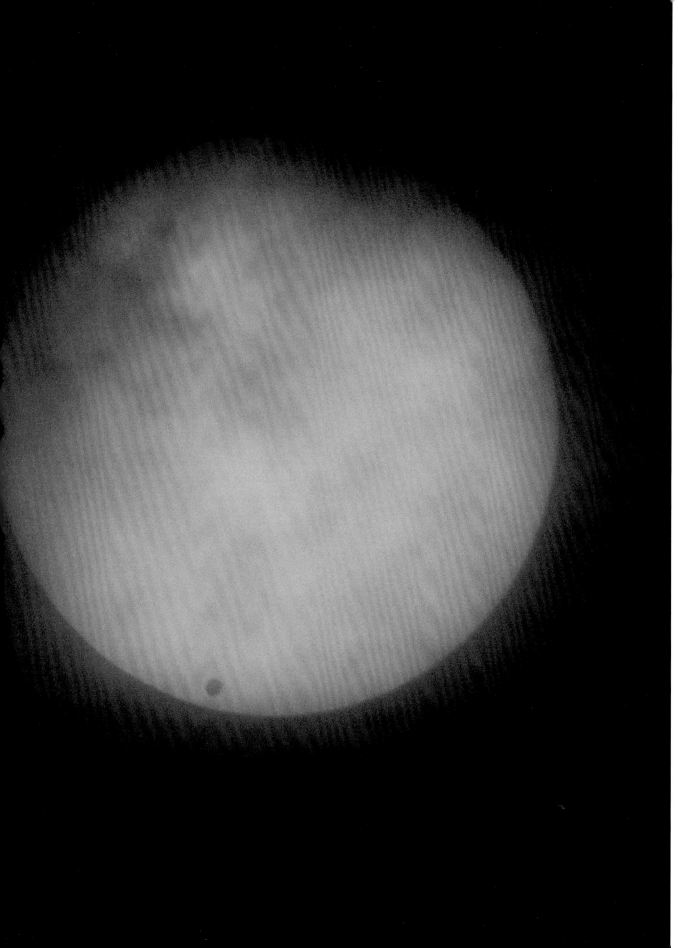

Artist's Biography

1968
Born in Remscheid, Germany

1987–1990
Lives and works in Hamburg, Germany

1990–1992
Studies at Bournemouth and Poole College of Art
 and Design, Bournemouth, England

1992–1994
Lives and works in London

1994–1995
Lives and works in New York

1995
Ars Viva Prize, Bundesverband der Deutschen
 Industrie e. V
Kunstpreis der Böttcherstraße, Bremen, Germany

1995–1996
Works in Berlin for three months

Since 1996
Lives and works in London

1998–1999
Visiting professorship at the Hochschule für bildende
 Künste (School of Fine Arts) Hamburg, Germany

2000
Turner Prize 2000, Tate Britain, London

2001
Honorary Fellowship, The Arts Institute at
 Bournemouth, England

Since 2003
Professorship of interdisciplinary art at Städelschule,
 Frankfurt am Main, Germany

Solo Exhibitions

1988
Approaches, Café Gnosa, Hamburg, Germany
Approaches, Fabrik–Foto–Forum, Hamburg, Germany;
 Municipal Library, Remscheid, Germany
Blutsturz, Front, Hamburg, Germany

1989
Café Gnosa, Hamburg, Germany

1991
Grauwert Galerie, Hamburg, Germany

1992
Diptychen, 1990–1992, PPS. Galerie F. C. Gundlach,
 Hamburg, Germany

1993
arsFutura Galerie, Zurich
Galerie Daniel Buchholz–Buchholz + Buchholz,
 Cologne, Germany
Interim Art, London
L.A. Galerie, Frankfurt am Main, Germany

1994
Andrea Rosen Gallery, New York
Fehlmann AG, Schoeftland, Switzerland
Galerie Daniel Buchholz, Cologne, Germany
Galerie Thaddaeus Ropac, Paris

1995
Interim Art, London
Kunsthalle Zurich (exh. cat.)
neugerriemschneider, Berlin
Portikus, Frankfurt am Main, Germany (exh. cat.)
Regen Projects, Los Angeles
Stills Gallery, Edinburgh

1996
Andrea Rosen Gallery, New York
arsFutura Galerie, Zurich
Faltenwürfe, Galerie Daniel Buchholz, Cologne, Germany
*For When I'm Weak I'm Strong/Wer Liebe wagt
 lebt morgen*, Kunstmuseum, Wolfsburg, Germany
 (exh. cat.)
Galleri Nicolai Wallner, Copenhagen
Kunstverein Elsterpark, Leipzig, Germany

1997
Galleria S.A.L.E.S, Rome
hale-Bopp, Galerie Daniel Buchholz, Art Cologne,
 Cologne, Germany
I Didn't Inhale, Chisenhale Gallery, London

1998
Andrea Rosen Gallery, New York
Café Gnosa, Hamburg, Germany
Le Case d'Arte di Pasquale Lecese, Milan, Italy
Fruiciones, Museo Nacional Reina Sofia, Espacio Uno,
 Madrid (exh. cat.)

1999
*Eins ist sicher: Es kommt immer ganz anders als man
 denkt*, Städtische Galerie, Remscheid, Germany
Galleria S.A.L.E.S, Rome
neugerriemschneider, Berlin
Regen Projects, Los Angeles
Saros, Galerie Daniel Buchholz, Cologne, Germany
Soldiers–The Nineties, Andrea Rosen Gallery, New York
Soldiers–The Nineties, arsFutura Galerie, Zurich
Soldiers–The Nineties, Neuer Aachener Kunstverein,
 Aachen, Germany
sommercontemporaryart, Tel Aviv
Space between Two Buildings/Soldiers–The Nineties,
 Maureen Paley/Interim Art, London
Wako Works of Art, Tokyo (exh. cat.)

2000

Blushes, fig-1, London
Galerie Meyer Kainer (with Jochen Klein), Vienna
Galerie Rüdiger Schöttle (with Thomas Ruff),
 Munich, Germany

2001

Andrea Rosen Gallery, New York
Science Fiction/hier und jetzt zufrieden sein AC:
 Isa Genzken, Wolfgang Tillmans, Museum Ludwig,
 Cologne, Germany (exh. cat.)
Super Collider, Galerie Daniel Buchholz,
 Cologne, Germany
View from Above/Aufsicht, Deichtorhallen Hamburg,
 Germany; Castello di Rivoli – Museo d'Arte
 Contemporanea, Rivoli, Italy; Palais de Tokyo, Paris;
 Louisiana Museum for moderne kunst, Humlebœk,
 Denmark (exh. cat.)
Wako Works of Art, Tokyo (exh. cat.)

2002

Lights (Body), Andrea Rosen Gallery, New York
Lights (Body), Galeria S.A.L.E.S., Rome
Maureen Paley/Interim Art, London
Partnerschaften II (with Jochen Klein), Neue Gesellschaft
 für Bildende Kunst, Berlin (exh. cat.)
Regen Projects, Los Angeles
sommercontemporaryart, Tel Aviv
Veduta dall' alto, Castello di Rivoli – Museo d'Arte
 Contemporanea, Rivoli, Turin (exh. cat.)
Vue d'en Haut, Palais de Tokyo, Paris (exh. cat.)
Wolfgang Tillmans: still life, The Fogg Art Gallery, Busch
 Reisinger Museum, Harvard; Cambridge, Mass.
 (exh. cat.)

2003

Andrea Rosen Gallery, New York
Frans Hals Museum, Haarlem, Netherlands
Galerie Daniel Buchholz, Cologne, Germany
if one thing matters, everything matters, Tate Britain,
 London (exh. cat.)
View From Above, Louisiana Museum for moderne kunst,
 Humlebœk, Denmark (exh. cat.)

2004

Wolfgang Tillmans: Freischwimmer, Tokyo Opera City
 Art Gallery, Tokyo (exh. cat.)
neugerriemschneider, Berlin
Panoramabar, Berlin (permanent installation)
Regen Projects, Los Angeles
Wako Works of Art, Tokyo (exh. cat.)

2005

2005, Galería Juana de Aizpuru, Madrid
Markt, Galerie Meerrettich, Berlin
Press to Exit Project Space, Skopje, Macedonia
Truth Study Center, Maureen Paley, London

2006

Freedom From The Known, PS1, New York (exh. cat.)
Helsinki-Festival, Taidehalli, Helsinki (forthcoming)
Kestner-Gesellschaft, Hannover, Germany (forthcoming)
Museum of Contemporary Art, Chicago; Hammer
 Museum, Los Angeles; Hirshhorn Museum and
 Sculpture Garden, Washington DC
Pinakothek der Moderne (permanent collection),
 Munich, Germany

Group Exhibitions

1989

Die Hamburg Schachtel, Museum für Kunst und
 Gewerbe, Hamburg, Germany (exh. cat.)

1991

Icons of a Mutinous Age: Three Photographers,
 Bournemouth and Poole College of Art and
 Design, Bournemouth, England

1992

i-D Now, Pitti Image, Palazzo Corsini, Florence, Italy
tomorrow people, Imagination Gallery, London
We Haven't Stopped Dancing Yet, PPS, Galerie F. C.
 Gundlach, Hamburg, Germany

1993

Atelier, collaboration with Isa Genzken; Galerie Daniel
 Buchholz, Cologne, Germany; Wilma Tolksdorf,
 Hamburg, Germany
Belcher, Höller, General Idea, Tillmans, Odenbach,
 Galerie Daniel Buchholz, Cologne, Germany
Christmasshop, Air de Paris, Paris
Fuck the System, Villa Rossi, Lucca, Italy
June, Galerie Thaddaeus Ropac, Paris
November Television, Videoprojekt Remscheid, Esther
 Schipper, Cologne, Germany
Phenylovethylamour, Unfair 1993, Cologne, Germany,
 stand of the Galerie Daniel Buchholz
Tresorraume, Unfair 1993, Cologne, Germany

1994

100 Umkleidekabinen, Bad zur Sonne, Graz, Austria
 (exh. cat.)
Ars Lux, 100 artist billboard light boxes across Italy
Les Dimanches de l'amour, École des Beaux-Arts de
 Rennes, Rennes, France
*Dinos and Jake Chapman, Georgina Starr, Wolfgang
 Tillmans,* Andrea Rosen Gallery, New York
L'Hiver de l'amour, Musée d'art moderne de la ville de
 Paris (exh. cat.)
Homegrown, Lotus Club, Cologne, Germany
Mechanical Reproduction, AP, Amsterdam (exh. cat.)
Photo '94, The Photographer's Gallery on Art 94,
 London
Rien à signaler, Galerie Analix, Geneva, Switzerland
 (exh. cat.)

Soggetto Soggetto, Castello di Rivoli – Museo d'Arte
 Contemporanea, Rivoli, Turin (exh. cat.)
Sonne München, Galerie Daniel Buchholz,
 Cologne, Germany
Streetstyle, Victoria & Albert Museum, London (exh. cat.)
The Winter of Love, PS1, New York

1995

ars viva 95/96 Photographie, Anhaltische Gemäldegalerie
 Dessau, Dessau, Germany; Frankfurter Kunstverein,
 Frankfurt am Main, Germany; Kunsthalle Nürnberg,
 Nuremberg, Germany (exh. cat.)
Benefit Exhibition for D.E.A.F., Inc., Nicole Klagsbrun
 Gallery, New York, organized by Jeff Koons
*Bildermonde – Modebilder: Deutche Modephotographien
 von 1945 – 1995,* Institute fur Auslandsbeziehungen,
 Stuttgart, Germany, organized by F. C. Gundlach
 (exh. cat.)
The Enthusiast, Gavin Brown's Enterprise, New York
Every Time I See You, Galleri Nicolai Wallner, Malmö,
 Sweden; galleri index, Stockholm
Galerie Analix B&L Polla, Geneva, Switzerland
Guaranteed Personalities, Lydmar Hotel, Stockholm,
 curated by Thomas Nordanstad
Human Nature, New Museum of Contemporary Art,
 New York
Kunstpreis der Böttcherstraße in Bremen, Kunsthalle
 Bremen, Bremen, Germany (exh. cat.)
Mondo Nova, Le Case d'Arte, Milan, Italy (exh. cat.)
Photographies, Galerie Rodolphe Janssen, Brussels
Take Me (I'm Yours), Serpentine Gallery, London;
 Kunsthalle Nürnberg, Nuremburg, Germany
 (exh. cat.)
White Columns, New York, Auction Benefit

1996

a/drift: Scenes from the Penetrable Culture, Bard
 College Center for Curatorial Studies, Annandale-
 on-Hudson, New York
Arken Museum for moderne kunst, Copenhagen
 (exh. cat.)
Blind Spot: Photography – The First Four Years,
 Paolo Baldacci Gallery, New York
By Night, La Fondation Cartier pour l'art contemporain,
 Paris (exh. cat.)
*Das deutsche Auge – 33 Photographen und ihre
 Reportagen,* Deichtorhallen Hamburg, Hamburg,
 Germany
Dites-le avec des fleurs, Galerie Chantal Crousel, Paris
Everything that's Interesting is New, The Dakis Joannou
 Collection, Athens; Art Academy, Athens;
 Arken Museum for moderne kunst, Copenhagen
Festival International de la Photo de Mode,
 Biarritz, France
Glockengeschrei nach Deutz, Galerie Daniel Buchholz,
 Cologne, Germany (exh. cat.)
I Feel Explosion, flat above Manchester Arndale Centre,
 Manchester, UK

Intermission, Basilico Fine Arts, New York, curated by
 Toland Grinnell and Matthew Ritchie
New Photography #12, The Museum of Modern Art,
 New York
Nudo y Crudo: Sensitive Body, Visible Body,
 Claudia Gian Ferrari Arte Contemporanea, Milan,
 Italy (exh. cat.)
Pictures of Modern Life, Galerie Rodolphe Janssen,
 Brussels; École régionale des Beaux-Arts de Tours,
 Tours, France
Le Plaisir et les ombres, Fondation pour l'Architecture,
 Brussels
Prospect '96 – Fotografie in der Gegenwartskunst,
 Frankfurter Kunstverein und Schirn Kunsthalle,
 Frankfurt am Main, Germany (exh. cat.)
*The Quiet in the Land: Everyday Life, Contemporary Art
 and the Shakers,* Sabbathday Lake, Maine,
 conceived and organized by France Morin; Institute
 of Contemporary Art, Maine College of Art, Portland;
 Institute of Contemporary Art, Boston
Shift, Haus der Kulturen der Welt, Berlin, organized
 by Neue Gesellschaft für Bildende Kunst (exh. cat.)
Traffic, CAPC Musée d'art contemporain,
 Bordeaux, France
Urgence, CAPC Musée d'art contemporain,
 Bordeaux, France (exh. cat.)
Visitors' Voices: Recomposing the Collection,
 Walker Art Center, Minneapolis
wunderbar, Kunstraum Wein, Vienna; organized
 by Stephan Schmidt-Wulffen; Kunstverein,
 Hamburg, Germany

1997

The 90s: A Family of Man?, Casino Luxembourg –
 Forum d'art contemporain, Luxembourg (exh. cat.)
Absolute Landscape: Between Illusion and Reality,
 Yokohama Museum of Art, Yokohama, Japan
 (exh. cat.)
Kunst . . . Arbeit, Forum der Südwest LB, Stuttgart,
 Germany (exh. cat.)
Die Kunsthalle Bremen zu Gast in Bonn, Kunst- und
 Ausstellungshalle der Bundesrepublik Deutschland,
 Bonn, Germany (exh. cat.)
*Positionen künstlerischer Photographie in
 Deutschland von 1945 – 1995,* Berlinische Galerie,
 Martin-Gropius-Bau, Berlin (exh. cat.)
Projects, Irish Museum of Modern Art, Dublin (exh. cat.)
Reality, Yokohama Museum of Art, Yokohama, Japan
Sous le Manteau, Galerie Thaddaeus Ropac, Paris
 (exh. cat.)
We Gotta Get Out of This Place, Cubitt, London
*Zeitgeist Becomes Form: German Fashion Photography
 1945 – 1995,* Pat Hearn Gallery, New York; Morris
 Healy Gallery, New York

1998

Berlin/Berlin, Berlin Biennale

Collection: Un autre regard, CAPC Musée d'art contemporain, Bordeaux, France

Curatorial Program, New York Curatorial Program, New York

The DG Bank Collection, Hara Museum of Contemporary Art, Tokyo (exh. cat.)

Edifying Sappho and Socrates, Sydney Gay & Lesbian Mardi Gras, Sydney

Fashion at the Beach, Bass Museum of Art, Miami Beach, Fla., curated and organized by Charles Cowles and Dennis Christie; Contemporary Art Center of Virginia, Virginia Beach, Va.; Orange County Museum of Art, Newport Beach, Calif. (exh. cat.)

Fast Forward Image, Hamburger Kunstverein, Hamburg, Germany (exh. cat.)

From the Corner of the Eye, Stedelijk Museum, Amsterdam (exh. cat.)

Galerie Daniel Buchholz, Cologne, Germany

Galerie Ghislaine Hussenot, Paris

Germania Anno 00 . . . , Newsantandrea, Savona, Italy

Kunstausstellung Holderbank, Holderbank Management und Beratung AG, Holderbank, Switzerland

New York Color School, Valerie's Gallery, New York

Die Parkett-Künstlereditionen im Museum Ludwig, Cologne, Germany

Photo Op, Geoffrey Young Gallery, Great Barrington, Mass.

Portrait: Human Figure, Galerie Peter Kilchmann, Zurich

The Sound of One Hand: The Collection of Collier Schorr, Apex Art, New York

La Sphère de l'intime, Le Printemps de Cahors Festival, Saint-Cloud, France

Still Life: 1900–1998, Marlborough Graphics, Marlborough Gallery Inc., New York; Kunsthalle Bremen, Bremen, Germany

Stretch, Tensta Konsthall, Stockholm (exh. cat.)

Sunday by Matthew Higgs, Cabinet Gallery, London

Veronica's Revenge, Lambert Collection, Geneva, Switzerland; Centre d'art contemporain, Paris; Deichtorhallen Hamburg, Hamburg, Germany (exh. cat.)

1999

Can You Hear Me?, 2nd Ars Baltica Triennial of Photographic Art, Stadtgalerie im Sophienhof, Kiel, Germany; Kunsthalle Rostock, Rostock, Germany

Flashes: Contemporary Trends, Fondation Cartier pour l'art contemporain, Paris; Centro Cultural de Belèm, Lisbon; Fondacion Miró, Barcelona, Spain; Centro Arte Contemporanea Palazzo delle Papesse, Siena, Italy (exh. cat.)

The Garden of Eros, Palau de la Virreina, Barcelona, Spain

How Will We Behave?, Robert Prime, London

Hypertronix, Espai d'Art Contemporani de Castelló, Castelló, Spain (exh. cat.)

The Image of the Other, Fòrum Universal de les Cultures, Barcelona, Spain (exh. cat.)

In Your Face, New Langton Fine Arts, San Francisco, curated by Robert Shimshak

Macht und Fürsorge: Das Bild der Mutter in der zeitgenössischen Kunst, Siemens Kulturprogramm, Trinitatis Church, Cologne, Germany (exh. cat.)

. . . om det sublima/. . . on the sublime, Rooseum, Malmö, Sweden (exh. cat.)

der siebte himmel, Christuskirche Köln, Cologne, Germany

Views from the Edge of the World, Marlborough Chelsea, New York

Vision of the Body: Fashion or Invisible Corset, Kyoto Museum of Modern Art, Kyoto, Japan; Museum of Contemporary Art, Tokyo (exh. cat.)

Wohin kein Auge reicht – Von der Entdeckung des Unsichtbaren, Deichtorhallen Hamburg, Hamburg, Germany (exh. cat.)

Word Enough to Save a Life, Word Enough to Take a Life, Clare College Mission Church, London

Zoom, Württembergischer Kunstverein Stuttgart, Stuttgart, Germany; Museum Abteiberg, Mönchengladbach, Germany

2000

90 60 90, Museo Jacobo Borges, in cooperation with the Goethe Institut, Caracas, Venezuela (exh. cat.)

All Dressed Up, Apex Art, New York

Apocalypse: Beauty and Horror in Contemporary Art, Royal Academy of Arts, London

The arsFutura Show, arsFutura, Zurich

Arts & Facts, Galleria Franco Noero, Turin, Italy

AutoWerke – Europäische und amerikanische Fotografie 1998–2000, Deichtorhallen, Hamburg, Germany (exh. cat.)

The British Art Show 5, organized by the Hayward Gallery, London, for The Arts Council of England; Scottish National Gallery of Modern Art, Edinburgh, UK; John Hasard Gallery, University of Southampton, Southampton, UK: Southampton City Art Gallery, Southampton, UK; Millais Gallery, Southampton, UK; Fotogallery, Cardiff, UK; Ikon Gallery, Birmingham, UK (exh. cat.)

Collection Première Heure, Groupe Premiere Heure, Saint-Cloud, France

Collector's Choice, Exit Art, New York

Complicity, Australian Centre for Photography, Sydney

Conversione di Saulo, Palazzo Odescalchi, Rome

Deep Distance: Die Entfernung der Fotografie, Kunsthalle Basel, Basel, Switzerland (exh. cat.)

Dire AIDS: Arte nell'epoca del AIDS/Art in the Age of Aids, Promotrice delle Bella Arte, Turin, Italy (exh. cat.)

German Photoworks, Wako Works of Art, Tokyo

'high five' im warmen Monat Mai, Galerie Schedler, Zurich

Joitakin Osia Maailmasta/Some Parts of this World, Helsinki Photography Festival, Helsinki (exh. cat.)

Landscape, organized by The British Council, London; Museu de Arte de São Paulo, Brazil; Museu de Arte Contemporânea de Niterói, Rio de Janeiro, Brazil; Sofia Municipal Gallery of Art, Sofia, Bulgaria; Centro Cultural del Conde Duque, Madrid; Galleria Nazionale d'Arte Moderna, Rome; Peter and Paul Fortress, St. Petersburg, Russia; Central House of Artists, Moscow; ACC Gallery, Weimar, Germany (exh. cat.)

Look at Me: Fashion and Photography in Britain, 1960 to the present, The British Council, Madrid; Kunsthal, Rotterdam; Fondazion Nicola Trussardi, Milan, Italy; Marina Alla Scala Art Centre, Milan, Italy; Centre for Contemporary Arts, Ujazdowski Castle, Warsaw; Mali Manezh, Moscow; State Museum of the History of St. Petersburg, St. Petersburg, Russia; Tallinna Kunstihoone Fond, Tallin, Estonia; Øksnehallen, Copenhagen; Museu de Documentatio I Museu Textill, Terrasa, Spain; Recinto Ciudadela, Pamplona, Spain; Palacio de abrantes, Salamanca, Spain; House of Art, Bratislava, Slovakia (exh. cat.)

Lost, Ikon Gallery, Birmingham, UK (exh. cat.)

Eine Munition unter anderen, Frankfurter Kunstverein, Frankfurt am Main, Germany (exh. cat.)

The Oldest Possible Memory, Collection Hauser and Wirth, Lokremise St. Gallen, St. Gallen, Switzerland

Platforma, sommercontemporaryart, Tel Aviv

Photography Now, Contemporary Arts Center, New Orleans, La. (exh. cat.)

Présumés innocents, CAPC Musée d'art contemporain, Bordeaux, France (exh. cat.)

Protest and Survive, Whitechapel Art Gallery, London

Quotidiana: The Continuity of the Everyday in 20th Century Art, Castello di Rivoli – Museo d'Arte Contemporanea, Rivoli, Turin (exh. cat.)

The Sea & the Sky, The Royal Hibernian Academy, Dublin; Beaver College Art Gallery, Glenside, Pa. (exh. cat.)

Les Trahisons du modéle, corps et attitudes II, Stéfane Ackermann agence d'art contemporain, Luxembourg

Turner Prize 2000, Tate Britain, London

Vanishing Points, Groupe Première Heure, Saint-Cloud, France

2001

Abbild: Recent Portraiture and Depiction, Landesmuseum Joanneum, Graz, Austria

AC: Isa Genzken / Wolfgang Tillmans, Museum Ludwig, Cologne, Germany

The Beauty of Intimacy: Lens and Paper, Kunstraum Innsbruck, Austria

Century City: Art and Culture in the Modern Metropolis, Tate Modern, London (exh. cat.)

Club Club Club, Le Confort Moderne, Poitiers, France

Contemporary Utopia, Latvian Centre for Contemporary Art, Riga, Latvia (exh. cat.)

Espace d'Art Contemporain, Geneva, Switzerland

Freestyle, Werke Aus Der Sammlung Boros, Das Museum Morsbroich, Leverkusen, Germany

Un mundo feliz / Brave new world, OMR, Mexico City

Museum unserer Wünsche, Museum Ludwig, Cologne, Germany

La natura della natura morta, Galleria d'Arte Moderna, Bologna, Italy (exh. cat.)

Neue Welt, Frankfurter Kunstverein, Frankfurt am Main, Germany (exh. cat.)

Open City: Street Photographs, 1950–2000, Museum of Modern Art, Oxford, UK; The Lowry, Manchester, UK; Museo de Belles Artes de Bilbao, Spain; Hirshhorn Museum and Sculpture Garden, Washington, DC

Places in the Mind: Modern Photographs from the Collection, The Metropolitan Museum of Art, New York

Portrait, Lindig in Paludetto, Turin, Italy; Zeitgenossische Kunst Milchof, Nuremberg, Germany

Record Collection, VTO gallery, London; International 3, Manchester Gallery, Manchester, UK; Forde Gallery, Geneva, Switzerland

Some German Photography, Mark Moore Gallery, Santa Monica, Calif.

Some Options in Abstraction, Harvard University Carpenter Center, Cambridge, Mass.

Sex – Vom Wissen und Wünschen, Hygienemuseum, Dresden, Germany (exh. cat.)

Shopping, Schirn Kunsthalle, Frankfurt am Main, Germany; Tate Liverpool, Liverpool, UK

Tattoo Show, Modern Art Inc., London

Uniforms, Order and Disorder, Stazione Leopolda, Florence, Italy (exh. cat.)

"Why bother?" The Burger King Exhibition, Whitechapel Art Gallery, London

Zero Gravity, Kunstverein der Rheinlande und Westfalen, Kunsthalle Düsseldorf, Düsseldorf, Germany (exh. cat.)

2002

Beyond Barbizon, Elias Fine Art, Allston, Mass.

From the Observatory, Paula Cooper Gallery, New York

HOSSA – Arte Alemàn del 2000, Centro Cultural Andratx, Mallorca, Spain

International Contemporary Art, Museo de Arte Moderno, Mexico City

In the Making, CCAC Wattis Institute, San Francisco, Calif.

Jochen Klein (1967-1997) und Wolfgang Tillmans, Neue Gesellschaft fur Bildende Kunst, Berlin

Moving Pictures, Solomon R. Guggenheim Museum, New York; Guggenheim, Bilbao, Spain

Painted, Printed and Produced in Great Britain, Grant Selwyn Fine Art, New York

Remix: Contemporary Art & Pop, Tate Liverpool, Liverpool, UK (exh. cat.)

Sensationen des Alltags, Kunstmuseum, Wolfsburg, Germany (exh. cat.)

Transform the World 2002, Wako Works of Art, Tokyo

2003

20th Anniversary Show, Galerie Monika Sprüth,
 Cologne, Germany
Abstraction in Photography, Von Lintel Gallery, New York
actionbutton, Nationalgalerie Hamburger Bahnhof, Berlin
After the Observatory, Paula Cooper Gallery, New York
Anniversary Exhibition, Gavin Brown's Enterprise, New York
Architektur der Obdachlosigkeit, Neue Pinakothek,
 Munich, Germany (exh. cat.)
Attack – Kunst und Krieg im Zeitalter der Medien,
 Kunsthalle Wien, Vienna (exh. cat.)
Auto-nom, NRW-Forum Kultur und Wirtschaft,
 Düsseldorf, Germany
Berlin/Moskau, Martin-Gropius-Bau, Berlin (exh. cat.)
Dubrow International, Roger Smith Gallery, New York
Fast Forward, Sammlung Goetz, ZKM, Karlsruhe,
 Germany (exh. cat.)
Looking In – Looking Out, Kunstmuseum Basel,
 Basel, Switzerland
M_ARS – Kunst und Krieg, Neue Galerie, Graz,
 Austria (exh. cat.)
Montagna: Arte, acienza, mito, Museo d'Arte Moderna e
 contemporanea di Trento e Rovereto, Rovereto, Italy
Mixtapes, California College of Arts and Crafts,
 San Francisco, Calif.
outlook, cultural olympiade, Athens (exh. cat.)
öffentlich/privat, Gesellschaft für zeitgenössische Kunst,
 Leipzig, Germany
Painting Pictures: Painting and Media in the Digital Age,
 Kunstmuseum Wolfsburg, Wolfsburg, Germany
 (exh. cat.)
Saint Sebastian, Kunsthalle Wien, Vienna (exh. cat.)
Sex, Karyn Lovegrove Gallery, Los Angeles
Society for Contemporary Art Selection, The Art
 Institute of Chicago
*Somewhere Better Than This Place: Alternative
 Social Experience in the Spaces of Contemporary
 Art,* Contemporary Arts Center, Cincinnati, Ohio
*Von Korpern und anderen Dingen: Deutsche Fotografie
 im 20 Jahrhundert,* Deutsches Historisches
 Museum, Berlin
Warum!, Martin-Gropius-Bau, Berlin

2004

Atmosphere, Museum of Contemporary Art, Chicago
BISS – Architektur der Obdachlosigkeit, Museum
 der Arbeit, Hamburg, Hamburg, Germany (exh. cat.)
Colección Taschen, Museo Reina Sofia, Madrid
Encounters in the 21st Century, 21st Century Museum
 of Contemporary Art, Kanazawa, Japan
Enthüllt, Städtische Museen, Heilbronn, Germany
 (exh. cat.)
The Flower as Image, Louisiana Museum for moderne
 kunst, Humlebœk, Denmark; Fondation Beyeler,
 Riehen, Switzerland (exh. cat.)
Friedrich Christian Flick Collection, Hamburger Bahnhof,
 Berlin (exh. cat.)
Im Rausch der Dinge, Fotomuseum Schweiz, Winterthur,
 Germany

Inventory, Scott King, Donald Urquhart, Portikus, Frankfurt
 am Main, Germany, curated by Wolfgang Tillmans
Jetzt und zehn Jahre davor, Kunstwerke, Berlin (exh. cat.)
Landscape 2, Tower Art Gallery, Eastbourne, UK
Likeness: Portraits of Artists by Other Artists, California
 College of Arts, Wattis Institute for Contemporary
 Arts, San Francisco, Calif.; McColl Center for
 Visual Art, Charlotte, N.C.; Institute for Contemporary
 Art, Boston, Mass.; Dalhousie University Art
 Gallery, Halifax, Canada; University Art Museum,
 California State University, Long Beach, Calif.;
 Illingworth Kerr Gallery, Alberta College of Art and
 Design, Calgary, Canada; Contemporary Art Center
 of Virginia, Virginia Beach, Va. (exh. cat.)
Monument to Now, The Dakis Joannou Collection, Athens
 (exh. cat.)
Il Nudo, Galleria d'Arte Moderna, Bologna, Italy
Rose C'est la Vie, Tel Aviv Museum of Art, Tel Aviv
Werke aus der Sammlung Boros, Museum für Neue
 Kunst ZKM, Karlsruhe, Germany (exh. cat.)

2005

Always a Little Further, 51st International Art Exhibition,
 Venice Biennale, Venice, Italy
*Arbeit an der Wirklichkeit – German Contemporary
 Photography,* The National Museum of Modern Art,
 Tokyo (exh. cat.)
Coolhunters, ZKM, Karlsruhe, Germany (exh. cat.)
Covering the Real, Kunstmuseum Basel, Basel,
 Switzerland (exh. cat.)
Extreme Abstraction, Albright Knox Gallery, Buffalo, Ny.
Growing Up Absurd, Herbert Read Gallery, Canterbury, UK
Helga de Alvear Collection, MEIAC Museum,
 Badajoz, Spain
Migration, Kölnischer Kunstverein, Cologne, Germany
 (exh. cat.)
Oktobarski Salon, Belgrade
Shadowplay – An Homage to H. C. Andersen,
 Kunsthallen Brandts Klaedefabrik, Odense, Denmark;
 Kunsthalle zu Kiel, Kiel, Germany; Landesgalerie
 Linz, Linz, Austria (exh. cat.)
Superstar, Das Prinzip Prominenz in der Kunst, Kunsthalle
 und Kunstforum, Vienna (exh. cat.)
Il Teatro dell'Arte, Villa Manin, Passariano, Italy
Thank you for the Music, Galerie Sprüth Magers,
 Munich, Germany
Weltbilder, Helmhaus, Zurich (exh. cat.)

2006

*Das Achte Feld – Geschlecter, Leben und Begehren
 in der bildenden Kunst seit 1960,* Museum Ludwig,
 Cologne, Germany
Click Double Click, Haus Der Kunst, Munich, Germany
Frankfurter Positionen: Klasse Wolfgang Tillmans,
 Museum für Moderne Kunst, Frankfurt am Main,
 Germany
The Sublime is Now!, Museum Franz Gertsch, Burgdorf,
 Switzerland

Knotenmutter, 1994

Bibliography

Monographs, catalogues for solo exhibitions, and artist's books

1995

Wolfgang Tillmans. Cologne: Taschen, reissued 2002

Wolfgang Tillmans. Frankfurt am Main, Germany: Portikus Frankfurt am Main

Wolfgang Tillmans. Zurich: Kunsthalle Zürich

1996

For When I'm Weak I'm Strong/Wer Liebe wagt lebt morgen, exh. cat., Ostfildern-Ruit, Germany: Kunstmuseum Wolfsburg and Hatje Cantz Verlag

1997

Concorde. Cologne, Germany: Verlag der Buchhandlung Walther König

1998

Fruiciones, exh. cat., Madrid: Museo Nacional Reina Sofia

Wolfgang Tillmans: Burg. Cologne, Germany: Taschen, reissued as *Wolfgang Tillmans*, 2002

1999

Soldiers: The Nineties. Cologne, Germany: Verlag der Buchhandlung Walther König

Total Solar Eclipse/Totale Sonnenfinsternis. Cologne, Germany: Galerie Daniel Buchholz

Wako Book 1999, exh. cat., Tokyo: Wako Works of Art

2001

AC: Isa Genzken/Wolfgang Tillmans. edited by Museum Ludwig, Cologne, Germany: Verlag der Buchhandlung Walther König

Partnerschaften II, exh. cat., Berlin: Neue Gesellschaft für Bildende Kunst

Portraits. Cologne, Germany: Verlag der Buchhandlung Walther König

View from Above/Aufsicht, Ostfildern-Ruit, Germany: Hatje Cantz Verlag

Wako Book 2, exh. cat., Tokyo: Wako Works of Art

2002

Wolfgang Tillmans. London and New York: Phaidon Press

Wolfgang Tillmans: Still Life. Cambridge, Mass: Harvard University Art Museum

2003

if one thing matters, everything matters. London: Tate Publishing

2004

Wolfgang Tillmans: Freischwimmer. Tokyo: Tokyo Opera City Gallery

Wako Book 3, exh. cat., Tokyo: Wako Works of Art

2005

truth study center. Cologne, Germany: Taschen

2006

Freedom From The Known. New York and Göttingen, Germany: PS1 and Steidl Verlag

Selected articles on the artist

This chronological list is alphabetical by author.
If no author is cited, alphabetical lists by article title and publication title then follow.

1989

Brudna, Denis. "Wolfgang Tillmans." *Photonews,* (December)

Gessulat, Stefan. ":Ikonen." *Prinz* (Hamburg, Germany) (August)

"i-D Newsflash." *i-D,* no. 66, p. 7

1992

Brudna, Denis. "I-deas für heute und übermorgen." *Photonews* (June), pp. 8–9

"Parallels." *Creative Camera* (February–March), pp. 24–27

1993

Poschardt, Ulf. "Ein Fleck Freiheit." *Vogue,* no. 8 (August), pp. 110–12

Reich, Elli. "Private Eye." *Prinz* (Frankfurt am Main, Germany) (July), p. 92

Zahm, Olivier. "Tendances." *Purple Prose,* no. 3 (June), pp. 14–15

1994

Adams, Brooks. "Wolfgang Tillmans at Andrea Rosen Gallery." *Art in America* (December), pp. 101–2

Aletti, Vincent. "Voice Choices." *The Village Voice,* September 20, p. 72

——. "Season's Greetings." *The Village Voice,* October 24, p. 73

Als, Hilton. "As Is, Wolfgang Tillmans' Lifestyle." *Artforum* (May), pp. 68–73

Hainley, Bruce. "Wolfgang Tillmans at Andrea Rosen Gallery." *Artforum* (December), p. 82

Königer, Maribel. "L'Hiver de l'amour." *Kunstforum,* no. 126 (March–June), pp. 344–346

Mosselmann, Arnold, and Corinne Groot. "Wolfgang Tillmans at Thaddaeus Ropac, Paris." *Metropolis M.,* no. 3 (June), p. 52

Muir, Gregor. "Wolfgang Tillmans at Interim Art, London." *frieze,* no. 14 (January), p. 56

Swingewood, Sally. "The Camera Never Lies Down." *Time Out Amsterdam,* no. 1 (June), p. 4

Tillmans, Wolfgang. "Techno Soul," in *L'Hiver de l'amour,* exh. cat., Musée d'art moderne de la Ville de Paris, 1994, pp. 8–9

Verzotti, Giorgio. "L'Hiver de l'amour at Musée d'art moderne de la Ville de Paris." *Artforum* (October), p. 112

1995

Althoff, Kai. "Diskussion am Grat." *Texte zur Kunst* (November), p. 172

Appel, Stefanie. "Wahre Coolness." *Prinz (*Frankfurt am Main, Germany) (September), p. 88

Bartas, Magnus. "Wolfgang Tillmans." *Index* (January), pp. 41–43, 61

Bonami, Francesco. "Wolfgang Tillmans." *Flash Art* (March–April), p. 95

Boyer, Charles. "Lifestyle." *Tribus* (March), p. 44

Enslein, Thomas. "Wolfgang Tillmans." *Siegessäule* (February)

Eshun, Kodwo. "Wolfgang Tillmans." *i-D* (March), p. 8

Fricke, Harald. "Die Noblesse des Lustprinzips." *die tageszeitung,* January 18, p. 13

Hierholzer, Michael. "Von Menschen und Bäumen." *Frankfurter Allgemeine Sonntagszeitung,* September 3

Huebel, Birger. "Dabeisein, Machen, Bewegung . . ." *Spex* (February), pp. 44–45

Kratzert, Armin. "Er trinkt Pepsi und glaubt an Gott." *Wochenpost,* April 1

Kuni, Verena. "Wolfgang Tillmans: Portikus Frankfurt." *Springer,* vol. 1, no. 5/6 (November), p. 101

Massery, Michel. "Nouvelles tribus culturelles en photo." *Le Nouveau Quotidien,* September 19

Molesworth, Helen. "Wolfgang Tillmans at Andrea Rosen Gallery." *Art & Text,* no. 50 (January)

Montgomery, Robert. "Street wise." *The List* (August), p. 75

Niemczyk, Ralf. "Joey Beltram." *Spex* (October), pp. 18–19

Pesch, Martin. "Wolfgang Tillmans." *Die Woche,* September 1

Sasaki, Naoya. "Wolfgang Tillmans: Because Quality Counts." *Switch* (September), pp. 131–39

Schmitz, Rudolf. "Rauskriegen was in der Luft liegt." *Frankfurter Allgemeine Zeitung,* September 19

Schönherr, Florian, and Urs Hattung. "Der Grenzgänger." *Journal Frankfurt* (August 25)

Ximenes, João. "Moda Verdade." *O Globo,* June 24

"Achtung, Achtung." *Spex* (September), pp. 42–43

"Ein ehrlicher Voyeur." *Kieler Nachrichten,* February 23

"Fotografien von Wolfgang Tillmans." *aktuell: Das Magazin der deutschen Aids-Hilfe,* no. 13, pp. 10–34, 52

"Im Zeichen des Pulp." *Neue Zürcher Zeitung,* April 8/9

"Installation und Gesellschaft." *Süddeutsche Zeitung,* January

"Die intimen Fotografien von Wolfgang Tillmans." *Frankfurter Rundschau,* September 2

"Kunstpreis für Wolfgang Tillmans." *Bremer Anzeiger,* November 11

"Pur und unverschämt." *Der Spiegel,* January 30, pp. 106–7

"Die Sehnsucht nach dem Paradies." *Allgemeine Zeitung Mainz,* December 8

"Am Selbstverständnis einer Generation mitarbeiten: Interview mit Wolfgang Tillmans." *Pakt* (May–June), pp. 20–21, 40

1996

Aletti, Vince. "Wolfgang Tillmans." *The Village Voice,* September 24, p. 10

Beard, Steve. "No Voyeurs Allowed – Candid Camera: The Roving Eye of Wolfgang Tillmans." *i-D,* no. 159 (December), pp. 68–71

Beil, Ralf. "Deutschland, deine Photographen." *Neue Zürcher Zeitung,* July 31, p. 46

Bianchi, Paolo. "Subversion der Selbstbestimmung." *Kunstforum* (May–September), pp. 56–64

Collin, Matthew. "A Weakness for Photography." *Wired,* UK (November), p. 89

Föll, Heike. "Wolfgang Tillmans." *neue bildende kunst,* no. 2 (April–May), pp. 39–46

Göttner, Christian, and Alexander Haase. "Wolfgang Tillmans*:* Frankfurt am Maingrafie als Selbsterfahrung." *Subway* (November), pp. 8–11

Karroum, Abdellah, and Hilton Als (eds.). *Urgence,* exh. cat., Bordeaux, France: CAPC Musée d'art contemporain

Lütgens, Annelie. "Not for Voyeurs." In *For When I'm Weak I'm Strong,* exh. cat., Ostfildern-Ruit, Germany: Kunstmuseum Wolfsburg, pp. 6–8

Maurer, Simon. "Fragile Schönheit." *Der Tagesanzeiger Züritip,* June 6, p. 60

Molesworth, Helen. "Picture Books." In *For When I'm Weak I'm Strong,* exh. cat., Ostfildern-Ruit, Germany: Kunstmuseum Wolfsburg, pp. 11–12

Pesch, Martin. "Wolfgang Tillmans: Authentisch ist immer eine Frage des Standpunkts." *Kunstforum,* no. 133 (February–April), pp. 256–269

———. "Obst und Gemüse." *Wochenpost,* September 19, p. 36

Sasaki, Naoya. "From Editors." *Switch* (April), pp. 13, 25

Schorr, Collier. "Things Gone and Things Still Here." In *For When I'm Weak I'm Strong*, exh. cat., Kunstmuseum Wolfsburg, Ostfildern-Ruit, Germany, pp. 13–14

Schwendener, Martha. "Wolfgang Tillmans." *Time Out New York (*October 17–24), p. 28

Wagner, Frank. *Family, nation, tribe, community SHIFT: Zeitgenössische künstlerische Konzepte im Haus der Kulturen der Welt,* exh. cat., Berlin: Haus der Kulturen der Welt/Neue Gesellschaft für Bildende Kunst, pp. 11, 14

Wamberg, Jacob. "Øjebliksbilleder fra 90erne." *Politiken,* June 16, p. 12

Ziegler, Ulf Erdmann. "Wünschelrute im Themenpark." *Die Zeit,* September 27, p. 62

"Sozio- und Popkultur: Die Fotografien von Wolfgang Tillmans." *Pur* (February), pp. 6–9

1997

Allen, Vicky. "Cry Wolfgang." *Arena* (July – August)

Aronowitz, Richard. "Invasion of the sewer rats." *The Highbury and Islington Express,* June 20, p. 6

Bach, Caroline. "Photographie et mode." *Art Press* (October), pp. 153 – 56

Beem, Edgar Allen. "The artist as spiritual tourist." *MAINE Times,* September 4, p. 20

Bernard, Kate. "Wolfgang Tillmans." *Hot Tickets,* June 5, p. 45

Boodro, Michael. "fashion for art's sake." *Vogue* (USA) (February), pp. 118, 122

Boogard, Oscar van den. "Ik leef nu." *Metropolis M.* (August – September), cover and pp. 34 – 37

Bonami, Franscesco, ed. *Echoes: Contemporary Art at the Age of Endless Conclusions,* The Monacelli Press, Inc., New York

Brittan, David. "The Crowd." *Creative Camera,* p. 35

Brubach, Holly. "Beyond Shocking." *New York Times Magazine* (May)

Bryant, Eric. "The 10 Best Magazines of 1996." *Library Journal* (May 1), pp. 42 – 43

Campany, David. "Little Boxes." *Creative Camera,* no. 349 (December 1997 – January 1998), p. 42

Cirant, Catherine. "Absolute Landscape." In *Absolute Landscape,* exh. cat., Yokohama, Japan: Yokohama Museum of Art, 1997, p. 143

Clancy, Luke. "Art with a sense of humour." *The Irish Times,* August 18

Coomer, Martin. "We Gotta Get Out of This Place." *Time Out London,* no. 1426/7 (December), p. 69

———. "Wolfgang Tillmans." *Time Out London,* no. 1405 (July 23 – 30), p. 51

Demir, Anaïd. "L'art fait le let de la mode." *Technikart* (March)

Dominicis de, Daniela. "Wolfgang Tillmans, S.A.L.E.S." *Flash Art*

Domröse, Ulrich and Inga Knölke. *Positionen künstlerischer Photographie in Deutschland seit 1945,* exh. cat., Cologne, Germany: DuMont Buchverlag (September), pp. 38 – 39, 138 – 39

Draxler, Helmut. "Requiem für einen: Jochen Klein." *Texte zur Kunst,* no. 28 (November), pp. 179 – 80

Dziewor, Yilmaz. "Tobias Rehberger." *Artforum* (January), pp. 74 – 75

Faller, Heike. "Aus dem Keller zu den Sternen." *Stern* (January), p. 82

Gächter, Sven. "Fotopoet der Strasse." *profil,* no. 50 (December 6), pp. 26 – 27

Gaskin, Vivienne. "Wolfgang Tillmans." *everything magazine* (July), pp. 5 – 7

Germer, Stefan. "Fluch des Modischen: Versprechungen der Kunst." *Texte zur Kunst,* no. 25 (March), pp. 52 – 60

Giampa, Pino. "Wolfgang Tillmans – Sociale, Sessuale e Spirituale," *Romarte* (March – April)

Gleadell, Colin. "Is This Tomorrow." *Art Monthly* (October), pp. 52 – 53

Goto, Shigeo. "Paradise #2: Virtual Insanity." *Dune,* no. 12 (spring), pp. 56 – 57

Greene, David. "Group Exhibition: New Photography #12." *Creative Camera* (February – March), p. 45

Halley, Peter, and Bob Nickas. "Wolfgang Tillmans." *index* (March), pp. 39 – 45

Halpert, Peter Hay. "Buy, Hold, Sell." *American Art* (March – April), p. 49

Heiferman, Marvin. "New Photography #12." *Artforum* (January), p. 79

Heiser, Jorg. "Heroin Chic." *Die Beute,* no. 15/16 (winter), pp. 127 – 36

Hermes, Manfred. "Kunst." *Spex* (January), pp. 32 – 33

Hüllenkremer, Marie. "Art Cologne 1997." *Kölner Stadt-Anzeiger,* no. 261 (November 10), p. 6

Kaufhold, Enno. "Positionen künstlerischer Photographie in Deutschland seit 1945." *Photonews* (November)

Koether, Jutta. "Kunst." *Spex* (January), p. 49

Kurtz, Thomas. "Kunst zeigt bedrohte menschenwürde." *Pforzheimer Zeitung,* February 3

Larson, Kay. "A Month in Shaker Country." *The New York Times,* August 10, p. 33H

Martin, Richard. "Zeitgeist Becomes Form." *Artforum* (March), p. 87

Marcoci, Roxana, Diana Murphy, and Eve Sinaiko (eds.). *New Art,* Harry N. Abrams, Inc., 1997, pp. 141 – 42

McQuaid, Kate. "Maine's 'Quiet in the Land' Plumbs Art of Shaker Life." *The Boston Globe,* August 15

Meyer, Claus Heinrich. "Schweres blut." *Süddeutsche Zeitung,* December 5

Millard, Rose. "The art gang." *The Independent Magazine,* (August 30), pp. 8 – 12

Moro, Silvia Gaspardo. "How to Marry a Million Tree." *L'uomo Vogue,* no. 283 (November), pp. 60 – 77

Morrissey, Simon. "Interrogating Beauty." *Contemporary Visual Art* (October), pp. 26 – 33

Murphy, Fiona. "A Shopping Sensation." *Guardian* (weekend), September 27, pp. 56 – 59

O'Flahert, Mark C. "Crazy, Sexy, Cool." *boyz* (June 14)

Parkes, James Cary. "The Cult of Wolfgang Tillmans." *Gay Times* (July), pp. 15 – 16

Ragozzina, Marta. "Wolfgang Tillmans." *Artel*

Remy, Patrick. "Esthétique du sursis." *Art Press* (October), pp. 157 – 59

Rian, Jeffrey. "The Generation Game." *Echoes: Contemporary Art at the Age of Endless Conclusions,* p. 68

Saltz, Jerry. "Camera Lucida: MoMA Takes a Clear-eyed Look at Some New Photography." *Time Out New York* (January 16 – 23), p. 35

Schmitz, Rudolf. "Die Raumfusion der gegenwärtigen Fotografie." In Brigitte Kölle, ed. *Portikus 1987 – 1997,* Frankfurt am Main, Germany, pp. 70 – 73, 252 – 253

Tiedemann, Holger. "Adam am Zermatt." *Deutsches Sonntagsblatt,* p. 29

"Interview: Wolfgang Tillmans/Photographer." *Hanatsubaki* (August), pp. 27–28

"Tailpiece." *Creative Camera* (February–March), p. 50

1998

Arning, Bill. "Wolfgang Tillmans." *Time Out New York,* no. 166 (November 26), p. 63

Blasé, Christoph. "Vorwarts – und nicht vergessen." *Frankfurter Allegmeine Zeitung,* April 7

Budney, Jen. "Come On Baby." *Parkett,* no. 53 (September), pp. 110–25

Casadio, Mario. "D – dedicate." *Vogue Italia,* no. 570 (February), pp. 324–331

Celis, Bárbara. "Emergentes en Arco 68." *El Pais de las Tentaciones* (February 6), p. 16f

Cotter, Holland. "Wolfgang Tillmans." *The New York Times,* November 6, p. E38

Deitcher, David. "Lost and found." In *Wolfgang Tillmans: Burg,* edited by Burkhard Riemschneider, Cologne, Germany: Taschen

Doctor Roncero, Rafael. "Fruiciones." In *Fruiciones,* exh. cat., Madrid: Museo Nacional Reina Sofia, pp. 144–77, 189

Duursma, Mark. "Mijn versie van normal en mooi." *NRC Handelsblad,* June 26

Eshun, Kodwo. "Leader of the pack." *i-D* (November)

Knopke, Burkhard. "Identität und Sinnlichkeit." *hinnerk* (February), pp. 6–9

Matsui, Midori. "Memory Machine." *Parkett* (September), pp. 94–103

McCormick, Carlo. "Talking Pictures." (interview) *Camera Austria International,* no. 64, pp. 48–62

Nesbitt, Judith. "Only Connect." *Parkett,* no. 53 (September), pp. 126–32

Nieuwenhuyzen, Martijn van. "Wolfgang Tillmans." In *From The Corner Of The Eye,* exh. cat., Amsterdam: Stedelijk Museum Amsterdam, pp. 13, 90–97

Piccoli, Cloe. "Le ultime donne." *i-D,* no. 94 (March–April), p. 63–72

Price, Dick. "We gotta get out of this place." *i-D,* no. 172 (January–February), p. 39

Sager, Peter. "Sammeln ist ein Trip." *Zeit Magazin,* no. 22, pp. 12–18

Saltz, Jerry. "Heaven Knows." *The Village Voice,* December 1, p. 135

Schiff, Hajo. "Wenn Van Gogh gezappt hätte." *die tageszeitung,* February 28

Seyfarth, Ludwig. "Sensationell oder banal." *Hamburger Rundschau,* no. 11 (March 12)

———. "Zurück in die Zukunft." *Szene Hamburg* (March)

Stange, Raimar. "Das Comeback der 80er Jahre." *neue bildene kunst* (February), p. 81f

Sutton, Tara. "Think Before You Shoot . . . Talking to Wolfgang Tillmans." *Big,* no. 19 (May)

Sweet, Matthew. "Porn again." *Frank* (April), pp. 152–55

Thompson, Charles. "Reaction." *Citizen K International,* no. 7 (summer), pp. 17, 19

Tiedemann, Holger. "Burg." *Photonews,* no. 12/1, p. 21

Wakefield, Neville. "Concorde." *Parkett* (September), pp. 104–109

Weber, Martin. "Gut geguckt, Hirsch." *Kölner Stadt-Anzeiger,* November 21–22, p. 7

Wellershoff, Marianne. "Stilleben mit Hinterhalt." *Spiegel Kultur Extra* (September), pp. 3, 6–11

Ziegler, Ulf Erdmann. *Parkett,* no. 53 (autumn)

"Nice Burg." *Gay Times* (December), p. 80

"Veronica's Schweißtuch und andere Abbilder." *Hamburger Abendblatt* (February 17)

"Wolfgang Tillmans." *Photonews,* no. 4 (April)

Entwurf – Religionspädagogische Mitteilunger (March), back cover

form, no. 161 (January)

Hanatsubaki, no. 571 (January), p. 5

Hanatsubaki, no. 572 (February), pp. 13, 15

Hanatsubaki, no. 574 (April), p. 35

The Male Nude, edited by Burkhard Riemschneider, Cologne, Germany: Taschen

Segno, no. 160 (January–February), p. 6

1999

Aletti, Vince. "Photo." *The Village Voice,* September 28, p. 75

Casati, Rebecca. "Erhabener geht's ja wohl nicht!" (interview) *Süddeutsche Zeitung Magazin,* no. 29 (July), p. 32

Hainley, Bruce. "Culture and Kleenex." *frieze,* no. 44 (January–February), pp. 44–45

Matsui, Midori. "Composite." *Hogado,* no. 11 (August), p. 133

McFarland, Dale. "Beautiful Things." *frieze,* no. 48 (September–October), cover and pp. 78–83

Miles, Christopher. "Wolfgang Tillmans." *Flaunt* (November), pp. 46–48

Nilsson, Bo. " . . . on the sublime/*om det sublime . . .*" *Rooseum* (January 23), pp. 7–20, 106–109, 147–56

Sergl, Anton. "Zuendgenarrt: Auf Tillmans Burg." *Our Munich* (January), p. 14

Slocombe, Steve. "Wolfgang Tillmans – The All-Seeing Eye." (interview) *Flash Art,* vol. 32, no. 209 (November–December), pp. 92–95

Tillmans, Wolfgang. "Tom Ford and Ann Hamilton with Wolfgang Tillmans." *Index* (September–October), pp. 67–78

Werneburg, Brigitte. "Zeitschriften sind Originale." *die tageszeitung,* January 16–17, pp. 13–14

"Wolfgang Tillmans." *Bijutsu Gaho,* no. 22 (August), p. 281

2000

Buck, Louisa. "Wolfgang Tillmans." *The Art Newspaper,* no. 106 (September), p. 73

Cork, Richard. "Farewell Then, Britart. Say Hello to the World." *The New York Times*, October 25

Cypriano, Fabio. "Mostra em Berlin destaca Wolfgang Tillmans." *O Estado de São Paulo,* February 11, p. 10

Dusini, Matthias. "Moss muss nicht aufs Klo." *Falter,* no. 14, p. 65

Eshun, Kodwo. "Under the Flightpath." *i-D,* no. 203 (November), pp. 104–16

Graham-Dixon, Andrew. *The Sunday Telegraph Magazine* (October 8), pp. 34–37

Grammel, Søren. "Wolfgang Tillmans: Soldiers." *Frankfurter Kunstverein Hefte,* no. 1, pp. 40–44

Harlock, Mary. "Turner Prize 2000." *Tate Britain* (October 25, 2000–January 14, 2001)

Irving, Mark. "Hot Shot on His Way to the Top." *The Independent on Sunday* (October 22)

Kernan, Nathan. "Moments of Being." In *Apocalypse. Beauty and Horror in Contemporary Art,* exh. cat., London: Royal Academy of Art, pp. 132–35

——. "What They Are: A Conversation with Wolfgang Tillmans." In *View From Above: Wolfgang Tillmans.* Ostfildern-Ruit, Germany: Hatje Cantz Verlag, pp. 7–11

Kimura, Midori. "Wolfgang Tillmans." *Bijutsu Techo,* no. 782 (January), p. 46

Knofel, Ulrike. "Stilleben mit Glatzkopf." *Der Spiegel,* no. 33 (August)

Maurer, Simon. "Man sollte die Kamera ganz vergessen." *Tagesanzeiger,* November 27

McAuliffe, Michael James. "Collector's Choice: Exit Art/ The First World through December 30." *ReviewNY.com,* December 15

Müller, Silke. "Geliebter Feind." *Art,* no. 11 (November), pp. 86–95

Ratnam, Niru S. "Bodies at Rest and in Motion." *The Independent,* September 19, p. 12

Rauterberg, Hanno. "Perfektionist des Hingeschleuderten." *Die Zeit,* no. 44, October 20, p. 47

Searle, Adrian. "Beauty to Make the Spirit Soar, Rubbish to Make the Heart Sink." *Guardian,* October 24, pp. 12–13

——. "Foreign Creativity Pierces Britart Bubble." *Guardian,* June 15, p. 9

——. "The End of the World as We Know It." *Guardian,* September 21, p. 13

Slocombe, Steve. "Lieber Turner." *Sleazenation,* pp. 40–41, 132–41

——. "Some Parts of This World." In *Helsinki Photography Festival,* exh. cat., pp. 5, 26–27

Sonna, Birgit. "Die Faszination der Fensterbank." *Süddeutsche Zeitung,* February 17, p. 22

Verzotti, Giorgio. "Art in the Age of AIDS." In *Dire AIDS: Arte nell'epoca del AIDS,* edited by Gail Cochrane et. al. Milan and Turin: Promotrice delle belle arti, pp. 37–38, 94–97

Ziegler, Ulf Erdmann. "Kunst mit doppeltem Gesicht." *die tageszeitung,* December 15

"Very New Art 2000." *BT magazine,* vol. 52, no. 782 (January), pp. 44–49

"The View from Here." *The Big Issue* (August 28– September 3), p. 1

2001

Aletti, Vince. "Wolfgang Tillmans: A Project for Artforum." *Artforum,* no. 6 (February), p. 129

Brudna, Denis. "Wolfgang Tillmans." *Photonews* (December–January), pp. 20–21

Craddock, Sacha. "Apocalypse: Beauty and Horror in Contemporary Art." *Tema Celeste,* no. 83 (January–February), pp. 114

De Potter, Pete. "Fan." *i-D,* no. 206 (February), p. 174

Egan, Maura. "Prize Matters." *Details* (January–February), pp. 124–31

Finsterwalder, Frauke. "The rise of photography and the dominance of the German school." *Tema Celeste*, no. 86 (summer), pp. 22–23

Gardner, Belinda Grace. "Die Hand umklammert den Haltegriff." *Frankfurter Allgemeine Zeitung,* October 19, p. 54

Gioni, Massimiliano. "New York Cut Up." *Flash Art*, vol. XXXIV, no. 217 (March–April), p. 73

Herstatt, Claudia. "Elizabeth Peyton, Wolfgang Tillmans, The Contemporary Face." *Kunstforum International Bd.* 157 (November–December), pp. 292–294

Jantschek, Thorsten. "Linienmuster des Alltags." *Die Welt,* October 24

Jocks, Heinz-Norbert. "Von der Zerbrechlichkeit der Nacktheit und der unerschrockenen Suche nach Glück." (interview) *Kunstforum International* (April–May)

Keil, Frank. "Hochkultur meets Subkultur." *Frankfurter Rundschau,* October 1

Kernan, Nathan. "What They Are. A Conversation with Wolfgang Tillmans." *Art on Paper* (May–June)

Krajewski, Michael. "Science Fiction/Hier und jetzt zufrieden sein–Utopische Horizonte." In *AC: Isa Genzken/Wolfgang Tillmans,* p. 8

Liebs, Holger. "Die dunkle Kammer Welt." *Süddeutsche Zeitung,* September 29–30, p. 15

Mayer, Sebastian. "re:minded." *Spex* (December), p. 49

McAuliffe, Michael James. "Collector's Choice: Exit Art/ The First World." *ReviewNY.com*

Riemschneider, Burkhard and Ute Grosenick, ed., *Art Now. 137 Artists at the Rise of the New Millennium.* Cologne, Germany: Taschen, pp. 500–504

Reynolds, Cory. "Index Portraits." *Index* (February–March), pp. 76–77, 85

Rodrigues, Julian. "Tillmans for all Seasons." *Photo District News* (March), p. 36

Ruthe, Ingeborg. "Die akzeptable Oberfläche." *Berliner Zeitung,* October 13

Schmitz, Edgar. "So weit die Wände reichen." *Texte zur Kunst,* no. 41 (March)

Shimizu, Minoru. "Wolfgang Tillmans: I WAR, TILLMANS." *Ryuko Tsushin* (June), pp. 120–23

Stewart, Christabel. "Wolfgang Tillmans, week 30, August 2000." (interview) in *fig-1,* exh. cat., London

Testino, Mario. "Art Index," interview with Sadie Coles, *V Magazine* (May–June)

Weich, John. "Wolfgang Tillmans." *Dutch Magazine* (March–April)

Woodward, Richard B. "Racing for Dollars, Photography Pulls Abreast of Painting." Arts & Leisure, *The New York Times,* March 25, sec. 2, p. 39–41

"Aufsicht." *Neverscheinungen* (winter), p. 43

"There's something about uniforms" *Tema Celeste,* no. 83 (January–February)

"View from above: review." *D.A.P.* (fall–winter 2001–2002)

"Wolfgang Tillmans." *Index* (April–May)

2002

Aidin, Rose. "Shooting from the Hip." *The New York Times Magazine* (March 9), pp. 42–45

Bellel, Zeva. "face to face." *Dutch,* no. 38 (March–April), pp. 78–79

Bruciati, Andrea. "Wolfgang Tillmans: Diechtorhallen Hamburg." *Tema Celeste* (January–February)

Burton, Johanna. "Bystander + Wolfgang Tillmans, Lights (Body)." *Time Out New York* (August 15–22), p. 46

Bush, Kate. "Best of 2002–Wolfgang Tillmans (Palais de Tokyo, Paris)." *Artforum* (December), p. 121

Eichler, Dominic. "Partnerschaften." *frieze* (April), p. 96

Eriksen, Peter. "Sokkerne på radiatoren." *Lousiana Magasin,* no. 7 (November), pp. 6–12

Graham-Dixon, Andrew. "Shooting Star." *Vogue* (UK) (March), p. 342

Guerrin, Michel. "Wolfgang Tillmans, les poils et les étoiles." *Le Monde,* June 8, p. 32

Gundlach, F. C. "Wie kommt Bedeutung in das Blatt Papier." (interview) in *reality-check, 2. Triennale der Photographie, Hamburg,* pp. 24–31

Jahn, Wolf. "Wolfgang Tillmans, Deichtorhallen, Hamburg." *Artforum* (March), p. 149

Jonkers, Gert. "De statigheid van een muis in een kartonnen doosje." *de Volkskrant,* July 24, p. 14

Kertess, Klaus. *Photography Transformed: The Metropolitan Bank and Trust Collection.* Harry N. Abrams Publishers, Inc., p. 222.

Koerner von Gustorf, Oliver. "Befleckte Idyllen." *die tageszeitung,* February 6

Koether, Jutta. "Zeug aus einer besonderen Zeit." Neuendorff, Torsten. "Wenn man geliebt wird, will man verstanden warden–but then you still want to be loved." Nakas, Kassandra. "Empathie und Distanz. Zu den Werken von Jochen Klein." Wagner, Frank. "Fährten und Verbindungslinien," in *Partnerschaften, Neue Gesellschaft für Bildende Kunst,* Berlin, 2002, pp. 41–46, 49–51, 53–56, 105–13

Lazimbat, Sascha. "Living on Video." *Groove,* no. 78 (October)

Matsui, Midori. *Art in a New World: Postmodern in Perspective* Japan: Asahi Press

McDermott, Stephen. "Head Games." *Gay City* (August 23–29)

Mortensen, Anders S. "Normal Utilpassethed." (interview) *Panbladet,* no. 1 (February), pp. 20–25

Nickas, Bob. "Best of 2002–Wolfgang Tillmans (Palais de Tokyo, Paris)." *Artforum* (December), p. 117

Paul, Benjamin. "Wolfgang Tillmans: Still Life." In *Wolfgang Tillmans: Still Life,* exh. cat., Cambridge, Mass.: Harvard University Art Museums, pp. 11–18

Perree, Rob. "Wolfgang Tillmans." Reviews, *Kunstbeeld,* no. 10

Pieper, Cornelia. "Bester Zeitgeist." *Frankfurter Allgemeine Sonntagszeitung,* no. 38, September 22, p. 28

Roth, Claudia. "Bestes Engagement." *Frankfurter Allgemeine Sonntagszeitung,* no. 38, September 22, p. 28

Schwenk, Bernhart. ". . . etwas menschliches herübertragen." (interview) in *Aidsmemorial München,* Frankfurt am Main, Germany: Revolver Verlag, pp. 14–17, 36–37

Shimizu, Minoru. "*Bijutsu Techo.*" *Bijutsu Shuppan-sha,* no. 782 (April), pp. 82–87

Smith, Caroline. "Wolfgang Tillmans." *Contemporary* (May), p. 105.

Sonna, Birgit. "Aus Zeit und Raum gerissen." *Süddeutsche Zeitung,* July 17

Temin, Christine. "A Dozen Options in Landscape at 'Beyond Barbizon.'" *Boston Globe,* April 14

Troncy, Eric. "Portrait of the Artist as a Young Man." *Numéro 34* (June), pp. vii–xi, 33–37

Turner, Jim. "Wolfgang Tillmans." *Flaunt,* no. 31, pp. 74–75

Vendrame, Simona. "Wolfgang Tillmans." (interview) *Tema Celeste,* no. 91 (May–June), pp. 46–51

Wood, Catherine. "Wolfgang Tillmans." *Art Monthly,* no. 256 (May), pp. 37–38

Zahm, Olivier. "Dans le vide des apparences." *Vogue* (Paris) (June), p. 22

"Exhibitions: See this!" *Guardian Guide* (April 6–12), p. 42

"Focus Germany." *Flash Art* (May–June)

"Strange Tail of New Pet Shop Boys Video." *New Musical Express* (January 12), p. 5

"Tillmans' view from above." *Sleazenation* (January–February)

"Wolfgang's gaze." *Out* (April), pp. 40–41

"Wolfgang Tillmans and the Pet Shop Boys." *Tema Celeste* (March–April)

2003

Aletti, Vince. "World Beat." *The Village Voice,* September 24

Barber, Lynn. "The Joy of Socks." *The Observer Magazine* (January 5), cover story, pp. 14–22

Brudna, Denis. "Wolfgang Tillmans–If one thing matters, everything matters." *Photonews,* no. 7/8 (July–August), p. 19

Durden, Mark. "Wolfgang Tillmans. Uninhibited Looking." *Portfolio,* pp. 29–30

Evans, Jason. "Review, Wolfgang Tillmans." *Photoworks,* (autumn–winter)

Garret, Craig. "Moving Pictures." *Flash Art* (March–April), p. 47

Goto, Shigeo. "Wolfgang Tillmans Long Interview." (interview) *Esquire Magazine Japan,* no. 3 (March), pp. 38–42

Heidenreich, Stefan. "Wolfgang Tillmans: 'We are not going back.'" *DE:BUG,* no. 32 (June), p. 32

Herbert, Martin. "Preview." *pluk* (May–June), pp. 27–28

——. "Wolfgang Tillmans–Tate Britain." *Artforum* (October), p. 167

Hohmann, Silke. "Die außerirdische Königin." *Frankfurter Rundschau* (June 27), p. 13

Holert, Tom. "Zwischen Ästhetisierung und Ikonografie." In *Mars–Kunst und Krieg,* Hatje Cantz Verlag/Neue Galerie Graz, pp. 290–303

Hubbard, Sue. "All things must pass." *The Independent Review* (June 10), pp. 14–16

Imdahl, Georg. "Dieses unstillbare Interesse an der Oberfläche." *Frankfurter Allgemeine Zeitung,* September 20, p. 45

Jongbloed, Marjorie, Brigitte Oetker, and Christiane Schneider. *Jahresring 50–Jahrbuch für moderne Kunst.* Cologne, Germany: Oktagon Verlag, pp. 208–213

Kiehl, Annette. "Wahrheitssuche." *Westfälischer Anzeiger,* August 14

Lehnartz, Sascha. "Der Maler des modernen Lebens." *Frankfurter Allgemeine Sonntagszeitung,* January 12, p. 47

Leopold, Jörg. "Lights (Body)." In *Fast Forward,* Karlsruhe, Germany: Sammlung Goetz, pp. 376–377

Liebs, Holger. "Paare, Passanten." *Süddeutsche Zeitung,* June 6, p. 15

Long, Andrew. "Wolfgang Tillmans." *Departures* (May–June), p. 99

Maestri, Tony and Alex King. "I had a camera and wanted to change my life." eyesore productions, pp. 18–20

Morton, Tom. "Wolfgang Tillmans. Tate Britain." *frieze,* no. 80 (October), p. 113

Hernert, Martin. "Wolfgang Tillmans." *Artforum* (October), p. 167

Pitman, Joanna. "In a World of His Own." *The New York Times,* June 9, p. 16

Pye, Harry. "Interview." (interview) *Untitled,* no. 30 (June–July), pp. 4–7

Sagner, Karin. "Anti-homeless device." (interview and photography) in *Architektur der Obdachlosigkeit,* Cologne, Germany: DuMont Buchverlag, pp. 20–27

Schütte, Christoph. "Künstler ohne Wäschespinne." *Frankfurter Allgemeine Zeitung,* June 27, p. 56

Searle, Adrian. "The Joy of Socks." *Guardian,* June 10, p. 12

Siedenberg, Sven. "Wolfgang Tillmans über Werte." *Süddeutsche Zeitung, Wochenende,* July 5–6, p. viii

Smith, Caroline. "Rebel rebel." (interview) *Attitude* (July), pp. 63–65

Tyrrel, Rebecca. "The Big Picture Show." *Sunday Telegraph Magazine* (June 1), p. 79

Weston, Alannah. "Wolfgang Tillmans. If one thing matters, everything matters." *HotShoe International* (June), pp. 5, 40–42

2004

Blank, Gil. "How else can we see past the fiction of certainty?" (interview) *Influence,* no. 2, pp. 110–21

Danicke, Sandra. "Wie es sich anfühlt, lebendig zu sein." (interview) *art kaleidoscope* (February)

Goto, Shigeo "Wolfgang Tillmans." *Hi-Fashion,* no. 299 (October), p. 160

Iida, Shihoko. "Wolfgang Tillmans: Spirit of the Freischwimmer." In *Wolfgang Tillmans: Freischwimmer,* edited by Shihoko Iida, Tokyo: Tokyo Opera City Art Gallery, pp. 104–109

Iizawa, Kotaro. "Wolfgang Tillmans." *Geijutsu Shincho,* (December), pp. 86–95

Ito, Toyoko. "Studio Voice." *Tokyo* (November), pp. 118–23

Kawachi, Taka, Kotaro Iizawa, and Kadota, Junichi. "Conversation on Photography." *Studio Voice,* no. 337 (January), pp. 52–53, 72–73

Kedves, Jan, and Cornelius Tittel. "Es geht mir um Wahrheit." *die tageszeitung,* July 6, p. 25

——. "Ich versuche nur, das Richtige zu tun." *Zoo* (March), p. 36ff

Kojima, Yayoi. *Esquire Magazine Japan* (December), pp. 266–267

Matsushita, Yukiko. "Luca." *Esquire Magazine Japan,* no. 7 (October), p. 175

Müller, Silke. "Es dreht sich jetzt nur noch um gute Kunst." *art,* no. 8 (August), pp. 72–74

Nagashima, Yurie. *Switch,* (December), pp. 122–25

Ollier, Brigitte. "L'excellence Tillmans." *Libération* (France), November 13

Penelas, Seve. "Wolfgang Tillmans. Abstraction." *EXIT 14,* pp. 76–81

Rauterberg, Hanno. "Wie viel Moral braucht die Kunst." *Die Zeit,* no. 39 (September 16)

Ribbat, Christoph. "Smoke gets in your eyes." *Kunstforum International,* no. 172 (September–October), cover and pp. 38–43

Schuman, Aaron. "Master of the universal." (interview) *ARTReview* (July–August), cover and pp. 48–57

Shimizu, Minoru. "Hihyo no Fuzai, Shashin no Kajo." *Shiro to Kuro to de—Shashin to . . . , Gendaishichosha,* pp. 151–67

——. "intoxicate." *NMNL,* vol. 52 (October), pp. 6–7

——. "Wolfgang Tillmans: The Art of Equivalence." In *Wolfgang Tillmans: Freischwimmer,* exh. cat., Tokyo: Tokyo Opera City Art Gallery, pp. 110–15

Shimizu, Minoru, and Shigeo Goto, (conversation) Ichihara Kentaro, Tsuchiya Seiichi, *Bijutsu Techo* (Special Issue of Wolfgang Tillmans/Larry Clark) *Bijutsu Shuppan-sha,* no. 857 (November), pp. 11–31 (plates) 32–48, 49–54, 55–61, 62–64 (Selected Book Guide)

Urae, Yumiko. "Wolfgang Tillmans." (interview) *BRUTUS,* no. 553 (August), cover and pp. 20–29

Wiedemann, Christoph. "Annäherung an das Abbild." *Süddeutsche Zeitung,* no. 17, p. 4

Wood, Catherine. "Let me entertain you." *Afterall,* no. 9, pp. 43–44

2005

Barton, Laura. "Joy Boy." *G2, Guardian,* September 23, pp. 14–17

Bodtlander, Bernd, and Frank Nicolaus. "Eine Schule fur den Wahnsinn." *art DAS KUNSTMAGAZIN,* no. 10 (October), pp. 70–77

Bright, Susan. "Wolfgang Tillmans." (interview) in *Art Photography Now,* London: Thames and Hudson

Burg, Dominique von. "Alltagliche Schizophrenie, Kunst und Pressebild von Warhol bis Tillmans." *NZZ Online* (July)

Chavez, Brenda. "Wolfgang Tillmans, Contra Indiferencia." *El Pais* (Madrid) (October 7), pp. 18–19

De Witt, Amy. "Wolfgang Tillmans, Maureen Paley." *Time Out London,* no. 1813 (September 21–28), p. 57

Diez, Georg. "Wie Sieht Die Welt aus?" *Tagesanzeiger, Das Magazin,* no. 40 (October 14), pp. 22–34

Doustaly, Thomas. "Wolfgang Tillmans s'assombrit." *Tetu* (October 1)

Fel, Loïc. "truth study center, L'équivalenc visuell." www.photosapiens.com (September 26)

Hakim, Jamie. "The truth is out." (interview) *Attitude* (October), pp. 88–91

Hakkarainen, Anna-Kaari. "Totuus on tuolla jossain." *muoto* (May), p. 69

Heidenreich, Stefan. "Wolfgang Tillmans, truth study center, 2005." *DE:BUG* (October 27)

Hilpold, Stephan. "Spiritualität im Sex-Club." (interview) *Rondo, Der Standard,* no. 338 (September 30), pp. 4–5

Hofer, Sebastian. "'Ein schwuler Kuss ist hochgradig politisch.'" *Profil* (Austria) (September 12)

Honnef, Klaus. "Details des Universums." *Die Welt,* September 7, p. 29

Iida, Shihoko. *Bijutsu Gaho* (January), pp. 290–291

Illies, Florian. "Der sinnliche Protestant." *Monopol* (October 1)

Jung, Irene. "Die Schönheit der Venus und die Zufälle des Lebens." *Hamburger Abendblatt* (September 17)

Lazimbat, Sascha. "Faltenwürfe und Wellenverläufe." *Groove,* no. 97 (November–December), p. 14

Leaver-Yap, Isla. "Wolfgang Tillmans: Truth Study Center." *Map Magazine* (November)

Lelièvre, Marie-Dominique. "Les yeux au ciel." *Libération* (France), October 18

Liebs, Holger. "Der billigste, für alle zugängliche Zauber." *Süddeutsche Zeitung,* September 7, p. 15

Lübbke-Tidow, Maren. "Wolfgang Tillmans: Truth Study Center." *Camera Austria,* vol. 92, pp. 91–92

Obricht, Hans-Ullrich. "The Tillmans show (Wolfgang Tillmans in conversation with H. U. Obricht and Rem Kohlhaas)." *NUMERO* (France) (October 1)

Polzer, Britta. "Covering the real. Kunst und Pressebild, von Warhol bis Tillmans im Kunstmuseum." *Kunst Bulletin* (July–August), p. 53.

Preuss, Sebastian. "Arena of Passion." *032c,* no. 9 (summer), pp. 94–96

Rehberg, Peter. "Von den Socken." *Siegessäule* (October 1)

Rubira, Sergio. "Wolfgang Tillmans." *EXIT Express,* no. 9 (February), pp. 3, 19

Schock, Axel. "Die Wahrheit des Augenblicks, Neue Fotografien von Wolfgang Tillmans." *hinnerk* (November 4)

Seidl, Claudius. "Der Zauberkünstler." *Frankfurter Allgemeine Sonntagszeitung,* August 21, p. 27

Swift, Simon. "My work isn't just about cocks." *Pink Paper,* no. 882 (September 1), p. 20

Vitorelli, Rita. "Gespräch mit Wolfgang Tillmans." *spike,* no. 6 (winter), pp. 38–49

Walder, Martin. "Äusserst geschärfte Wahrnehmung." *Neue Zürcher Zeitung,* May 1, p. 65

Waldron, Glen. "From stargazing to people-watching." *i-D* (November), pp. 84–93

"Wolfgang Tillmans." *EXIT,* no. 18 (May–July), pp. 70–79

"Wolfgang Tillmans, Art of living people." *Esquire Magazine Japan,* vol. 19, no.1 (January), p. 33

2006

Nickas, Bob. "Wolfgang Tillmans." *Stnd Magazine,* vol. 1, no. 1 (May)

——. "Pictures to Perceive the World." *Freedom From The Known.* New York and Göttingen, Germany: PS1 and Steidl Verlag

Thomas, Tobias. "Das Ungeklärte in der Wertigkeit der Dinge." (interview) *Spex XXV, 25 Jahre Jubiläumsheft,* no. 1, pp. 50–54

Photography, writings, interviews, and projects for magazines, catalogues, videos, and record covers

This chronological list is organized by year. Within each year, entries are listed alphabetically by publication and chronologically by issue.

1989

Artist's page. *Hamburger Rundschau*, no. 49, p. 15
"Opera House." *i-D*, no. 69, p. 8, "Hamburg *i-D* Night," pp. 12–14
"Lutz Huelle." *Prinz* (Hamburg) (September), p. 14, "Gaststätte Sparr," p. 16, "Boy George," "Christoph Schafer and Cathy Skene," pp. 24–25, "Hamburg Nightlife," pp. 30–34
"Nightlife." *Tango* (March), pp. 146–147
"Martin Kippenberger," "Hendrik Martz," "Trude Unruh," "Gerhard Schroder," "Marius Zmuller-Westernhagen," "Alfred Mechtersheimer," "Uta Ranke-Heinemann," "Willy Millowitsch," "Natja Brunkhrse," "Raner Fettig," "Dr. Jürgen Schreiber." *Tempo* (September), pp. 50–56

1990

"Berlin," (text and photos) *The Face*, no. 17 (January), p. 109
"Euroclubbing." *The Face*, no. 24 (August), p. 70
"Peep Show." *Prinz* (Hamburg, Germany) (March), pp. 10–11, "The Weather Girls," p. 24, "Nightlife," pp. 30–34, "Yoko Tawada," p. 38, "Sport Idols + Willi Schulz," pp. 44–48, "Ulich Wildgruber," p. 103
"Adamski." *Prinz* (Hamburg, Germany) (June), cover and p. 24, "Nightlife," p. 42–46, "Friedrich Kurz," p. 112
"First Fashion Story." *Prinz* (Hamburg, Germany) (October), pp. 74–78
"Soul II Soul." *Spex*

1991

"Techno Reportage Gent and Frankfurt." *i-D*, no. 99, pp. 18–23
"Fashion (Couples)." *Prinz* (Hamburg, Germany) (October), pp. 76–79
"Electronic." *Spex* (May), pp. 38–40
"Stephen Duffy." *Spex* (July), pp. 26–28
"Primal Scream." *Spex* (August), cover and pp. 3, 26–27, "Rebel MC," pp. 18–20

1992

"Aids Page." (photos and text) *i-D*, no. 100, p. 50
"Fashion." *i-D*., no. 102, p. 4, "Florence + Video Stills," p. 12, "Cyberpunk Technology," pp. 36–40, "Straight-up Portraits," pp. 21, 46, 57
"Glam Club." *i-D*, no. 104, pp. 81–82
"Athens Reportage," "Juan Atkins," "Darren Emmerson." *i-D*, no. 105, pp. 10–13, 18–22
"Levi's." *i-D*, no. 106, p. 42

"Public Enemy." *i-D*, no. 107, pp. 18–21
"Sega." *i-D*, no. 108, pp. 60–61, "Dexter Wong," p. 75, "Chris O'Reilly," p. 80, "Colin Harvey," p. 82, "Gay Pride London," pp. 86–90, "Love Parade, Berlin," pp. 64–69
"General Levy." *i-D*, no. 110, p. 45, "Chemistry Club," pp. 56–58, "Fashion Like Brother Like Sister Alex & Lutz," pp. 80–87
"Ragga," "Jamaica," "Shabba Ranks," "Lady Patra." *i-D*, no. 111, pp. 4–10
"Aids Page." *i-D Japan*, no. 4, p. 43
"Gay Pride London." *i-D Japan* (December), pp. 86–89
"Suede." *i-D now* (November supplement), p. 5, "St. Etienne," p. 7, "Velda Lauder," p. 8, "Tomoko Yoneda and Jon Barnbrook," p. 9, "Alan Maughan," p. 13, "Lawler Duffy," p. 20, "Al Berlin," p. 22, "Non-Aligned," p. 23, "Eugene Soulemen," p. 24, "Spiral Tribe," p. 25
"My Bloody Valentine." *Spex* (March), cover and pp. 26–28, "Joey Negro," pp. 6–7
"Henry Rollins." *Spex* (April), cover, "Soul II Soul," pp. 3, 6–7, "Adrian Sherwood," pp. 38–41
"Beastie Boys." *Spex* (May), pp. 3, 46–48
"Stereo MCs." *Spex* (September), cover and p. 22
"Ten City." *Spex* (October), pp. 36–38
"Mike D." *Spex* (December), cover and pp. 36–37
"Ragga Twins." *Spex*, cover
"Momus." *Tempo*
"Street Portraits Portfolio." *Zeit Magazin*, no. 38, pp. 24–20

1993

"Survival Stories." *i-D*, no. 113, pp. 4–8
"Vic Reeves and Bob Mortimer." *i-D*, no. 114, pp. 8–10, "Fashion (Sweaters)," pp. 68–70
"Ears." *i-D*, no. 115, pp. 12–14, "Suede," p. 43, "Roland 303," pp. 58–59, "Dries van Noten Devotees," pp. 70–71
"Abient." *i-D*, no. 117, p. 3, "Fashion (Brown)," pp. 14–15
"Faslane Peace Camp." *i-D*, no. 118, pp. 14–17, "Fashion Camouflage," pp. 22–25, "Street Portraits (Lothar Hempel, Alan Belcher, and Others)," pp. 66–67
"Moby." *i-D*, no. 119, p. 3, 28–31
"*i-D* Night Rimini," "Ten City," "Graeme Park," "Tony Humphries," "Simon DK." *i-D*, no. 120, pp. 67–68, "Fashion Sportswear," pp. 70–73
"Fashion Lars," "Alex and Alex," "Lutz and Others." *Ray Gun* (November), pp. 5, 75–80
"Shara Nelson." *Spex* (September), pp. 34–35
"Club Portfolio." *Tempo* (July), pp. 118–25
"Street Fashion." *Time Out Amsterdam*, no. 3, p. 7, "Tattoo Museum," "Squats," p. 8, "Amsterdam," pp. 12–13, "Clubs," pp. 23–24, "Gay Nightlife," p. 34, "Restaurants," pp. 43–44
"Amsterdam." *Time Out Amsterdam*, no. 5, pp. 49–55
"Berlin Portraits." *Time Out London*, no. 1174 (Feburary 17–24), cover
"Street Portraits." *Time Out Student Guide*, p. 43

1994

"Oktoberfest." *ADAC Special,* no. 22, pp. 84–89

"Portishead." *i-D,* no. 125, pp. 3, 20, "Ewan McGregor,"
p. 19, "Kaliphz," p. 25

"Victor & Rolf," "Pascale Gatzen," "Marcel Verheijen,"
"Saskia van Drimmelen," "Lucas Ossendrijver." *i-D,*
no. 126, pp. 38–43

"A Guy called Gerald," "Deep Blue," "LTJ Bukem,"
"Ray Keith," "DJ Hype," "Kenny Ken," "Jumping Jack
Frost," "Goldie." *i-D,* no. 128, pp. 42–46

"Music Technology." *i-D.,* no. 129, pp. 52–58

"Criminal Justice Bill Demo." *i-D,* no. 130, p. 9, "Erasure,"
"Gus van Sant," pp. 24–28

"Madrid *i-D* Night." *i-D,* no. 131, pp. 74–75

"Kai Althoff and Justus Koencke." *i-D,* no. 132, p. 40,
"X-Project/Rebel MC," p. 83

"Ray Brady." *i-D,* no. 133, p. 19

"Richie Hawtin." *i-D,* no. 134, pp. 32–36

"Richard Pandiscio's 'Ones to Watch.'" *Interview* (March)

Lutteurs, Swiss Work Wear catalogues

Purple Prose (winter), pp. 74–75

"Portfolio." *Switch,* no. 7, pp. 130–36

"Fashion Gillian Haratani," "Christopher Moore," "Thuy
Phem," "Tom Borghese and Ramon." *Tempo* (May),
pp. 92–94

"Gay Lifestyles." *Tempo* (August), cover and pp. 20–25

"Fashion Gillian Haratani," "Christopher Moore," "Thuy
Phem." *Vibe* (April), pp. 84–87

1995

"Project." *Aktuell,* no. 13, pp. 10–35

"Paula, John & Paul Nudes." *Brutus,* no. 1, pp. 28–37

"Simon Reynolds and Joy Press." *i-D,* no. 138, p. 13

"Carl Craig." *i-D,* no. 139, pp. 22–27

"Sam Sever." *i-D,* no. 141, p. 7

"Fashion Tristan Webber," "Alex Bircken Faridi,"
"Alexis Panayiotou," "Lutz Huelle." *i-D,* no. 144,
pp. 16–19, "Gay Pride London and New York,"
"Isa Genzken," "Jochen Klein," "Inga Humpe,"
pp. 94–97

"Blur." *i-D,* no. 145, p. 11

"Harmony Korine." *i-D,* no. 146, pp. 32–36

"Chris Ofili." *i-D,* no. 147, p. 38, "Georgina Starr," p. 39,
"Tracey Emin," p. 42, "Gillian Wearing," p. 43

"Deana," "Sister Bliss," "Smokin' Jo," "Queen Maxine
and Vikki Red," "Mrs. Wood," "Anita Sarko," "Princess
Julia," "Belinda Becker," "Rachel Auburn." *Interview*
(April), pp. 84–91

"Mistress Formika," "Liv Tyler," "Margaret Wertheim," "Dan
Matthews," "Ed Burns," "Morwenna Banks,"
"Grandmaster Flash," "Michael Bergin," "Gaetano
Pesce," "Jill Sobule," "Mariko Mori." *Interview* (July),
pp. 64–71

"Andrew Sullivan." *Interview* (September), pp. 132–35

"Mizrahi Skirt." *Interview* (October), p. 98

"Aphex Twin." *jetzt,* no. 23, p. 14

"Bronx Skaters Reportage." *jetzt,* no. 44, cover and
pp. 3, 8–14

"Chloe Sevigny." *jetzt,* no. 45, pp. 12–13

"Fake New York Diary." *Max* (G) (June), p. 170

"News, Cigs, Mags & Teens talk of danger." *Permanent
Food,* no. 1

"Bernadette Corporation," "Gillian Haratani," "Elizabeth
Peyton." *Purple Fashion,* no. 1

"How Much Portfolio." *Purple Prose,* #9, pp. 22–29

"Ritchie Hawtin/Plastikman." *Spex* (February), pp. 24–26

"Blur." *Spex* (September), cover, pp. 28–34, and thirty-
two-page insert (Portikus catalogue)

"Boss Hog." *Spex* (December), pp. 28–31

"Evangelischer Kirchentag Portraits." *stern,* no. 26,
pp. 56–66

"Visual Diary #2." *Switch,* no. 8, pp. 146–47

"Visual Diary #3." *Switch,* no. 9, pp. 148–49

"Visual Diary #4." *Switch,* no. 10, pp. 154–55

"Take That Fans." *Tempo* no. 9, pp. 62–69

1996

"Manifesta 1 Portfolio Project." *Blvd. Amsterdam* (June),
pp. 39, 46

Château Marmont Hollywood Handbook. inner cover,
pp. 2, 48, 149

Series of 20 postcards. Fotofolio, New York

"The KLF." *i-D,* no. 151, pp. 36–40

"Love Parade '96." *i-D,* no. 156, pp. 52–57

Fold-out poster. Habitat Broadsheet (autumn) *i-D,*
no. 158, p. 98

"Allison Folland." *index* (February), cover and pp. 6–9

"Udo Kier." *index* (April), cover and pp. 6–7

"Mira Nair." *index* (June), cover and pp. 6–10

"Larry Brown." *index* (August), cover and pp. 6–9

"Parker Posey." *index* (November), cover and pp. 6–10

"Twister Fashion." *Interview* (June), pp. 78–83

"Gay and Lesbian Parents." *Out,* no. 2, pp. 90–93

Permanent Food, p. 105

"Faridi fashion." *Purple Fashion,* no. 2

"Chateau Portfolio." *Purple Prose* (winter), pp. 84–91

"Bruce LaBruce," "Tony Ward," "Rick Castro." *Spex,* no. 5,
pp. 66–69

"Youth and Violence Project." *Spex,* no. 9, pp. 48–56

"Suede." (photo and interview) *Spex,* no. 10, pp. 20–21

"Gallon Drunk." *Spex,* no. 11, pp. 4–5, "J. Saul Kane,"
p. 12

"Nan Goldin." *Spin* (November), p. 82

"Fashion Model Gillian Wearing." *Süddeutsche Zeitung
Magazin,* no. 16, cover and pp. 42–49

"Robbie Williams." *Süddeutsche Zeitung Magazin,* no. 38,
cover and pp. 18–22

"Visual Diary #5." *Switch,* no. 1, pp. 154–55

"Visual Diary #6." *Switch,* no. 2, pp. 138–39

"Fashion Model Gillian Wearing." *Switch,* no. 3, pp. 13,
26–39, "Visual Diary #7," pp. 136–37

"Visual Diary #8." *Switch,* no. 4, pp. 122–23

"Visual Diary #9." *Switch,* no. 5, pp. 124–25

"Visual Diary #10." *Switch,* no. 6, pp. 156–57

"Portfolio." *Zine,* no. 2, pp. 34–40

1997

"Phillip." *Honcho* (December), pp. 3, 24–31

"Matthew Collin and John Godfrey." *i-D,* no. 163, pp. 58–65

"John Waters." *index* (January), cover and pp. 6, 17

"Gilbert & George." *index* (September–October), pp. 44–52

"John Lynch." *Interview* (January), p. 44

Ad for Matsuda (also in Matsuda catalogue). *Interview* (April), p. 9

"Aphex Twin." *jetzt,* no. 38, p. 18

"Mouse Walk with Me Portfolio." *Landscapes,* no. 1, pp. 2–13

"Neil Bartlett." *Out,* no. 40, p. 48

"Portfolio." *Skool of Edge,* vol. 2, pp. 52–55

"Supergrass." *Spex,* no. 4, cover and pp. 24–27

"Wu Tang Clan." *Spex,* no. 6, cover and pp. 34–39, "Rob Playford," pp. 26–29

"Kraftwerk." *Spex,* no. 7, p. 9

"Goldie." *Spex,* no. 9, cover and pp. 24–27

"Concorde Portfolio." *Suddeutsche Zeitung Magazin,* no. 26, pp. 32–41

"Kate Moss." *Visionaire,* no. 22

"Fashion Kate Moss." *Vogue* (February), pp. 246–251

"Kate Moss." *Vogue* (March), p. 70

"Fashion Naomi Campbell." *Vogue* (November), pp. 356–361

"Nan Goldin." *Zeit Magazin,* no. 6, cover and pp. 11–19

1998

"Soldiers—The Nineties." (project and text) *Big,* no. 19

"Michael Clark." (portrait) *Dazed and Confused,* no. 48 (November), pp. 142–45

7 postcards (last part of a total of 27). *Fotofolio,* New York

Poster. Gay Games Amsterdam

"Stuart Shave." (portrait) *i-D,* no. 182 (December), p. 38, "Sure Shot," (photography) p. 104

"Daniel, Jochen and Christopher." (project) *i-D family— Future Postive,* p. 146

"Bianca Jagger." *index* (June), cover and pp. 10–17

"Pulp." *jetzt,* no. 19, pp. 6–7

"Blumentopf nach Hause tragen." 1997 (project) *Kunstbuch,* Cologne, Germany: Walther König, p. 163

Insert. *Paradex,* no. 1

"Martin Margiela Summer 98." (photography) *Purple,* no. 1 (summer)

"Martin Margiela/Alex Bircken Faridi." *Purple Fashion,* no. 5

"Pulp." *Ray Gun,* no. 55, cover and 7 pages

"Performance." (photography) *RE-* no. 2 (winter), pp. 32–33

"Jutta Koether and Christoph Gurk." *Spex* (February), p. 65

"Pulp." *Spex* (April), pp. 18–21

"Kodwo Eshun." (portrait) *Spex,* no. 8 (August), pp. 36–39

Cover photo. *Studio Voice,* vol. 265 (January)

"Jochen Klein." Cologne, Germany: Verlag der Buchhand- lung, Walther König, monograph edited by Wolfgang Tillmans, also foreword by W. T.

"Light." *Visionaire,* no. 24

"Gala 1997." (project) *Vogue Italia,* no. 570 (February), pp. 328–29

1999

"Soldiers: The Nineties." (project) *Art,* no. 11 (November), pp. 86–95

"K78," "das Titel von die Portfolio ist Nestbeschmutzung." (project) *Berlin/Berlin,* Cantz Verlag, Ostfildern, pp. 339–340, 377–380

Cover. (project) *Domus,* no. 812 (February)

Dub Infusions 1989–1999. CD and record cover, Sonar Kollektiv

35 postcards. Gebr. König Postkartenverlag, Cologne, Germany

"Strings of Life by Rhythim is Rhythim." (project) *i-D,* "Beyond Price," p. 238

"Tom Ford and Ann Hamilton with Wolfgang Tillmans." *Index* (September–October), pp. 66–78

"Mouse on Mars." (portrait) *Spex,* no. 8 (August), cover and pp. 30–35

"Princess Julia." (photography) *Süddeutsche Zeitung,* no. 11, March 19, pp. 14–15

"Anatoli Karpow." (portrait) *Süddeutsche Zeitung,* no. 16, April 23, pp. 12–20

"Zwölf Uhr mittags." (project) *Süddeutsche Zeitung,* no. 29, July 23, pp. 26–33

"Silke Otto-Knapp." (photography) *Süddeutsche Zeitung,* no. 37, September 17, p. 34

2000

"The View From Here." *The Big Issue* (August 28), (guest edited by Wolfgang Tillmans) cover and pp. 3–24

Goldfrapp. "Lovely Head." (music video) Mute Records

Goldfrapp. (video stills) *i-D,* no. 199 (July), pp. 156–57

"Joshua/Zelda." (portrait) p. 2, "Rem Koolhaas," (portrait) pp. 30–38, "André Weisheit," (portrait) *index* (September–October), p. 32, "Käthe Gilles," (portrait) p. 100

"Signal—Collection by Lutz." (photography) *Libération* (France), no. 4 (winter), pp. 122–23

Russell Haswell. *Live Salvage 1997–2000.* CD back cover, Mego

"Portfolio." (project) *Männer aktuell,* no. 1 (January), pp. 37–46

"Purple look, J'adore." (photography) *Purple,* no. 5 (summer), pp. 208–217

"Lutz in sanddunes." (photography) *Spex,* no. 9 (October), p. 15

"Irm Hermann." (portrait) *Süddeutsche Zeitung*, no. 12, March 24, cover and p. 57; and "Rosa von Praunheim," (portrait) p. 58.

"rats." (project) *Tate*, no. 23 (winter), pp. 48–49

"James Turrell." (interview) *Vogue Hommes International* (spring), pp. 74–78

2001

"A Project for Artforum." *Artforum*, no. 6 (February), pp. 130–33

"Bernhard Willhelm." (portrait) *Butt*, no. 1 (spring), cover and pp. 14–18

"Some Things Wolfgang Tillmans Saw and Liked." (photography) *Butt*, no. 2 (autumn), pp. 56–60

"Hedi Slimane." (portrait) *i-D*, no. 207 (March), pp. 186–88

"Studiomaus." (project) *i-D*, no. 213 (September), p. 293

"Richard D. James." (portrait) *Index* (April–May), pp. 68–73

Hall, Peter. "The Return of the Concorde." *Metropolis* (June), p. 140–44 (illus.).

"Andreas Gursky." (portrait) *The New Yorker* (January 22), p. 62

"Stella McCartney." (portrait) *The New Yorker* (September 17), p. 131

Postcard book. *Snap Art Collection*, amus arts press, Osaka

Poster for London Film Festival, November

"Ruth Wyner and John Brock." (portrait and text) *Purple*, no. 7 (spring), pp. 78–79

"Neil Tennant." (portrait and text) *Purple*, no. 8 (summer), pp. 62–63

"Cerith Wyn Evans." (portrait and text) *Purple*, no. 9 (fall), pp. 76–77

"I want to work it out." (photography) *Sleazenation*, no. 1 (February), pp. 100–107

"Deutschlandreise." (photography) *Süddeutsche Zeitung*, no. 35, August 31, cover and pp. 11–40

"Donald Cameron." (portrait) *Vogue Hommes International* (spring–summer), p. 86

2002

"No shock, no scandal. Just a gay couple on holiday." (project) *Butt*, no. 5 (autumn), pp. 48–57

Pet Shop Boys. *Disco 3*. CD and record front cover, EMI

"Blushes #13." 2000 (project) *The Face—Pop* (spring-summer)

"Crossover." (portrait) *i-D*, no. 218 (March), p. 205, "Miss Kittin," (portrait) pp. 206–207, "DJ Hell," (portrait) p. 210

"Zandra Rhodes." (portrait) *i-D*, no. 220 (May), pp. 66–70

"Gilbert & George." (portrait) *i-D*, no. 221 (June–July), pp. 96–104

"Michael Imperioli." (portrait) *index* (April–May) pp. 15–18

"Der Blautopf in Blaubeuren, 2001." (project) *N°B Magazine* (February), pp. 132–37

Pet Shop Boys. "Home and Dry." (music video) EMI

"Marilyn." (portrait and text) *Purple*, no. 10 (winter), pp. 62–63

"Miss Kittin." (portrait and text) *Purple*, no. 11 (spring), pp. 80–81

"Ryan McGinley." (portrait and text) *Purple*, no. 12 (summer), pp. 62–63

"Isa Genzken." (portrait and text) *Purple*, no. 13 (fall), pp. 64–65

"Josh Hartnett." (portrait) *Süddeutsche Zeitung*, *Jetzt*, no. 12 (March 18), cover and pp. 6–11

2003

39 postcards. Gebr. König Postkartenverlag, Cologne, Germany

"Film with music, words, and singing." 45 minute video film made for Tate & Egg Live event

"Thomas Eggerer," (portrait) *Architectural Digest, Deutschland*, no. 10, pp. 146–47

"Butt page." (photography) *Butt*, no. 6 (spring), p. 6, "A True Encounter in a Hotel Room in the Middle East." (project), pp. 44–48

"Isa Genzken—A conversation with Wolfgang Tillmans." (interview) *Camera Austria*, no. 81, pp. 7–18

"Peter Saville." (portrait) *frieze*, London, designed by Peter Saville, p. 9

"Farewell." (photography and text) *G2, Guardian*, October 17, pp. 2–3

"Kompakt—Ein Haus aus Pop." (photography) *Groove*, no. 81 (April–May), cover and pp. 24–30

"Ricardo Villalobos." (portrait) *Groove*, no. 84 (October–November), cover and pp. 3, 24–28

"Two Divided by Zero." Pet Shop Boys (portrait and interview) *i-D*, no. 238 (December), pp. 94–99

"Portrait of Tony Maestri." *I had a camera and wanted to change my life*, eyesore productions, Bournemouth, UK, p. 3

"We are not Going Back." (photography and text) *Purple*, no. 15 (spring–summer), cover and pp. 2–48

"Claudia." (portrait) *Re-Magazine*, no. 10 (spring–summer), pp. 33–35

Anti-war poster. *Sleazenation*, (March)

2004

"Wolfgang Tillmans on Donald Urquhart." (text) *Artforum*, no. 5 (January), p. 139

"Corrective Lens—letter to the editor." (text) *Artforum*, no. 5 (January), p. 18

"Michael Stipe." (portrait and interview) *Butt*, no. 9 (spring), cover and pp. 10–19

"Lutz." (portrait) *Butt*, no. 10 (summer), pp. 24–29

"Self/Sweat." 1993 (project) *Chroma*, no. 1 (summer), cover

"Ost-West." (project) *Freier*, no. 3

"Soldiers: The Nineties." (text) in *Friedrich Christian Flick Collection*, exh. cat., Cologne, Germany: DuMont Buchverlag

"Page 3 Stunnas!" (project and text) *G2, Guardian*, April 19, pp. 2–3, reprinted in *Newspaper Jan Mot*, no. 42 (May), pp. 2–4; *Der Standard* (May), p. Album B3; *Courier International*, no. 711 (June), p. 16

"Miss Kittin." (portrait) *Groove*, no. 87 (April–May), p. 24

"Clubfotografien." (photography) *Groove,* no. 91, cover
 and pp. 48–55
"Lutz with Wolfgang Tillmans." (portrait and interview)
 index (September–October), pp. 96–98
 Miss Kittin. *I Com.* CD and record cover, EMI
"21st Century Radical Chic." (project and text) *Purple–
 fashion,* no. 1 (spring), pp. 336–343
 Superpitcher. *Here Comes Love.* CD and record back
 cover, Kompakt

2005

"In conversation: Who Do You Love? Isa Genzken and
 Wolfgang Tillmans." *Artforum* (November),
 pp. 226–229
"Tony Blair." (portrait) *Attitude,* no. 132 (April), cover and
 pp. 40–43
"Dominic Masters." (portrait) *Butt,* no. 12 (spring), p. 58
"Bottoms." (project) pp. 6–9, "John Waters," (interview)
 Butt, no. 13 (summer), pp. 15–24
"Leaving Japan 18 Oct. 2004." (project) *Esquire Magazine
 Japan,* no. 2 (February), pp. 68–77
"La ciudad." (photography) *EXIT,* no. 17 (February–April),
 pp. 24–37
"Family." (artwork) on Family re-launch flyer, London
"DJ Koze." (portrait) *Groove,* no. 94 (May–June), cover and
 pp. 16–20
"Mein Plattenschrank." (text) *Groove,* no. 97 (November–
 December), p. 46
"M.I.A.–Louder than Bombs." (portrait) *i-D,* no. 255 (June),
 cover and pp. 62–67, "Make Poverty History."
 (project), pp. 160–61
"Billie Ray Martin." (portrait) *i-D,* no. 258 (October), p. 257
"Jerry Hall." (portrait) *index,* no. 5 (June–July), cover and
 pp. 58–63, "Slavoj Žižek," (portrait and interview)
 pp. 32–39, "Hot Chip," (portrait) pp. 70–71, "The
 Organ," (portrait) pp. 88–89
"L'equilibriste." (portrait) *Numéro,* no. 63 (May), pp. 52–53
 André Galluzzi. *Berghain 01.* CD cover images, *Ostgut
 Crusaid Annual Review* 2004–2005 (photography)
"Entreprenøren Fra Kreuzberg." (portraits) Frank, Erik Lars.
 Panbladet, no. 5 (June), cover and pp. 6–7
"Glas." 1999 (photograph) on Quaker Social Action
 charity card
"Martin Kippenberger." (portrait) in *Tate Modern Exhibition
 Guide,* cover
"Gold." (project) in Volume 0 *The sky is thin as paper here,*
 Galerie Daniel Buchholz, Cologne, Germany

2006

"Portraits of Tiga." *Dummy,* no. 1 (spring), pp. 66–72